雲煙過眼
陳其寬的繪畫與建築

Painting and Architecture of Chen Chi-kwan

臺北市立美術館
TAIPEI FINE ARTS MUSEUM

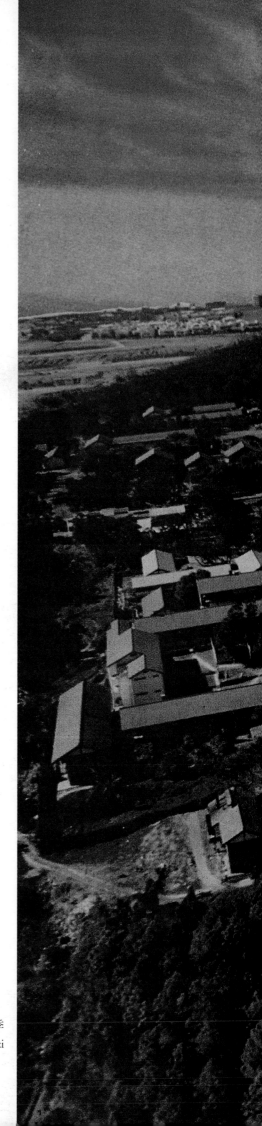

東海校園鳥瞰圖　攝影：余如季
Birdview of Tunghai Campus　photo: Yu Ru-zi

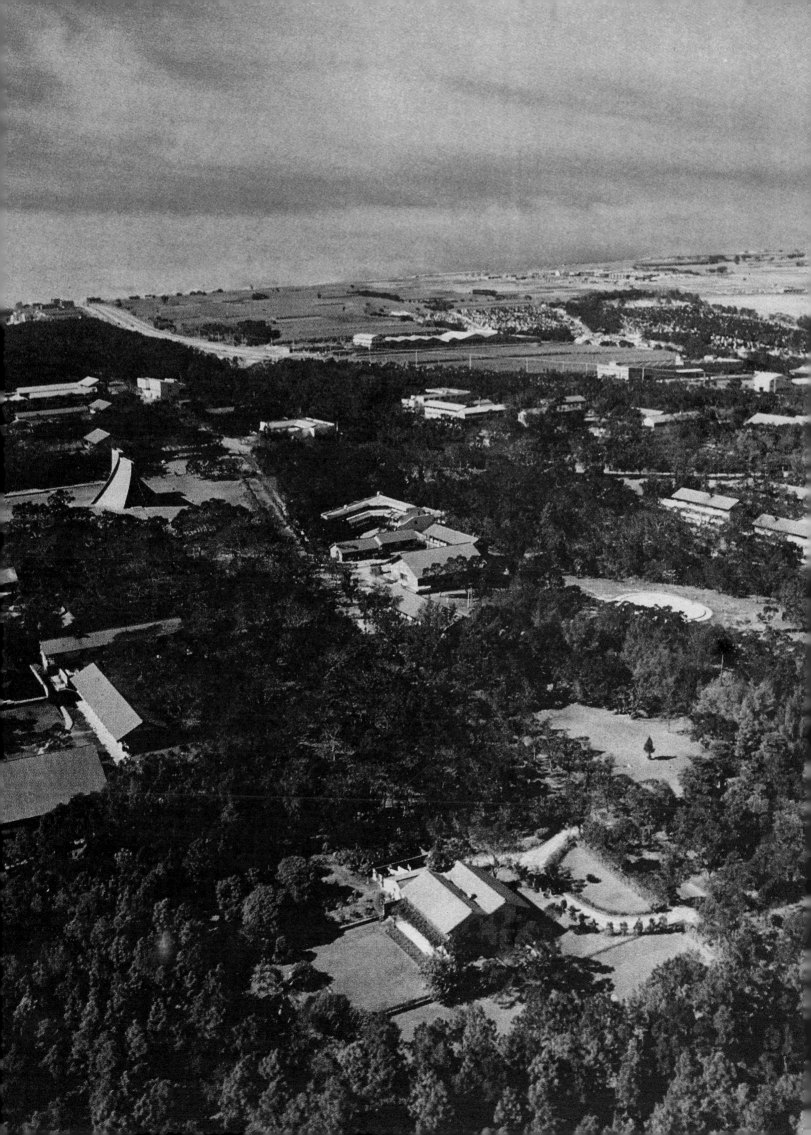

本書為「雲煙過眼—陳其寬的繪畫與建築」之展覽專輯，該展為台北市立美術館策畫，展覽期間為2003年11月8日至2004年2月1日

The catalogue is published in conjunction with the exhibition: Painting and Architecture of Chen Chi-kwan, November 8, 2003 - February 1, 2004, organized by Taipei Fine Arts Museum.

目次 Contents

序

面對時代的演進，具有千年傳統的水墨，其創新之表現是當代藝術永恆的主題。進入新世紀後，搜尋「水墨現代化」在二十世紀百年之中的軌跡，更刻不容緩。以建築師為本業的陳其寬先生從事水墨創作至今已逾五十年，傳統樣貌與現代感兼具的風格，拓展出前人未達的畫境，在眾多的現代水墨形貌中，獨樹一格，是中國傳統藝術在二十世紀的發展進程中，不可忽視的一環。尤其對於「水墨現代化」在新世紀的表現，更具有重要的啟示作用。

這次臺北市立美術館舉辦「雲煙過眼—陳其寬的繪畫與建築」即是要重新審視陳其寬先生自五〇年代早期迄今逾五十年的繪畫創作，釐清其中風格之流變，闡述其時代新意。然而，要對陳其寬先生的藝術造詣予以適切的歷史評價，則需要更深入、更全面的搜尋與探索。細究陳其寬先生在另一個藝術領域的成就，東海時期的建築作品(包括路思義教堂)，與繪畫創作同樣地展露「現代」與「傳統」相互交融的視野與格局。因為它們不僅貫徹了現代主義的建築理念，也蘊涵了中國傳統建築的思維與情緒。同時鑑於過去相關之論述一致強調，陳其寬繪畫當中鮮明的設計觀念以及總體與細部的平衡感，與其所受的建築訓練有著密切的關連。本展希冀突破以往的展覽架構，尋求繪畫與建築兩大藝術範疇之間對應的可能性，以闡明陳其寬藝術創作的整體性。

儘管時空的阻隔提高了畫作收集的難度，本展仍得以完整呈現陳其寬先生自五〇年代早期迄今逾五十年的繪畫創作歷程，這要特別感謝國內與海外的藏家熱誠的響應。並蒙李鑄晉先生、漢寶德先生以及羅時瑋先生賜文，使本展在作品展出的廣度增加之外，更兼具學術的深度。最後，對於東海學術文教發展基金會與東海大學建築系鼎力襄助本展模型之製作，在此一併致上最誠摯的謝忱。

臺北市立美術館館長
黃才郎

Preface

With the changing times, the innovative expression of Chinese water-and-ink painting – an art form with a thousand-year history – has become a perpetual theme for contemporary artists. In our new century, retracing the history of the modernization of water-and-ink painting during the 20th-century is a pressing priority indeed. Mr. Chen Chi-kwan, an architect by profession, has been actively painting in water-and-ink for over 50 years. His styles have spanned the spectrum from the deeply traditional to the intensely modern, and he has opened up new artistic frontiers no others had explored before him. Amongst the many new forms of contemporary water-and-ink painting, his are unique. They stand as an integral part of the development of traditional Chinese art in the 20th-century that cannot be ignored. They also serve an important inspirational role, particularly for new expressions of modern water-and-ink painting in the coming century.

The current exhibition presented by the Taipei Fine Arts Museum, "The Painting and Architecture of Chen Chi-kwan," is an attempt to reappraise the art of Chen Chi-kwan from the early 1950s to today, to clarify his stylistic transitions throughout this period, and to set forth their meaning for the current era. Yet to provide an appropriate and precise historical assessment of Chen's artistic attainments requires more in-depth and thoroughgoing research and exploration. A detailed examination of Chen Chi-kwan's successes in another field of art – the architectural designs of the Tunghai University campus (including Luce Chapel) – reveals a vision and style that blends the modern and the traditional – just as in his paintings. This is because they are fully imbued with the ideas of modernist architecture, and also embody profound thoughts and feelings toward traditional Chinese architecture. Furthermore, in light of the emphasis that previous examinations of Chen Chi-kwan's works have consistently placed on his fresh design concepts and sense of balance, both overall and in individual details, and on their inextricably link to his training as an architect, this exhibition hopes to break through the structural limitations of previous exhibitions, and explore the possibilities of a correspondence between the two artistic fields of painting and architecture, to shed light on the integrated nature of Chen Chi-kwan's entire body of work.

Even though the barrier of time has increased the difficulty of gathering together the paintings of Chen Chi-kwan, this exhibition has succeeded in revealing the creative process through which Mr. Chen has traveled from the early 1950s to today; for this we are especially indebted to the enthusiastic and sincere response of collectors both in Taiwan and abroad. The contribution of written articles by Mr. Li Chu-tsing, Mr. Han Pao-teh and Mr. Lou Shi-wei has also increased the breadth of this exhibition and bestowed on it a scholarly depth. Finally, I wish to extend my heartfelt gratitude to YEFA, Tunghai University Endowment Fund for Academic Advancement, and the Department of Architecture, Tunghai University for creating the architectural models featured in this exhibition.

Huang Tsai-lang
Director
Taipei Fine Arts Museum

專文

Essays

陳其寬——一個貫通中西的天才

李鑄晉，前美國堪薩斯大學藝術系教授

本文原為一九九一年台北市立美術館舉行「陳其寬七十回顧展」所作，因全文對其生平及藝術成就有較詳盡的論述，故曾轉載多次。同年載於香港名家翰墨第二十期，其後又於一九九六年陳氏在德國柏林東亞美術館及科隆亞洲美術館展出時所出版之德文譯本全文刊出。二〇〇一年沈春池文教基金會主辦之「陳其寬八十回顧展」在北京中國美術館及上海美術館先後展出，亦再用本文於其特刊中。此次台北市立美術館再度舉行其回顧展，再用此文，對其一生成就仍極適合表揚其成就。

其寬與我年齡相近，一生經驗亦頗接近，童年時代曾經歷不少民國初年政局的動盪，內戰、外侮、逃難及其他種種不安定局面都曾經歷過。抗日戰爭期間，輾轉流離之下，幸得以完成中學及大學教育，戰後又幸得來美留學，接觸世界前輩之訓練。其後數十年間雖一在台、一在美，仍得時常見面機會。我曾於一九六四年來台在故宮研究期間籌辦一個名為「中國山水畫的新傳統」之展，將其寬、余承堯、王季遷、劉國松、莊喆、馮鍾睿等人之作品一同展出，從一九六六年開始，在美國巡迴展覽兩年。今將屆四十年，在此再展，值得特別紀念。

著者識2003

在目前活躍的中國畫家群中，藝術道路走得最廣最長遠的，莫過於陳其寬了。他多才多藝，是建築師，又是畫家，二者的成就，都早已達到了世界第一流的水準。奇怪的是，他為人沉默木訥，不事鋪張，做事嚴謹，因此一般對他的藝術成就，有多方面深刻了解的並不多。要對他有較多的認識，我們必看他的建築、繪畫與背景，作一個全面的討論。

一、童年時代(一九二一～一九四〇)

陳其寬一九二一年出生於北京，當時軍閥割據，北京政府對外侮內患，頻於應付。在動盪的局勢中長成，這是他這一代的中國人的命運。在那時代，免不了有顛沛流離之苦。但如今回首過去，就覺得十分的有意義了。因為，他們這一代經驗了各種人生的衝擊，是年輕一代人所沒有體驗過的，他住在北京東城雍和宮附近的北新橋王大人胡同三十號裏的一位文人家中。他的故居就是一個清朝的舊王府由五進院的住宅改建成的。一家中有四兄弟姊妹，祖孫三代住在一起。他出生不久，兩歲就隨著家人搬到江西南昌。四歲，又遷回北京。回北京後，開始私塾家教。他早年的教育，完全是傳統的四書五經和書法。對他影響最大的，是他家收藏的字畫和古董，使他從小就對藝術有深愛。到八歲時，由於國民政府北伐成功，定都南京，全家又遷到南京，仍是私塾家教，翌年，一九三〇年，他又遷回北京(當時已改為北平)，他已九歲，正式入離家不遠的方家胡同小學，插入四年級，開始受新式的教育，參加了團體生活。並且對基本的知識，打好了基礎。

一九三三年，他十二歲，由於日本「九‧一八」侵佔東三省後，向華北步步進迫，他家就又遷回到南京去。他的初中教育，是在南京中學與鎮江中學完成的。到他升高中的時候，正值一九三七年「七‧七」抗戰開始，華北華東，都受日軍侵入。那時他正進入南京的鍾南中學，因為上海戰事威脅到南京，他就隨校搬到安徽和縣上課。和縣在安徽蕪湖附近，長江以北當時還未受戰事波及。但日軍佔上海後，就向西進軍直逼南京，因此他在安徽也祇過了三個月左右，在南京淪陷前一週，趕回南京，搭上最後一班英國輪船，隨著許多難民移到漢口，再轉乘四川民生公司輪船到達重慶。戰時政府在重慶接納流亡學生，因此入了四川合川的國立第二中學高中部，到一九四〇年畢業。因此他的童年時代，隨著時局的動盪，已走遍了不少地方。北京、南昌、南京、安徽、湖北、四川、三峽、津浦鐵路沿線各地曾走過多次，各地風土人情都有不同的印象，給予一個敏感的少年極其豐富經驗。

他從小就喜好書法和繪畫。在北京方家胡同小學的時候，他的書法已獲得全校的首獎。在南京讀初中時，他首次受到西洋美術教育，作了不少素描水彩，也是班上最優秀的畫家。以後雖在抗戰的流浪的期間，他仍能保持不斷的在書法和繪畫方面下工夫。他的第一張水彩畫是《水天一色》。在六歲時聽到姐姐讀《滕王閣序》的「落霞與孤鶩齊飛，秋水共長天一色」，就引起他畫這張景致的幻想，於是私下託他的二祖父為他購水彩顏料，試著畫這張畫——私下託二祖父，是因為怕父親不准畫畫，怕被打被罰。

二、大學時代(一九四〇～一九四四)

他中學畢業後，考進了中央大學的建築系。參加當時的聯考，考場即在合川。考試完畢的當天下午，日軍轟炸機來到合川上空，誤把合川作重慶，用燒夷彈及千磅炸彈把合川夷為平地，全城大火。國立二中在合川城外蟠龍山上，才得免於難。也恰巧是看大火的最近的場所，令他終生難忘，也使他深感廣島的核彈是日本軍國主義的因果報應。當時許多有藝術天份的青年，要找一門能報國的學問，多半都選上了屬於工學院的建築系。中央大學原在南京，抗戰期間，遷到重慶近郊的沙坪壩。他進中大的時候，正值日軍已佔領沿海地區，開始對重慶大轟炸的時候，那時逃警報成為家常便飯，十分驚險，這種生活到了一九四一年冬，日本奇襲珍珠港，展開太平洋戰之後，重慶才因此得到安定。陳其寬到大學二年級之後，就較為安心求學了。

重慶當時是抗戰期間的文化中心，不少畫家都聚於重慶及其近郊。那時中大藝術系正是全國美術的首府，徐悲鴻、吳作人、呂斯百、陳之佛、張書旂、傅抱石，都在該系任教。當時的建築教育是採用法國藝術學院的方式，美術方面的課程很多。建築系的學生，都要有很好的基本素描、人體素描及水彩的訓練，同時還時常到藝術系去看畫。

對他影響最大的建築系繪畫老師是一位留英的李汝驊 (李劍晨) 教授。其寬先生在重慶時，看到很多俄國的畫展及木刻展。抗戰勝利後，他在重慶也看到了徐悲鴻及傅抱石的兩次最大個展。

那一個階段他的作品，現在差不多已完全遺失了，幸而陳其寬還保存了幾張水彩畫。《嘉陵江》是他剛進中大那年一九四〇年作的。沙坪壩就在嘉陵江畔，風景幽美，霧氣甚重，晴雨不定，使他悟出中國水墨畫中的雲嵐之美的來源，他那時已能完全把握住這一個實景的情調了。

三、遠征印緬及勝利還都(一九四四～一九四八)

正當他大學畢業的時候，當時的中日戰爭已經變成二次世界大戰的一環。一九四四年，戰局已經完全扭轉。亞洲方面，日本佔了整個東南亞，兵力分散。這時英美聯軍正在印度開始進入緬甸反攻，而中國也正式派遣遠征軍從雲南入緬甸，參加作戰。為了配合盟軍，需要很多的翻譯人員。政府就把一九四四年那一屆的大學畢業生完全徵用，經過短期訓練後派入國內各地區。陳其寬也在這時候應徵了。在昆明訓練三個月，訓練之後就被派往印度及緬甸作少校翻譯。出國的翻譯都授以少校官階，為的是怕被盟軍輕視。

參加了軍隊之後，陳其寬就獲得了一個極其難得的機會，走遍了中國西南；四川、貴州、廣西、雲南都有不少他的足跡。這些地方，在抗戰以前，根本就很難有機會走到。抗戰之後，政府西遷，於是不少沿海的人才有機會見到西南的名山大川，真是美不勝收。對於陳其寬，能夠到處旅行實在是一個很大的收穫。當時西南有不少的少數民族，歷代以來都很少與外界往來，因此在生活風俗習慣上，仍保持了他們固有的作風。如今因為戰爭，與其他漢人接觸的機會就多了。陳其寬在他的旅途中，也接觸了不少這些民族。目前他還保留了一些畫稿，描寫《貴州苗族跳月的服飾》，那是一九四四年作的，他畫了些緬甸的佛塔，以及苗人的音樂舞蹈及服飾，表明他畫人物的技巧已經可以支配自如。

中國遠征軍入緬甸作戰後，陳其寬也得到了入緬甸和印度的機會。這是他首次離開中國到鄰邦去，一切人物景色都十分的新鮮。對於他這位藝術家來說，也是大飽眼福。深入人跡罕至的熱帶雨林，終日與蛇獸共處，古木參天的樹梢是大批猴群棲息之地。《密芝那戰地速寫》亦作於一九四五年，是他仍保存著的一張緬甸風景。另有一些印度風光，如《泰姬瑪哈陵》，尚未發表。

作為一個建築系畢業生，他並沒有找到本行的機會；而被徵入伍，反而得到不少的機會來發展他旅遊作畫的機會。這是十分難得的。一九四五年戰事結束前一月返回昆明，在八月十二日當他正在南屏電影院看電影時，突然打出了日本投降的字幕。觀眾衝出了戲院，一連三天的瘋狂慶祝，是他終生難忘的。於是退役飛回重慶，開始轉到他建築的事業上去。一九四六年，大半的人都隨政府復員。陳其寬也在這時到南京找到一份工作，在當時最具聲譽的基泰建築師事務所任職，是他在重慶時代的大學設計教授楊廷寶手下工作。一九四七年，他入了內政部首次設置的全國性的營建司任技士，追隨劉敦楨老師及由英返國的都市計劃專家陳占祥，從事各種計劃。到一九四八年，他轉入了美軍顧問團任工程師，是為了準備出國，增加練習英語的機會。

四、留學美國(一九四八～一九五一)

一九四八年，陳其寬申請到美國伊利諾州立大學的入學證，完成他留美的志願。

那時第二次世界大戰已結束三年，美國還在復員期間。當時從上海到美國，一般都坐輪船。從上海到舊金山，在橫濱、東京和夏威夷各停前後一共是十八天左右。當時是太平洋航線的，就只有美國總統輪船公司的兩條小船：戈登將軍與美琪將軍。陳其寬就是乘戈登將軍號到了舊金山。先到洛杉磯與大姐陳其恭共遊二週，再入中西部伊利諾州立大學。

當時美國戰後的建築思潮，深受兩種重大的影響：其一是美國大師萊特 (Frank Lloyd Wright, 1967-1959) 的有機建築的理論，主張建築應與自然環境相配合，有點受了中國、日本的「天人合一」達成和諧的看法；其二是德國包浩斯 (Bauhaus) 學派，主張儘量利用現代器材及工具，力求最簡純之美的建築。這一派的幾位大師，都於大戰前被迫離開德國到美國來。葛羅培斯 (Walter Gropius, 1883-1969) 在哈佛任教，而密斯范德羅 (Mies Van der Rohe, 1886-1969) 在伊利諾理工學院教書，都有很大的影響。陳其寬在伊大念書的時候，對這兩種潮流都有較深的認識。

對於建築影響很大的，當時還有一位瑞士建築史家基地安 (Siegfried Giedion, 1893-1956) 所寫的幾部書，如《機械的領導》(Mechanization Takes Command) 及《空間、時間與建築》(Space, Time, and Architecture)，都是每一個建築學生必讀的書。陳其寬當時也深受這些書籍的影響，尤其是時間與空間的理性與感性平衡新觀念，無論在哲學上及藝術上，都有極大的激勵。這不但在陳的建築上，而且在繪畫上都有極大的影響。一九四九年，他在伊大念了一年，就已取得碩士學位。那時他除了建築外，還對藝術發生了很大的興趣。於是他轉到加州大學洛杉磯，去住在大姐家中讀藝術系。注重設計方面，他念的課程包括工業設計、室內設計、陶瓷和繪畫 (油畫及水彩)。這樣，他對西方藝術與建築的課目，都有了深刻的認識。

在當時美國的藝術與建築教育，因為都是注重設計和創作，所以到了碩士，就算完結，並沒有博士的課程。他以一年念完了建築的碩士學位，而以另一年修工業設計及繪畫。陳其寬的才能在伊州及加州兩大學念書的時候，就已顯露出來。在伊州大學念書的時候，伊州的丹維爾市(Danville)舉行了一個市政廳設計的競賽代替了畢業設計，他參加了，結果獲得了首獎。這是難得的榮譽。同時他在加州大學的時候，繪畫和設計都相當的突出，因此他在洛杉磯找到建築工作。這家建築公司大半是做休斯飛機公司建築業務的，並不太理想。他那時希望再繼續學習下去，他素聞哈佛大學建築研究所之名，當時正由德國包浩斯的葛羅培斯主持，他遂去申請。

一個偶然的機緣，轉變了他的一生。他申請許久，並沒有什麼著落，一九五一年一月卅日，正當他在加州大學念到第二年中期，也正在準備回中國大陸的時候，突然葛羅培斯來了一封電報：「碩士班臨時有一個空缺，如願來就學，望於二月五日到此上課。」收到這位大師的電報，真是又驚又喜。那時僅有一星期的時間，他就立刻收拾一切離開加大，乘灰狗巴士三天兩夜馬不停蹄的趕到波士頓。他趕到波士頓附近的劍橋，見到了葛羅匹斯，一談之下，原來哈佛學費很貴，他根本沒有這筆費用，因此無法入學。另外由於已有碩士學位，無法申請獎學金。幸好葛羅培斯對他十分賞識，也很同情他的處境，相談之下，就告訴他暫時不必入學，並慨允到他本人的建築事務所給他一份工作，希望他存些學費後再入學。這也就注定了他一生的發展。

五、劍橋三年(一九五一～一九五四)

在劍橋的三年，是陳其寬一生從夢想轉到實現的階段，給他一生在建築上和學術上，打了一個極穩固的基礎：第一是在葛羅培斯事務所工作，實在比上課還可以學得多些，是一個最難能可貴的經驗；第二是以前做夢也想不到可以在全世界的第一位大師下做事，而且在他們事務所裏的同事，大多是葛的學生，因此可以學到不少新的觀念和技術。另外是他把握了所有在哈佛建築系的評圖、展覽、名人演講的學習機會；第三是他在工作之餘，開始作畫，而且常到紐約的現代美術館去看展覽，受到了刺激，而展開了他的藝術生涯；第四是他在葛羅培斯推薦下開始擔任麻省理工學院的建築系設計講師，這就開展了他一生的發展。

葛羅培斯除了在哈佛執教外，還設了一個建築合作社(TAC)，是他與一些哈佛的畢業學生辦的。因為葛羅培斯的名氣很大，請他設計屋宇及建築物的人很多，因此他成立了這個合作社。陳其寬原非他的學生，能入這合作社工作，實在是很榮幸的一回事。當時TAC全部只有十五位人員，他進入這合作社不久，工作的能力就很受葛氏及一些同事的賞識。所以到翌年一九五二年，在葛羅培斯推薦下，就被麻省理工學院請去任建築設計的講師。麻省理工學院是美國理工的牛耳，他的受聘也是極大的榮譽，這個教職提供他更多的學習機會。

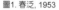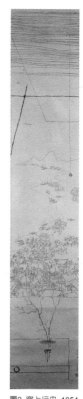

圖1. 春泛, 1953 圖2. 窗上行舟, 1954

就在這個時候，他開始業餘的作畫，而且他的作品也開始受人注意了。他最早的幾張畫。如《山城泊頭》、《街景》、《運河》等，都是一九五二年所作，似乎都根據他在中國的經驗，而用一種新的時空觀念描寫出來。這些畫都用一些長而窄的紙來畫，這顯然是保存了中國傳統的手卷方式，更加拉長，而且也是中國傳統的筆法。《山城泊頭》寫的完全是從江上望重慶山城的景色。屋宇一層層的依山而築，從下至上，至少有數百石級，很親切反映了重慶山城的生活，也可說是一張豎著看的《清明上河圖》。《街景》及《運河》都採用了一種從空中下望，而見到下面屋頂的幾何圖案，其他畫中充滿了人及船隻。這種新的觀點，顯然是從他的建築訓練而來的，這樣他就把中西合璧，完成了一種新的時空觀念繪畫，充分表現了他的想像力。

同一年間，他還畫了一些以中國傳統書法為主的作品。《母與子》是一張由七張小畫構成的一個長軸，有如從傳統冊頁拆開來裱在一個長條上，每張用活潑的毛筆線條，畫出一種母與子的構圖，或抱著、或拉著、或舉著，但用的是半抽象半書法的方法，變成了筆的動作，而非寫實的，完全表現了線條的變化與美妙。另一張《拔河》則是一個橫卷，描寫兩組人兩方拔河，畫的主要部份仍以線條為主，雖較寫實，但全卷最明顯的是線條的動作與奇妙的韻律。這也是一卷半抽象的作品，也是他個人的獨創。同年的《關不住》及《倆小無猜》，都是用中國書法的抽象美來描寫的。

在這一年間，他在繪畫上做了不少的試驗，從較實景到較抽象，從高望到低，從橫卷到長軸，從中國書法到西洋素描，

都具有他個人的特徵。題材仍多是中國的，技巧則仍一半傳統、一半現代，觀點則接近西方，構成一種新的作風。在他一九五三到五四年的作品中，這些特點更為明顯。一九五三年的《球賽》與《草原》與一九五四年的《足球賽》都是橫卷或立軸，把足球賽與草原奔馬簡化到純是書法的動作，變成純抽象的線條。這一年他也開始用色，用新的時空觀點來畫中國的山水。《什刹海》、《風帆入室》、《一元復始》、《黔邊印象》、《西山滇池》、《春泛》(圖1)、《燈節-1》(圖3)、《漁魚》、《重九》、《欲飛》等，充滿了新意，予人以極強的想像發揮。這一直到一九五四年的《窗上行舟》(圖2)、《風帆入室》與《戲風》，都保持這種作風，每一張都有它的特點，令人感到生活趣味與純線條與色彩之美。

一、《足球賽》這張畫已顯現了廣角鏡照相所帶來的影響，看到了球場的兩端，另一點是打算用草書的運動感來表現球場上足球員運動的軌跡。

二、《西山滇池》、《燈節-1》，已開始試驗尋找新的質感(Texture)表現方法，來代替傳統中國畫中的皴法，這種試探影響了以後很多中國畫家去找各自的皴法。

三、《欲飛》中的鳥都有延長影像的變形，是受了照相「動」的影像延長的影響，鳥與鳥之間的透明感是受了X光照相片的影響。

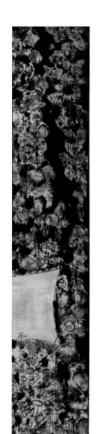

圖3. 燈節-1, 1953

他這三年的發展，一方面是他已有很純熟的技巧，另一方面他也接觸到西方最進步的現代藝術思潮。從葛羅匹斯和他的同事中，他吸收了不少包浩斯學派的理論與觀點。在他麻省理工學院的同事中，有一位匈牙利來的藝術理論家(Gyorgy Kepes, 1906-)，曾寫了一本名為《視覺的語言》一書，當時在歐美都有很大的影響。這本書是用攝影的手法，強調我們日常接觸的事物中，可以看到許多看不到的新事物。這本書對當時抽象美術的影響很大，陳其寬在這種環境中，自然也接觸到不少這些新的思潮，但他不是盲目的跟隨別人的看法，而是吸收了他們的精華，來豐富他自己的表現，在劍橋這三年中，開始他的發展過程。

就在這短短的三年中，他已成為一個受注目的畫家。一九五二年，他已有首次的個展，在麻理工學院的藝術館舉行，一鳴驚人。這展覽的成功，又繼續第二次及第三次個展。在紐約的懷伊畫廊及波士頓的卜朗畫廊，全部作品被收購一空。波士頓著名的《基督教箴言報》及紐約的《時報》

評論他的展覽，認為他是具有中國傳統而又有新表現的畫家。隨後他在各地都有畫展。中國畫家在美，在當時已成名的，有幾位華僑畫家如曾景文等，但從中國來了不久而立刻成名的，那時就只有陳其寬了。

六、新的開展(一九五四～一九六○)

一九五四年，正當他在劍橋已成為名畫家的時候，一個新的機會使他的建築事業有了新的開展。這一年，已在紐約大地產商Webb&Knapp擔任建築部主任成名的中國建築師貝聿銘前來邀他參加一個重大的建設計劃。當時美國紐約的中國基督教大學聯合董事會，正在籌備在台灣建一所新的教會大學，取名東海大學，並邀請貝聿銘為他們設計全部校園。這項工作極其重要，由於貝聿銘慨允共同合作，共同具名，於是他放棄了兩個寶貴職務欣然接受，就從劍橋搬到紐約。

一九五三年，董事會擇定台中近郊的大度山為東海大學校址。一九五四年，董事會邀請貝聿銘來主持設計工作，貝因為計劃浩大，就請陳其寬來幫忙。另外也請了張肇康共同規劃，張氏在中途退出赴香港開業。

對於任何建築師來說，東海大學的計劃與建造，具有極深的意義。普通一個建築師，初期的工作多半是設計一所房子，再進一步的就可以找到一些設計一所大樓的機會，但向來很少有設計整個大學校園的機會。因此，對於貝聿銘和陳其寬來說，這個計劃是一個很大的挑戰。貝聿銘因為在他公司內負擔許多工作，因此不能專心於這個東海的計劃，於是設計東海的重擔，最後就落到陳其寬的肩膀上來。當時董事會並沒有任何詳細的指示，而是完全由他們來做策劃的工作。

從一九五四到一九五六年，陳其寬在紐約與貝聿銘開始計劃東海校園，他們希望能由這個機會尋找中國建築的精髓，來完成一所現代的教育學府。董事會要求全校園的中央有一所教堂，作為全校的中心點。校董事會已向美國《生活》、《時代》兩雜誌的發行人魯斯(Henry R. Luce)捐得一筆基金來建這教堂，因此，教堂設計為計劃中最後之重點。

路思義教堂經過兩年多的計劃與修改，經十餘種的模型及設計，才決定採用當時歐美建築最先進的屬於拋物線雙曲面構成的「堪腦依」(Canoid)為結構依據，使全教堂有極強之向上昇天之感。全堂線條簡單、樸素，有幾何彎曲線條之美，有極強的現代建築感。這計劃完成後，先發表於美國的《建築論壇(Architectural Forum)》雜誌一九五七年三月號，成為全世界建築界所注目的成功設計；前一年他已先在同一雜誌主辦的青年中心競賽，在全美國五七三名徵圖中獲得了首獎。這兩個計劃，都在這有名的雜誌發表，使他開始在建築界上確立了他的貢獻。

經過兩年多的計劃，一九五七年，陳其寬首次踏足台灣，到台中去實地考查校園的各項工程。

為著要了解一下中國早期建築的傳統，陳其寬在一九五七年赴台灣探討初步計劃得失之前，就到日本西京及奈良去考查一些中國式的古建築。在奈良仍留存的許多古寺，如法隆寺等都按照了中國早期的建築建造。尤其是唐招提寺，是一位唐朝的高僧鑑真由揚州到日本來建造的，因此它的風格完全是中國唐代的作風。這給予陳其寬以許多觀念，在他和貝聿銘的計劃中，就採用了不少早期漢唐時期建築「佈局」的東方特色在設計中。

在這期間，他仍用許多業餘的時候來作畫，而且在紐約及其他的地區舉行過不少的個展。除了波士頓的卜朗畫廊外，紐約的懷伊畫廊(Weyhe Gallery)及一位中國人歐陽可宏夫婦開的米舟畫廊(Mi-Chou Gallery)，以及在麻省、新澤西州以至於德克薩斯州的畫廊，都舉行過他的畫展。還有波士頓大學美術館及波士頓附近的卜藍代斯大學(Brandeis University)，都先後舉辦他的個展，這使他的畫在美國流傳很廣。米舟畫廊還把他作為台柱，有十多年每年都為他舉行畫展一次。在藝評中，《紐約時報》、《藝術新聞》等，他都一致獲得好評。耶魯大學的吳訥孫首先在《藝術新聞》雜誌上著文稱他為近年來最具創造性的畫家。倫敦大學的蘇立文在他一九五九年出版的《二十世紀中國藝術》一書中，把他與趙無極及曾幼荷譽為成就最高的海外中國畫家。

他在藝術與建築所獲得的新成就，也予他一種新的自由。為了增進他個人的見識，他於一九五八年再度返台並曾到東南亞、泰國、緬甸及印度等國家去考察古蹟名勝，以增進他的建築思想。一九五九年，又再度返台並到歐洲、北非及埃及去參觀藝術館和古建築物，及現代法國建築大師考布(Le Corbusier)等的建築物。這些在他個人的發展來說，都是增強了他個人的精神修養，而予他的藝術以新的開展。

這一期間的作品，有一部分是繼續他劍橋三年的路向，《北海》(一九五五)、《荷影》(一九五五)、《窗上行舟》(一九五五)、《聽聲下注》(一九五五)、《把酒臨風》(一九五五)、《出世》(一九五六)、《暮雲春樹》(一九五六)、《郊遊》(一九五七)、《除夕》(圖4)(一九五七)、《橋》(一九五七)等，都是根據在中國的回憶和中國山水的傳統演變而來，但都有極強烈的現代感，造型大膽而新鮮，自由的改變固有的時空觀念。每一張畫都是一首抒情詩，想像豐富、意味雋永。

除了這些近乎鄉思的作品外，他在這期間有不少的新發展，都是他這些年旅行的結果，《縮地術》(一九五七)、《雲低》(一九五八)，很顯然都是他經歷過各地山水後的代表作。

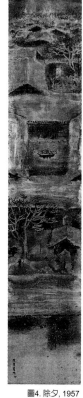

圖4. 除夕, 1957

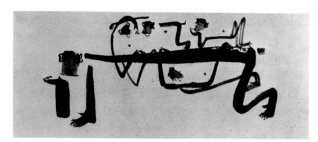

圖5. 負擔-1, 1955

在他的旅行中，他也獲取了不少的新題材。日本的《嚴島神社》(一九五七)，以一個建在水上的神社著名。這座神社全部是朱紅色油漆，在他的筆下，變成了朱紅的交響曲。全畫十分簡單，充滿了水光波影，但卻變化萬端，令人神往。《聖瑪珂廣場》(一九五六)及《威尼斯》(一九五七)、《教堂》(一九六○)也用相似的技巧，用強烈的色彩，來畫廣場的飛鴿及水影，也把現實的景物，改變成幻想的世界，充滿詩意的世界。這些作品也許受了一些瑞士畫家克利(Paul Klee, 1879-1940)的影響，但他的手法，是吸收了克利的靈感，而創造他的宇宙。

在這一期中，他又走到另一個新方向。他取材於日常最簡單的事物，如花、鳥、蟲、魚，而用新的技巧，寫成了微妙的形象，予人深思哲理。這種作風，顯然是受了中國南宋時代禪宗畫的影響而來的。五十年代在歐美的藝術界有一種東方熱，繪畫上，對中國傳統的書法及禪宗畫，如牧溪的作品，有極強的喜好。不少畫家就不期而然的採取了一些靈感，尤其是抽象表現派畫家，更為禪宗畫所吸引。另一些陶瓷藝術家，對中國、日本的傳統陶藝更是五體投地。這些影響，都是由日本方面介紹到美國的。牧谿的禪宗畫，尤其是他幾張在日本的蔬果，影響最大。用最普通的題材，用最簡潔的手法，來寫出了真髓，以表現禪宗「一粒沙中有一個世界」的思想。陳其寬一九五三年時，已畫過一張《醃菜》，在這時期中，更有《宴》(一九五五)、《阱》(一九五九)、《多景》(一九五六)、《茄》(一九五六)、《負擔》(一九五五)以及後來的《鮮》及《秋色》(一九六四)等，都有這一種表現。《負擔-1》(圖5)一方面循著他前一期的用書法筆法著手，另一方面也有禪畫的意思，同時是他一個新系列的猴畫開始。他以後用這題材，用極簡的筆法，變化萬端，成為他的作風的特徵。

七、東海時代(一九六○～一九八○)

一九六○年，東海大學已有五年的歷史。雖然全校還在逐步建造，教堂的計劃仍在停頓中，校園的計劃，這時已有了相當的規模。全部計劃的實現，還需要陳其寬時常到台灣來指導。東海當時辦了三個學院，文理及工都不斷的延聘各方的人材來充實教學陣容。工學院包括一個建築系，正在物色系主任中，那時他和貝聿銘的校園設計工作已近完成。由於他對人謙和以及他一九五四年以來對東海的貢獻頗大，一九五九年東海校長吳德耀主動的提出，延聘他任建築系主任。他

因此就順其自然的辭去與貝聿銘合作之職，在一九六○年九月遷到東海大學。

這是他的順其自然、不強求的個性下的選擇。也許是天命，就在他離開紐約前兩週，魯斯基金會決定重新開始建造教堂的計劃，於是設計及建造路思義教堂的責任就落在陳其寬的肩上。

在東海的早期，他很快的就延聘了一些年輕有爲的講師助教。其中包括最早期的華昌宜，現爲都市計劃專家；以及漢寶德，後來經由他的大力推薦到哈佛取得學位，又回到東海接替他做系主任，現任世界宗教博物館長，對文化建築有極大的貢獻；李祖原也由於他的大力推薦，後來到普林斯頓取得學位，並與貝聿銘合作一九七○大阪博覽會中國館，爾後回台灣成立他的事務所，是目前台北建築界的翹楚；胡宏述後來到美國在(Cranbrook)學院取得設計學位，現任愛奧華大學的藝術學院設計系主任；莊喆在台是已成名的畫家，在美國密西根州繼續他的發展，建立他的世界性的地位。這都可說是他鼓勵與支持出來的後輩。

六○年代，第一屆建築系學生畢業後，他開始在台北發展他個人的建築師事務所，但他仍繼續作畫。《咫尺千里》(一九六六)、《谷音》(一九六四)、《澗》(一九六六)、《桃源》(一九六六)、《雪峰夕照》(一九六八)、《迴旋#2》(一九六七)、《金烏玉兔》(一九六九)、《夢遊》(一九六九)、《午》(圖6)(一九六九)、《夕陽》(一九六八)，都是這一時期的作品。他的《午》(一九六九)，畫的是一個紅日當中，四邊四個山頭，向著它高聳，予人以一個新天地之感，這是這一期的代表作。其中一九六七年的《迴旋#2》把山水畫由立軸畫成橫幅，表現了飛行中所見迴旋的風景，突破了過去幾千年傳統的「平視」山水的限制，是一幅極具突破性的作品。吳訥孫曾有專文在《譯叢》介紹。一九六九年《金烏玉兔》是由天空的一端轉視到另一端的試驗。一九六九年《夢遊》是試驗色彩的濃度與複雜內涵的可能性，提供了改變中國畫色彩純單單調的可行性。是繼《幻遊》(一九五五)的再發展。

圖6. 午, 1969

七○年代時，曾作有《凍港》(一九七七)，用了更複雜的技巧寫山水的變化。這些都和以前的山水不同。此外，在《少則得》(一九七七)，他用以前的金魚題材，用極簡潔的線條色彩，寫出動物的情趣。《痛飲》(一九七七)，畫一隻蚊子在一瓣西瓜上似乎在吸血的痛飲。《秀色可餐》(一九七九)，全畫祇用了三條長線來畫一個裸女的乳，肘及膝相接之處，而其中又有一隻蚊子，這三張畫，都用最簡單的畫怯，寫出昆蟲在人生中的一點幽默，趣味無窮。

一九六六年以前，他都是一個遊子到處流浪，隨遇而安，到處爲家，但一直都沒有安居下來的感覺。他在定居下來引受，才算是結束了他的長期飄泊的生活。結婚及生子，使他初次嚐到美滿的家庭生活。這種情趣，似乎在他畫猴子的題材中反映出來。

猴子是他多年常用的題材。還在劍橋的時候，他已畫過了《閒不住》(一九五二)，用書法線條，寫兩隻猴子嬉戲。這種簡筆的方法，似乎是從牧谿(南宋畫家，約1200-1279)、石恪(五代時期畫家)、四僧的畫意而來，但又是他自己獨創作的作風，用猴子來反映人間的生活趣味。《負擔》(一九五五)《眾醉獨醒》(一九五六)及《嬉》(一九五九)，就發展了這種題材到一個新的境界。他的筆法運用自如，很簡單的點出眾猴的表情。這種作風，到他在台北定居下來之後，更有新的表現。《清理》(一九六四)、《拿鼎》(一九六五)、《如漆如膠》(一九六六)和《團聚》(一九六六)就充分表現了他的多方變化，而實際上都反映了他的人情味。到一九六七年的《眾生相》，就可說是這種題材的大成，其百猴的狀態，洋洋大觀，有喜悅、嬉戲、幽默和純眞，是他看人間的縮影。同年的《吾子》(一九六七)正寫出了他得子的歡欣。其他的猴畫，《老奴》(一九六七)、《童心》(一九七八)、《舞》(一九八○)和其他不少的同類作品，其中有不少自傳性的表現。

其他的常用作風，是他的減筆畫，一方面有禪宗的意味，另一方面也和現代畫家的抽象表現有關。早在劍橋時代，他已開始這種嘗試。一九五三年的《生命線》，用極簡單的拙墨筆調，寫四隻小豬正向母豬吸乳。這張畫可能是受到了牧谿、石恪及四僧的影響，充滿生命的活力。他一九五六年用雞作題材的《母與子》，也有同樣的意味。其他的這類畫，《勢》(一九五九)、《可望而不可及》(一九六七)、《大劫難逃》(一九七三)、以及《終點》(一九七七)等，都在筆墨、抽象、禪理和幽默情趣間，表明了他的藝術的精髓。

陳其寬的畫名在國外遠比在國內爲高。他在五十年代開始，差不多每年都在紐約或波士頓等地有多次的展覽，可是他在台灣定居之後，二十年間，由於他那種木訥、內向、不好鑽營、不善炫耀的性格，使得他在台的首次個展，卻是在一九八○在台北歷史博物館才舉辦，而且還是在陳長華女士及何政廣、何恭上、何浩天督促下達成的。這樣的一位國際有盛譽的畫家，幾乎差不多在台灣被埋沒了。

台北歷史博物館的展出，是由加拿大維多利亞美術館展出後的畫件。一九七七年擔任維多利亞美術館東方部主任的徐小虎女士，特地由加拿大到台灣找陳其寬開畫展。他們本不相識，找了很久找不到。在臨行的前兩天，才從建築界的朋友處得知電話，取得聯繫。在見面的當天，約定在《藝術家》雜誌社碰面。恰巧遇到兩位女記者——《聯合報》的陳長華與《中央日報》的蔡文怡，第二天《聯合報》與《中央日報》用大幅版面報導了徐小虎，新聞刊了一張猴畫，陳其寬就被台灣各界知道，認定為畫猴子畫家了。

八十年代，陳其寬開始在香港展出。這也是由於八十年代在國際上幾家拍賣公司把中國畫提昇到被人注意的高峰，再加上中國大陸在海外推廣中國畫的活動使然。鑽研中國畫現代化近三十五年的陳其寬適逢其會。

八、兼具宏觀微觀的畫家(一九八○～一九九一)

八十年代以前，他的繪畫成就就如同中國傳統的詩人一樣，都著重於五言、七言絕句及律詩方面，少有史詩出現。陳其寬的畫每張都是精湛小品，意味深長，卻也都是即興之作，未若范寬《谿山行旅》與郭熙《早春圖》般的宏偉，這是中國傳統詩畫的特徵，並非陳其寬個人的抉擇。

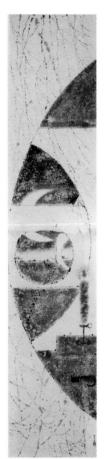

然而，最近幾年他的畫已有趨於「史詩」的傾向。一九八六年，他已將東海大學工學院長職務辭去，無需花太多的精力在行政工作上，因此能集中精力與時間在繪畫創作上。

從1982年的。《約》(圖7)開始，他在一系列作品中，展現了古詩的情懷《約》是張長軸，全畫由月的弧與門窗的弧形相互輝映。遠處海邊的地平線上有幾艘小舟，一條小徑將近景與遠景巧妙的連接起來。畫中所描述的月、柳、燭、睡貓及赭石色調，都是黃昏景象。再加上作者的英文題名：(West Chamber)「西廂」二字，更引人遐思《西廂記》中的男女戀情了。

同年的《憶》表現的也是同樣的意境。用一個四瓣花形的門作基本圖形。在這兩張畫中，他採用了同一手法，以斷斷續續的線條表現出藕斷絲連之感，反映出他對故鄉的回憶：似乎有點模糊，卻又記憶猶新的感受。在用色上，他的技法也是在於表現此點，除了明月及紅燭外，它如青、藍、赭都非原色，也非完整的色面，而是深淺有序，幻化莫測的景象，有如古詩中過往事物，依稀可見

圖7. 約, 1982

之意。這正是陳其寬所說的「意眼」的最佳寫照。這些古詩、詞的情懷到近幾年還很鮮明，一九八八年所做的《江南》(圖8)是一個很微妙的例子，以江南庭園的圓形門窗為主題，重重相間，由近而遠。這是受了唐代白居易《憶江南》詞的啟示：

圖8. 江南, 1988

「江南好，風景舊曾諳，日出江花紅勝火，春來江水綠如藍，能不憶江南?」

從生氣蓬勃的構圖中反映出題意的詩境。這一回憶江南山水的構思，既充滿了「杏花春雨江南」的情調，也有「小橋流水人家」的鄉思。全畫以斷斷續續的線條寫成，更增強了思古之幽情。

他的《藕》Rhizome(一九八八)(圖9)，看似單純，實則複雜。缸的橢圓，窗的圓與太陽的圓構成了幾個相間的圓；與遠山的弧，荷葉的弧相共鳴，產生不少韻律感；將近與遠，室內與室外，有機與無機相交疊，形成「物物相關」之感。正如其英文標題：Labyrinth(即迷宮之意)後改名為Rhizome，引人遐思。蓮花在中國有出淤泥而不染的節操，就像那朵純淨的荷花一般；它又是夏天最佳的清涼食品，這不禁讓人想起「藕斷絲連」。過去中國畫有關「荷」畫，很少有畫「根」(即藕)的，因此他作了這種試探。

圖9. 迷宮, 1989

這十年中，他的繪畫有了新的發展，他開始探索宇宙與生態的奧秘。他過去也曾涉獵過這個題材，但從一九八三年起，成了他最樂於表現的主題。他在六十年代期間對此主題的探索，可由一九六七年的《迴旋#2》及《天旋地轉》中窺其大概。但到了八十年代，經過了數十年對實景的抽象化與記憶印象化的追求，他又更深一層的探索宇宙的奧秘。其實，這種追索，與五代北宋以還所探索的理想是不謀而合的。五代北宋的畫家，從荊浩、關仝到李成、范寬、燕文貴、許道寧和郭熙等，都在追求一種宇宙、自然與人間的關係。北宋山水畫往往寫大型的山水，就是要反映這種訴求的成果。陳其寬並沒有走復古的路子。北宋至今已近千年，人類對太空的探索也正方興未艾。登陸月球及人造衛星傳送回了許多地球

和宇宙的奇景，打開了人類的視野，豐富了人們的想像力。陳其寬也敢於接受這些新事物的啟發，將他的畫轉化爲對宇宙、生態與人間的奧秘的探索。

八十年代，陳其寬的畫達到了他所謂的「宏觀」的境界。「宏觀」也可說是一種宇宙觀。他想像自己似乎就飛翔在天空中，觀賞著地球、宇宙、日月星辰、早晚、晨昏的時節變化；是將「肉眼」及「物眼」昇華到「意眼」的階段。這種「宏觀」是他多年來擴大眼界的合理的發展。一九五七年的《縮地術》便有了這種感覺，把遠近景物全都「擠在一個平面上」，同時採用了多視點的效果。一九六七年的《迴旋#2》已由靜態的山水轉變成動態的宇宙，橫觀豎賞皆得宜。

葉維廉向他提起《返》(圖10)中已有此表現，他回答說：

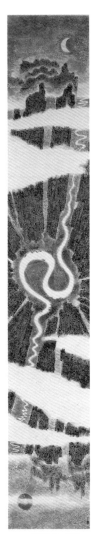

但那時我還沒有往更廣的層次看。兩千多年前，老子竟然說出了如下的話，雖然他在當時僅能憑想像。他說：「大曰逝，逝曰遠，遠曰返。」就是說大到後來就看不見，遠到後來就又回來，他當時可能已經想像到地球不是平的，可能是圓的，他並且可能意想到時間與空間的連帶關係。從我們現代的立場來看，可能還牽涉到不少天文的理論。比如有人說宇宙由膨脹再收縮，收縮再膨脹，那種週期性的情形。不管怎樣，我覺得老子那幾句話很奇特，我有一張畫《返》便是由這句話而來。

由此開端，這種「宇宙觀」的作品，成了他八十年代最常用的主題。一九八三年的《大地》又比《迴旋#2》和《始》更進一步。但在《大地》中，全畫的焦點集中在畫的中心。有一條河由中心向兩方流去，當我們的目光向上移動時，可以看到蜿蜒曲折的河道漸漸變小，直到畫的最上緣。河道旁的山巒平直的站立著，直到消失於地平線上，有如走到了世界的盡頭。在天際間一輪紅陽高掛著。由畫的中心向下移，又見蜿蜒的河道向遠方逝去，兩旁的山巒都是向下垂的，直到消失於地平線上。天空中懸掛著皎白的月。我們似乎身處太空，回望地球，一方是太陽，另一方是月亮，無有上下，正反觀之都有理。這是陳其寬在探索宇宙奧秘中的成果，把觀眾引入了輕浮飄渺的宇宙中，無有重力，不分上下。

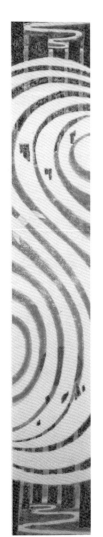

圖10. 返, 1984

圖11. 巽, 1986

一九八三年的《始》，把《迴旋》中左右移動的韻律化爲統一的中心消逝點的處理。描寫在群山高聳的深谷中，遠眺夕陽的情景。高山排列整齊，由地通天，更顯示了長軸的優點，予人以一種歐洲哥德式教堂高聳昇天的設計轉化，充滿了精神祈求的感覺。一條長河蜿蜒流向遙遠的天際，頗有《易經》伏羲氏「一畫開天」的寫照。此畫的英文題名爲Genesis，即聖經中所謂的《創世紀》的一章。冥想宇宙洪荒時代生命之開端，這也是陳其寬宇宙「宏觀」的肇端。正如他所提示的，這種「宏觀」是得自於老子與莊子的啟發。在陳其寬的心裏，宇宙已無所謂上下、高低、方向之分了。在他的畫中，日、月、晝、夜可同時出現在同一畫面，也是智知與感性的同時呈現。

一九八四年的《方壺》中，他以古來傳說的蓬萊三島爲題材，把群山環繞的島嶼組合成兩個弧形，左右對稱的置於畫的中心。其間雲霧環繞，更增加了這些仙嶼的浮動神秘感，也是傳統山水中雲山的延續。用神話將大地與宇宙表現出來，這是陳其寬結合科學探索太空中的無重感與中國古來追求理想仙境的融合。

同一年的《一元論》是這一系列探索中集大成之作。他摒棄了長的立軸與橫的卷軸的形式，而畫了一張圓形的畫，將日、月、山、水安排在這個圓裏，象徵著宇宙初生，萬物同源的刹那。正如畫題所闡示的「一元論」。據他而言，「一元論」的山水是中國哲學中最基本、最原始的泉源。他緣此將宇宙掌握於寸尺之宣紙中，是其個人的成就。

依陳其寬的看法，他的畫從自然出發，加以變形、重組、再造，最後仍回到人間現象，方達最大的溝通與共鳴；否則太過於抽象化與個人化，則不易傳達。他一九五八年的《曦》，彷彿進入了太空，回首觀看地球的一瞥，可以體會到生命的根源與地球的珍貴，從而認識到山水乃人類生命之起點及文明之發源地，如此便擴大了人類的宇宙觀。

一九八六年的《巽》(圖11)，就賦予了這些元素更多的動力。畫幅的上下端都有河流穿越於群山之間，但全畫的大部爲表現風勢的一個大「S」形。從這風勢的光彩的間隙，可以看到藍色的天空及一彎明月。下半部紅色的天中似有一輪紅日，兩端山水呈現一百八十度的倒轉。這樣的構圖，將大自然中的風勢抽象化。一九八八年的《遙》、一九八九年的《昇》及《遠》都是由此主題的衍生，充份的顯現了陳其寬的想像

圖12. 天‧地‧人, 1989

力。《風》畫的形象,是由《易經》「巽」卦得來的,巽卦象曰:「兩風相重,隨風也。」

一九八八年的《長庚》一畫中,他從長的條幅轉換成方形的構圖,全畫充滿了崇山峻嶺,雲煙瀰漫;河流貫穿其間,由近而遠,直通天際。左邊的天有一彎新月,右邊的天有一輪紅日,兩個星體之間即畫的主題——長庚星,又名太白,即金星(Venus)。這顆在中國天文學上早已被發現有奇特現象的星,令陳其寬產生興趣。

與《長庚》同年的《和平共存》是反映陳其寬的理想的作品。這也是一張方形的構圖,看似一幅普通的山水,中有一排山嶺峭壁,其間有瀑布,飛流直下,畫中充滿動物,悠遊於大自然中。《和平共存》是描寫一個理想的自由天地,一切動物都可快樂的共存於此環境中。這是陳其寬的理想境界。他也深深為人類社會永遠不能達到這種境界引以為憾。他也想用這張畫提醒世人要追求和平共處。

這種理想的天地,是他近年來常用的主題。與《和平共存》相似的是一九九○年的《天‧地‧人》,這也是一張方形的畫。在雲煙飄渺的重山峻嶺間,有一輪紅日,山腳下的數條河流曲折蜿蜒的穿梭在大地上。陳其寬自己敘述,這是他一九四四年從軍,從重慶坐車到昆明,沿途所見的山川勝景的回憶。這條公路,險象橫生,尤以其中的七十二彎為最;但這些地方都是人世間最美的境地。《天‧地‧人》(圖12)畫中一些民居散見於群山峻嶺間。陳其寬自己回憶:「雲貴高原的地形,由重慶去,是步步高昇的。每次上到一個山頂,在山頂的谷中就有一塊平地,稱之為『壩』。邊疆民族都聚居在壩上。」畫中的民居便是他心目中記憶的壩,雖所佔面積不大,但他以細筆鉤畫,寫出如苗人跳舞及野台戲等的活動,藉以反映出心靈中的世外桃源,遠離塵世的喧囂、爭執及戰火等苦難,在《天‧地‧人》之間尋求理想和諧之境。這張畫中充滿了人間活動,達到了微觀的極致。

同一主題也在另一張立軸《長安盛世》(圖13)中表現出來具有歷史性的省思。這張畫的寫成,充份的顯現了他的想像力與包容力。在構圖上與「宏觀」系列相同,將畫之焦點集中於畫幅中心。向上望,可見層疊的樹木園林,隨著彎曲的小河及風箏的線逝入天際。遠方的地平線上隱約可見古長安的城牆。天空中紅日高張。反觀畫幅的下方,也是層層的樹木園林,遠處依稀可見大雁塔高聳其上。新月升空,一片靜穆的氣氛籠罩其間。園林之間,描寫了不少平民在郊區的活動,表現出長安太平盛世之感。

據陳其寬自己的說法,他的原意是在「畫杜甫詩《麗人行》:『三月三日天氣新,長安水邊多麗人』之句,但無意中卻轉變到『平民行』。」因為杜甫的詩意是描寫唐明皇時宮內的生活,陳其寬將之轉化成了平民安居樂業的景象。因此,此畫的題意與前兩畫一貫,寫出人間安居樂業、太平盛世之感,這也是他渴望中國將來會有這種好日子,一種心境的流露。

圖13. 長安盛世,1990 圖14. 自然與科技,1990

然而在理想與現實之間,陳其寬顯然也對目前的中西文化有點困惑。這在他一九九○年的《自然與科技》(圖14)中可以看出。這張立軸看似他那些「宏觀」系列的作品,在煙雲群山間寫一瀑布向下渲洩。一而二、二而四,到最後竟變成了無數的分支。上端屬於較自然的山水,但愈往下,則愈顯得機械化。正如他自己所說的:「到下端瀑布愈分愈細,有點像積體電路板,也像電腦影像中把自然的形態變成格子狀的、塊狀的形狀,失去了原形,增加了溝通的困難。下端的鶴鳥也成幾何圖案狀。這是一幅寓意的畫,由觀者自由去想。可能表示反科技的,也可能是贊同自然與科技配合的,也可能是表示科技本來也是自然現象的利用與表現的。」這是人類目前共同的問題,很難有固定的答案,予人困惑之感。陳其寬乃自傳統中國畫出發,透過他的藝術,表現了一個現代中國知識份子對這個問題的看法。在西方的現代畫中,從畢卡索、克利到

馬達(Roberto Matta, 1911-2002)等，也都對這個問題作過表達。陳其寬利用傳統的方法，表現了現代人的內心的矛盾。

陳其寬從中國文人的傳統出發，一直保有中國藝術的特色。從善用書法的筆墨妙趣，追求寓意深遠的山水精神，到吸取西方現代藝術精華，如對時空的新觀念及抽象的表現形式。他在創作過程中，融合了中西傳統，將之轉換成一種極強烈的個人風格。他在藝術上的成就打破了地域與國界的分隔，重組了東西文化的精華。從這個觀點來看，陳其寬不僅是現代的中國畫家，更不愧為具有開創能力的國際性畫家。

九、藝術觀

陳其寬在建築與繪畫上一向都以實踐為主，很少去談理論。他雖曾寫過一些建築理論方面的文章，刊於東海大學早期的建築雜誌，但在繪畫上的文章卻少有發表。但我們可以肯定的說他是注重理論的，只不過他所注重的不是大套的哲學體系，而是不斷的去探索。他在過去四十年的創作生涯中只寫了一篇較為具體的理論性的文章，那是三十年前刊載在台灣《作品》雜誌，亦就是前面已經提到的，為支持「五月畫會」而寫的《肉眼·物眼·意眼與抽象畫》。關於這三種「眼」的意義前文已經提過。他在該文中不但強調了藝術與時代，尤其是這個科學的世紀間深厚的關係，也曾提到了藝術的理想環境。身為一個建築師，他當然密切注意現代各種科學、工業與技術的發展。這些新的觀念，不但被採用在他的建築設計上，同時也很自然的走進他的藝術創作中。

陳其寬的這種現代感，在當今中國甚至於全世界的畫家中，是獨一無二的。他對一切新發現的事物都十分注意，而且不斷省思如何將新的事物與觀點表現出來。作為一個藝術家，他未曾受到這些新事物在物質及機械上的束縛；反而利用了想像力與幻想力，創造了新的藝術。他摒棄了單一「平視」的觀點，而用「俯視」、「仰視」、「轉視」以至於「宏觀」和「宇宙觀」來作畫，時而兼用望遠鏡與顯微鏡的視界，描寫了廣大的山河與宇宙的奧秘，同時也畫出了細小的人間百態與生命的微觀。

雖然他吸收了不少歐美新藝術的觀念，但他不曾專事模仿，而始終堅持自己的道路。他對近年歐美許多藝術家，想極力脫離傳統平面的繪畫，而走向觀念藝術、地景藝術、環境藝術，以至於表演藝術等的途徑，不曾反對，因為藝術是無所不在的。這也類似莊子所說「道」無所不在是一樣的道理。但是對他而言，無論藝術思潮如何變化，無論是幾度空間的發展，藝術最後還是以二度平面的繪畫來表現「現世」的一切。當然在藝術的領域中，建築與雕塑是三度空間的表現，但未若繪畫居於主流的地位，因為繪畫是將宇宙中三度或多度空間的事物轉換到二度空間的平面上。在這種轉變的過程中，可說是脫離了現實，走入抽象，再加上畫家的想像力、創造力，便組合成了不受時空、邏輯、大小等的束縛，成了創新的作品。

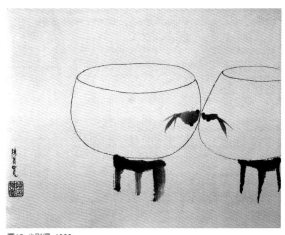

圖15. 少則得, 1988

這種觀點是在於強調二度空間畫面的重要性，繪畫因此不是把自然的事物完全翻印下來，而是透過藝術家的敏思與銳眼，在畫面上重新組合。且其有自身的法則與因素，如韻律、節奏、週期性、和諧等變化，藝術的美就是從這些因素中產生。陳其寬在中學時，曾讀過豐子愷的一篇文章，認為「美」就是「變化中求統一，統一中求變化」的表現。他深受這觀點的影響，成了他的基本信念。事實上他也體悟出這就是宇宙間的自然法則，而生命與人類也正是在這種條件下，在地球上產生的。

陳其寬的畫一向是以小見大。他雖然畫了不少以宇宙「宏觀」為題材的畫，但他的小品，多半是二尺平方，他的長幅手卷，最長也不過五六尺左右。他未曾作過如壁畫般巨型的作品，這是他一向保持著的「小是美」的觀念的結果。他的畫雖小但卻包羅萬象。乍看之下只是普通山水，細品之則見許多微小的人，人間百態，真是美不勝收，都充滿了生機，予人一種青春喜悅之感。因此陳其寬的畫是在浩瀚的宇宙「宏觀」中，還有尋求細小萬物和諧情趣的「微觀」，充滿了無限的人間味。這是他畫中潛藏的動力。

在一九七七年，由徐小虎為他主辦維多利亞美術館個展時，即曾以「小是美」為主題，這種「小是美」或「少則得」(圖15)的觀念，一則可說是中國文藝作品古來有之的特色，因為歷代以來，充滿了抒情的詩，卻少有嘗試史詩的巨作。書畫方面，多以立軸、手卷、冊頁為主，是為個人品賞而設計的格式，不適合大庭廣眾觀看的；二則是受到西方新思潮的影響，「小是美」是英國經濟學家舒馬可理論的根據。近二十年來在歐洲受到相當的重視。這與陳其寬的想法，不謀而合。他在日本旅行時，就已注意到日本小巧且別出新裁的設計原則一以輕、薄、短、小為主的美感。他也深深受日本和歌詩所感動，特別是那首：「靜靜的池塘，一隻青蛙跳下水」，表現了極深的意境！在西洋畫家中，他最欣賞的是保羅·克利以小取勝而回味無窮的作風。吳訥孫曾以《芥子大千》評述他的畫，而何懷碩於一九八〇年為文推崇他的畫時，即以《納須彌於芥子》為題，與吳訥孫的論點不謀而

合。須彌是喜瑪拉雅山的別稱，何文用此爲題頗恰當。他於文中提出「簡、諧、小、長、奇」五字來形容陳其寬繪畫的特色。何曾提到他在美國華盛頓參觀國家美術館東廊新館的時候，看到了一些大而不當的畫及雕塑，相較之下，陳其寬的畫分外有意思：

> 其寬先生特別以小幅而示人，有其深意在焉。
> 我以爲一則是他特別纖密細膩的慧心所使然；
> 一則是他提倡精緻文化(Refined Culture)對美國與
> 受美國影響的偏激之「大」表示對抗。藏須彌
> 於芥子，這是東方的慧悟。
>
> (《陳其寬畫冊》，藝術家出版社，1981，頁20)

何懷碩以自身爲一個畫家的眼光，對陳其寬的畫藝作了極精湛的解說。蘇立文在他一九五九年出版的《二十世紀中國畫》一書中亦曾提到，以照相印刷來看陳其寬的畫是不公平的，因爲那些細節無法完全表現出來。

從「小是美」出發，再進一步瞭解陳其寬對「美」的觀念，他還是自傳統出，而摻入現代的觀點。他認爲中國傳統所追求的美，與西方現代許多畫家，以描寫社會黑暗醜惡的一面，用以促進改革的訴求不同。中國傳統作風向以藝術與繪畫爲人類最高精神之表現，因而作風較象徵化、理想化，要以提昇人的品格與道德爲主，予人以啓發、樂觀、美的感受。對陳其寬而言，這便是繪畫主要的功用。

要達到這種「美」的境界，陳其寬自己便認爲必須脫離中國繪畫過重臨摹的作風。他覺得他必須不斷的試驗，不斷的發現、突破，不斷革自己的命。他不參加任何美術團體，也不執意於一種畫風，因爲團體會約束他的獨創性。他希望儘量發揮個人精神的感受，不願過度強調「方法」、「畫法」、「技法」，因爲方法也是一種束縛。他作畫不高談闊論，因爲理論容易固定個人的作風。他每天都有新的發現、新的靈感，只須掌握住這些瞬間的感受，將之轉化成繪畫，較之理論更爲實際些。

在西方的畫家中，英格爾、泰納及莫內等人都給了他不少啓發，作爲他各種不同試驗的例子。他觀察、嘗試，用類似的技巧，尋求相似的技巧；將西方畫家之所長，納爲個人的作風。泰納的光彩、莫內的點、葛雷柯的人體變形與英格爾的人體都啓發了他，在他的畫中，都有痕跡可尋。

據陳其寬言，他近年來採用的斷斷續續，厚、薄、寬、窄的線是從班尙(Ben Shahn)的畫中領悟而來。班尙畫中的線條都很活潑，

圖16. 門，1985

是因爲受了兩方色彩的排擠，而被掩蓋或變形了。對陳其寬而言，這種線條是工筆線條的變體，虛實、晦暗之間，令人難以捉摸。正如香港劉欽棟所說：

> 享譽建築界的陳其寬，展品《門》(圖16)、
> 《光》、《潮》都是具有典雅的文人氣質的佳
> 作。他的思維相當細膩，精緻而富涵養。韌而
> 不僵的線條，配合多種混雜的技巧，色感十分
> 雅澹清雋，具有一種現代詩意的造境，甚富時
> 代氣息與創意。
>
> (載於《當代中國畫展》一文，見《藝術家》第一三四期)

其實，對於筆者來說，陳其寬這種斷續的線條，是用來描寫童年的回憶，引發人無限的鄉思，使過往的形象湧上心頭，若隱若現，欲斷欲續。有藕斷絲連，依依不捨之感，成了他獨特的技巧。

同樣地，他畫中事物的表面，無論是山石、河川、田野、房屋、器物等，都有相同的特點。他從來不平鋪著色以求光滑的表面，他始終採用一些特殊技巧，而得到模糊不清，若隱若現的效果，是種「屋漏痕」的延伸。這也引發了人們思幻之情緒，增強了他畫中的內涵。這也多少受到中國的「拙」與日本的「澀」(shibui)的影響。

從以上所提的特點中，我們可以了解到陳其寬對藝術的中心思想，是以中西合流，創造出一種新的藝術，用以表現對天、地、人，也就是時間、空間、人間的看法與感受。對於這一點，歷年來，不少藝評家都曾提及。到了一九六六年，筆者在《中國山水畫的新傳統》畫展的目錄上也曾提到此點。一九八一年台北藝術圖書公司出版《陳其寬畫集》的時候，不但刊載了吳訥孫、蘇立文及筆者的文章，同時還納入了在美國的艾瑞慈、高居翰，加拿大的徐小虎，香港的何弢和台灣的席德進、何懷碩等；此外，在美國的唐德剛、葉維廉，台灣的羅青、陳長華、巴東，新加坡的劉奇俊等人的文章。他們在文中大都強調了這一點爲陳其寬藝術中最重要的一環。

在《陳其寬畫集》(藝術家出版社，1981)中，吳訥孫教授的序文中曾說：

> 陳其寬畫中的空間與時間，不是「量」的，而
> 是「質」的，不是累積而可以衡量的數量，不
> 是幾寸或幾里，不是禍福、身世的憂喜，而是
> 沒來由的一種認識，或是驚訝，或是感嘆，都
> 有與天地萬物的同情與連繫。在這一方面他的
> 畫裏面，中國文化的氣味特別濃厚，也因此他
> 的畫面與傳統國畫不似，正是他的「不似」反
> 而正令他的地位近乎正宗。

這與筆者一九七七年介紹陳其寬的文章中所提到的觀點完全
相同：

> 陳其寬不是一位模仿者，因為西方的觀念、設
> 計、表現方法，使得他把中國畫提昇了一步。
> 但並不是完全改變了它。陳其寬應該被視為把
> 傳統中國畫發展到近代中國畫的先驅。他的畫
> 擴大了我們對自然視覺的領域，激發了我們對
> 過去事物更深一步的視覺領悟，啟發了我們對
> 周遭環境一種新的看法，增強了構圖、質感與
> 情感的關聯。他的繪畫把我們從單調的、沈悶
> 的日常生活中，提昇到一種永恆的歡愉，這才
> 是一位偉大的藝術家所應有的特質。
>
> (《陳其寬畫冊》，藝術家出版社，1981，頁16)

從這些觀念，再回頭看陳其寬近年來的作品，我們可以了解
到他對時間、空間、人間的描寫，不但為中國繪畫傳統打開
了一條新路，而且還把這種新精神與表現，帶到了世界的藝
術領域中。(本文中所論及之畫作，請參照本專輯附錄索引)

Time, Space and The Human World:
on the development of Che Chi-kwan's Paintings

Chu-tsing Li, Former Professor of Department of Art History, Kansas University

Among the Chinese artists active today, none has pursued the path of art more broadly or longer than Chen Chi-kwan. A man of great versatility, he is both an architect and an artist, and successful in both fields, having achieved the topmost world standards early in his career. Oddly, because of his taciturn, modest nature and serious dedication to his work, few people have an indepth understanding of his artistic achievements. To attain a greater familiarity with Chen Chi-kwan, we must view his architecture, his paintings and their background, and undertake a well-rounded discussion of his work.

I. Early Development (1921-1940)

Chen-Chi-kwan was born in 1921 in Peking, the capital of the ten-year-old Republic of China. Faced with foreign invasions and internal strife, the Peking government experienced a long period of instability. Like other Chinese of his own generation, he grew up as a child of that stormy age, going through many political struggles, wars, dislocations, wanderings, and other tribulations. This kind of experience has given him the character of restraint and optimism.

During the 1920s and 1930s, Peking was a peaceful and lovely city. In spite of the many great political changes, there were many things that could fill the warm memory of the common people. The city, with the Forbidden City as the focus, still retained the atmosphere of the more than two and a half centuries of the Ch'ing dynasty. Most of the middle class people lived in the traditional Chinese-style houses, which had served as residences of Manchu officials. [1]

Chen's family lived in one of these houses with five court-yards in the northeast section of the city close to the Lama Temple There generations of his family lived in this house. Within the house compound were many trees, such as elm, juniper ,date-trees, mulberry ,willow ,and some potted plants , which create endless changes during four seasons. All these in addition to the family collection of paintings, calligraphy, and porcelain, have given Chen numerous images for his later paintings.

Because of the political and military strife in China at that time, the family did not stay in Peking. When he was two, the family moved to Nanchang in the Yangtze valley for two years .At the age of seven, he moved with his family to Nanking for three years and later returned to Peking. In 1933, when he graduated from grade school, the family moved again to Nanking because of the Japanese occupation of Manchuria. He received his high school education in several places, including Nanking , Chenchiang, Hochou in Anhui Province, and Hochuan in Suzechwan ,partly due to the outbreak of the war with Japan in1937. By the time he completed his high school education in1940, he had traveled through many parts of the Yangtze valley, from Kiangsu to Anhui, Kiangsi, Hupei, and Szechwan.

II. University Days (1940-1944)

After graduating from a high school in Ho-chuan, Szechwan, Chen passed the joint examination to enroll in the Department of Architecture at the National Central University, which had moved to Chungking from Nanking. Sha-p'ing-pa, where the Nation Central University was located, next to Chungking University, ranked with the National Southwest United University in Kunming and the Hua-si-pa in Chengtu, where five Christian universities were located, as the three major educational centers in the interior of China during the war. [2]

Chen spent all four-college years, from 1940 to 1944, in Chungking the cultural center of China during the war. It was in this period that he began to paint, mainly in watercolors. Although most of the works of this period have disappeared, he still has one, The *Chia Ling River*, painted in 1940. It depicts a beautiful view of the river that flows from northern Szechwan to the Yangtze seen from Sha-p'ing-pa. It is a work that reveals Chen's talent in capturing the poetic quality of the scene.

III. Expedition to Burma and India (1944-1948)

In 1944, when Chen was graduating from the National Central University, the war with Japan was entering its final phase, with the Allies on the offensive. A combined force of American and Burma armies launched their attack from India into Burma, and, in a joint effort, China also sent an Expeditionary force from Yunnan into Burma. To coordinate the war effort, a large number of interpreters were needed. Under government orders, the whole graduating class of the National Central University was drafted to serve as interpreters. Chen was one of them. After undergoing a training period of three months in Kunming, he was sent with the rank of major to Burma to join the Chinese army for liaison work.

This special tour in the army gave him the rare opportunity to gain some extraordinary experience. He was able to travel in the great southwest, including Szechwan, Kwangsi, Kueichow, and Yunnan, all known for their famous mountains and rivers. In addition, he began to come into contact with many minority groups in those regions, each with its own tribal customs and colorful activities. Fascinated by them, Chen did quite a number of sketches and studies.

However, his most memorable experience during this period was his first flying trip from Kunming to India. With limited capacities at that time, American planes flown by American pilots had to fly over the highest mountains in the world, called the Hump (the southern branch of the Himalayas), in order to reach Ledo in the eastern part of India. The trip gave him the opportunity to see the mountains and scenes from above as a totally new experience. He was especially overwhelmed by what seemed to be the swirling earth underneath as the plane was about to land at the Ledo airport. Years later, in1967 in Taiwan, this unique experience resurfaced in his mind to follow a misplaced stroke in his brush as a way to recapture this experience of vertigo. This experience first made him realize the tremendous potential offered by new ways of seeing as a result of modern machines. In his later development, he did not follow the one-point perspective generally used by artists in the West since Renaissance, but adopted the traditional Chinese way of moving focuses to depict visits to mountains and rivers and blended it with the vertiginous movements to show a new view of the world and cosmos as a result of his new feeling for space and time. Also, as his first sojourn outside of China, this army tour of duty gave him the fascination of seeing new people and things in a strange land. During his leaves he visited many place in India including Calcutta, New Delhi, and the Taj Mahai plus many places in the northern part of Burma. A watercolor, *Myitkyina, Burma*, done

in1945, remains one of the major records of his stay. About a month before the end of the war, he was called back to Kunming. In the following years, he worked as an architect in Nanking, first with Kuan, Chu, and Yang, Architects, an architectural firm in China, and later with the United States Military Advisory Group.

IV. Study in America (1948-1951)

In 1948, as civil war was raging in the northern part of China between the government and Communist forces, he left Nanking to go to the United States, having been admitted to the University of Illinois at Urbana. [3]

In the period immediately after the Second World War, American architecture finally shook off all the nineteenth century revivals of classical and other styles to move toward the modern style, in the "form follows function" direction of Louis Sullivan. There were two major schools of the modern style: the Romantic School, seeking harmony between architecture and nature, as represented by Frank Lloyd Wright (1867-1959), and the Abstract School, or the International School, advocating simplicity and abstract beauty achieved by the use of modern equipment and tools, as represented by the leaders of the Bauhaus in pre-war Germany. After Hitler came to power in 1933, some of the leaders went to America to continue their work. Walter Gropius (1883-1969) went to Boston to teach at Harvard University and Mies van der Rohe (1886-1969) went to Chicago to teach at the Illinois Institute of Technology. Both exerted a strong influence on American architecture during the post-war period. In his study at the University of Illinois, Chen Chi-kwan came to have a deep understanding of these two schools.

In the postwar period, one of the strongest influences on the development of architecture was the Swiss scholar Siegfried Giedion (1893-1956), whose two books, *Mechanization Takes Command and Space, Time and Architecture*, became standard books for all architectural students. Chen naturally came to be influenced deeply by these works, especially such ideas as the new concepts of space and time and of the balance between reason and feeling in architecture.

In the years after the war, there was a rapid development in America not only in social and economic aspects but also in cultural activities. In art, there was a great interest in the European masters before the war, such as Matisse and Picasso, and in the development of Abstract Expressionism. Chen had not had much contact with these in China. In America, he tried to absorb as fast as he could new ideas from Western art. At the University of Illinois, he saw an exhibition of the works of Andrew Wyeth (1917-), which had a profound effect on him. He admired this painter who, in spite of spending his whole life mainly in one small village in the eastern part of the U.S., was able to draw endless inspiration from all aspects of life for his paintings.

After completing his M.A. in architecture at Illinois and receiving the first prize for the design of the city hall of the town of Danville nearby, he went to stay with his sister in Los Angeles. There he enrolled in the Department of Art at the University of California at Los Angeles, studying industrial design, interior design, ceramics and painting (both oil and watercolor). After completing these courses, it was the fateful year of 1951, when the Korean War was at its height. With China and the United States in a state of war, Chen had to face the choice of either going back to China or staying in the U.S. to develop his career. Finally deciding to stay, he took jobs at two architectural firms in Los Angeles.

Still in the back of his mind, he was trying to learn as much as he could in the U.S. Reviewing his situation, he applied to the Graduate School of Design at Harvard, headed by Walter Gropius. Since Gropius was a world figure in the field, Chen realized that chance of getting admitted there was very slim. He was prepared to return to China to develop his career. However, on January 30, 1951, a telegram arrived with this message: "Sudden vacancy in master course. Wire if you can start here February five. Walter Gropius."

Surprised and overjoyed by this new development, he left immediately for Boston. After spending three days and two nights on a Greyhound bus, he arrived in Cambridge. In discussing his plans with Gropius, he realized that he did not have the money to pay the high tuition at Harvard. Fortunately, showing sympathetic understanding of his difficult situation, Gropius offered him a job at his own architectural firm, TAC. Thus this telegram was the turning point for Chen's later development.

V. Three Years in Cambridge (1951-1954)

Dreams began to come true during the three years he spent in Cambridge, establishing a firm foundation in both architecture and painting for the rest of his life. [4]

At the same time, there was a new development in his painting. In his spare time, he visited many of the scenic sights of New England and saw many important paintings in many museums in this region. With new stimulation, he began to paint from his memories of China in Chinese ink and paper. One of his works of 1952, *Market Day*, depicting a view of Chungking in wartime, is an exploration of new concepts of space and time. Using the traditional Chinese long and narrow format, he portrays a view of Chungking from the boats on the Yangtze River below, up the hundreds of steps with houses on stilts, all the way up to the top of the hill, showing a panorama of all the human activities against a background of houses and structures in verticals, horizontals, diagonals, and other semi-abstract elements. Most interesting are the changing points of view in space and time throughout the painting, a new development in the Chinese traditional approach of shifting focuses and a sharp difference from the one-point perspective in the traditional works of the West.

A number of works, all executed in ink on paper in a long and narrow format, were done in the same period. One of them *Window Landscape* is also based on his memory of Chungking, combining a near view and a distant view in one, again attempting his new space and time concept. Another, *Boat Floating in the Window* also blends the inside and outside of a house into one.

In 1953, a new development in his painting can be found in two works, *Street and Canal*, where he combines the viewpoint of an airplane with the "projection geometry "in architecture to depict his memory of the typical scenes of Chiangnan in China. The abstract beauty of houses, rooftops, courtyards, and bridges seen from above is interwoven with all the human activities, creating a work filled with the warmth of life. It shows that Chen does not try to carry abstraction to its pure rational extreme, as Mondrian does, but attempts to achieve a sense of harmony between reason and feeling and between abstraction and realism.

In the same year he also painted a work based on Chinese calligraphy, *Mother and Child* composed of seven small works to make a long and narrow hanging scroll. Again it is an attempt to combine the abstract calligraphic lines with expressions of human feeling. *Tug of War* also done in 1953 is a hand scroll on the same principle, working toward semi-abstraction. This can be clearly discerned in his *Secure* of 1953,

based on his childhood memory of accompanying his mother traveling to southern Hopei and watching horses roaming over the steppes, executed with the abstract quality of grass-style calligraphy. The most abstract works he ever painted are those depicting ball games, *Football game* of 1953 and *Soccer* of 1954, both of which capture the movements of the running players with total abstract, calligraphic lines. This is as far as he went in the direction of abstraction. They were done at the time when Abstract Expressionism was at its height in both America and Europe. He had come into contact with many of the works of this movement during his visits to museums in the Boston area, and discovered that there is a great deal in common between abstract painting and Chinese calligraphy. But to him, Western artists seem to be too rational and too theoretical in the pursuit of abstraction, thus leading to a blind alley. For him, reason and feeling must be balanced and harmonized. *Football Game* and *Soccer* are his limits in this direction, and he never went that far again.

In addition to Abstract Expressionism, Chen Chi-kwan also became interested in many of the works he found in museums in the U.S., for they gave him many important ideas to work with. He was quite excited about the Cubist works of both Picasso and Braque as the first breakthrough in modern concepts of space and time. An offshoot from Cubism, Umberto Boccioni's Futurist *A Bottle in Space* made him aware of the fact that an object could be seen from many different angles simultaneously. Marcel Duchamp's *Nude Descending a Staircase* revealed to him the possibility of breaking away from traditional realism and of multiple exposure in photography. Also, Surrealism led him to the realm of imagination. All these expanded his vision and deepened his power of observation. But at the same time, Chen was somewhat disappointed at their overemphasis on theory and their rather mechanical application. As a result, in his own works, although he did absorb their new approaches to space and time, he did not follow their ways of application but still maintained the integrity of the depicted objects and the quest for poetic expression.

Chen's approach to Western painting is also reflected in his interest in sculpture. He greatly admired Henry Moore, whose works he often compared with the Lake Tai rocks so much cherished by the Chinese. Moore's handling of positive and negative space and of yin and yang, with all kinds of variations, to create both human and animal forms on the one hand and pure abstract ones on the other, could be compared, in Chen's view, with Chinese practice of calligraphy. Also, to Chen, Alexander Calder's mobiles signified a great revolution in sculpture in moving from "stable sculpture" to "moving sculpture," since Calder's works show the continuous inter-action of time and space, which is close to the Chinese traditional concept of interaction of yin and yang. In 1952, Chen also worked on some mobiles of his own, which were shown in an exhibit in New York during that year.

During those years in Boston, Chen was especially interested in a number of Abstract Expressionists, which was enjoying its golden age. Both Mark Tobey and Jackson Pollock drew his attention. Although Tobey was influenced by Chinese calligraphy in his abstract forms, Chen did not think that he had a real understanding of Chinese brushwork. While Pollock developed "action painting," which carried abstraction to its furthest point, Chen felt that his works had "historical value" but lacked "artistic value." He did not neglect to study some of the realists. For example, he was interested in the lines of Ben Shahn (1898-1969), which often show dripping and breaking quality that evokes appearing and disappearing memories in one's mind. Similarly, as mentioned earlier, the quiet, lonely, melancholy styles of Andrew Wyeth left a strong impression in Chen's work. As a whole, Chen's way of absorbing the essence of Western art, did not follow any one particular school or style, but drew ideas from a variety of sources, Indeed, his painting still maintained the spirit of Chinese tradition. First, his subjects remained the Chinese landscape, figures, and animals. Second, his media were still typically Chinese, mainly traditional brush and ink, though with some watercolors. Third, his style came from traditional Chinese painting and calligraphy. However, he did not limit himself to the literati tradition, but combined elements from old and new and from Chinese and Western Painting. His painting, *Vital* depicting a group of piglets nursing from their mother, is done with a few simple and quick strokes of the brush. It probably came from some of the elements of Liang Kai and Mu Chi of Southern Sung, but also from the Four Monks of late Ming and early Ching, and from the modern painter Chi Pai-shih. It is a happy blending of traditional Chinese brush-work, Western abstraction, Chinese human interest, and his own sense of humor.

This attempt to combine the special quality of Chinese calligraphy and semi-abstraction of the West reached its height in Chen's works in his paintings of monkeys. Since the 1950s, the monkey has been one of his most frequently used subjects. Discussing this with various scholars, he indicated that painting the monkey was like practicing Chinese calligraphy, because the structure of a monkey with his four limbs outstretched looked like a Chinese character. Also, since the monkey is very close to man, painting it is like painting the human world. This is really one of the major purposes of his paintings. [5]

During the 1950s, Chen created another type of landscape in color, as shown in the *Lake Tien under the West Hill* a place dear to his heart in Kunming, Yunnan Province. The totally vertical cliffs of *West Hill* overlooking the beautiful lake are depicted in Chen's long and narrow format in ink and colors. The composition is vertically divided into two parts: a precipitous cliff occupying the right side, and a totally open view on the left side, with only a few birds flying above and a few boats below. In this bold structure, he has achieved a semi-abstract painting. Similar treatment can be seen in works such as *Leisure, Boat Floating in the Window, Beginning of the year, Lodge, Spring, Lantern Festival, Pier, Play on the Wall*, and *Intention to Fly*. They all come from his memories of China, but seen trough the formal approaches of the West.

In these three years (1954-1957), Chen Chi-kwan changed from a foreign student to a university instructor, a designer in a famous architectural firm, and an acclaimed artist. After teaching for some time at M.I.T., he gave a one-man show in the university gallery. The success of this show led to a one-man show in the Brown Gallery in Boston, and later in the Weyhe Gallery in New York. Soon his works attracted the attention of art critics in Art News and the New York Times, one of the most interesting comments came from the Christian Science Monitor of Boston: "The pictures of Chi-kwan Chen combine the arts of painting and drawing. They are reflective, interpretative, and symbolical. They reach us in different ways, in different moods. Few strokes are generally required to create an illusion an object, say a house, a tree branch, a figure of a person, an animal, or bird. Often the artist seems to leave an idea half stated, since partly communicated thoughts may be completed in the imagination of the beholder. Compositions are sometimes evolved around the picture edges; or they are worked into the composition by indirection. The pictures vary in shape. They are tall and narrow, or broad and shallow. There may be in them a great sweep of spaciousness, a manifoldness of imagery, a concentration of action. In the paintings of Chi-kwan Chen, there are often humorous passages. Trifling episodes are recorded whimsically. To the eye of the artist there can be significance in diminutive things as well as topics of magnitude. And in the transient, he may reveal something of permanent significance." (December 22,1953)

Such attention paid to a young amateur Chinese painter in Boston was

rare. If he continued to stay and paint in the U.S., his future would be wide open. However, in his own mind, architecture was still his major profession, and he continued to develop along this line.

VI. New Developments (1954-1960)

In 1954, when Chen Chi-kwan was already a renowned artist in Cambridge, an invitation came from I. M. Pei of New York for him to participate in an important architectural project, the design of Tunghai University, a new university in Taiwan. Since I. M. Pei had many projects to work on, he asked Chen to join him to design this project. Chen decided to meet the challenge. [6]

From 1954 to 1956, Chen was at I. M. Pei's office in New York working on the initial design of Tunghai campus. [7] After more than three years of planning the design, Chen first arrived at Taiwan in 1957 to make a survey of the site for Tunghai University. AS far back as 1954, he had already drawn up a general view of the whole campus in New York. Now when he came to the site, he already had everything in his mind. Within four months after his arrival, he was able to straighten out what had been a big mess on the whole campus. His plan laid down the foundation for what was to become the most beautiful campus in Taiwan.

The campuses of many of the Christian colleges on Mainland China were dominated by the Chinese palatial style of red brick walls and green tiles. To both Chen and Pei, that style was no longer suitable. They wanted to go back to the Chinese style before Ming. However, at that time, it was not possible to go to China to study early architecture. On the other hand, Japan has preserved many buildings that reflect early Chinese style. Thus, before his visit to Taiwan, he spent several months in Japan, traveling in Honshu, Shikoku, and Tokaido, searching for old temples that showed Chinese style. In Nara, he found a number of buildings especially the Toshodai-ji that embodied the typical Tang style. Through his study he came to understand that the spirit of early Chinese architecture lay in its site-plan, not in its buildings. In other words, it was the empty space, or the courtyard, that was more important than the solid area. It was this concept in balancing the solids and voids that underlay his approach to the Tunghai campus.

During this period, he still found a considerable amount of spare time to paint. His one-man shows were held not only in the Brown Gallery in Boston, but also in the Weyhe Gallery and the Michou Gallery operated by Ouyang Kohung in New York, the university galleries of Boston University and Brandeis University, and galleries in New jersey and Texas. From then on, his works were shown extensively. Indeed, Michou Gallery regarded him as the major artist in their program and held annual exhibits for him for more than ten years. Good reviews of his works appeared in the New York Times and the Art news and a number of other papers Nelson Wu, an art historian teaching at Yale University, was the first scholar in the U.S. to write about his art, as seen in the following excerpt:

"Chen paints the China he knows, and communicates to his contemporaries effortlessly. He is not viewing the traditional world with a new slant, but is viewing a new China, or the world wherever he goes, which necessitates a new viewpoint. In an unpretentious manner, he arrives easily at the level of common, everyday language in pictorial art and grasps the natural images of his time. In creating his ideograms, he goes both to the traditional forms and to the images. His mind's eye sees from various angles, sometimes directly from above, sometimes traveling along a plane parallel, straight up and down, to a mountain cliff. It would be absurd to call any of these in Western perspective, for these 'written pages' of ideograms expression defy measurement. Images here are in shape focus from corner to corner, and a sense of movement is felt by the organic arrangement of the ideograms. Looking first at the two junks by West Mountains and then again at the group of birds on top, the viewer feels as if he will vanish into the distant sky himself. Two things Chen learned from the tradition have been put to good use. By not offering the spectator a spot to identify himself with, he can move the viewer over the picture at will. And by giving the format that traditional strenuous proportion of height and width, a strong suggestion of unlimited space outside the picture is gained. Thus he can move the audience in and out of the picture, too. Some of his works are actually pictures within a picture, and there the travels of the audience can become very complicated indeed. (Art News, 56/7, November 1957)

Two years later, Chen was mentioned by Michael Sullivan of the University of London as one of the three Chinese artists outside China (together with Zao Wu-ki of Paris and Tseng Yu-ho Ecke of Honolulu) who had attained high achievement, which could not be matched in freedom and creativity by any artist in Mainland China.

The reputation he had achieved in architecture gave him more time for his paintings. He returned to Taiwan in 1958 for the construction at Tunghai University, and then went on to visit famous sites and monuments in Thailand, Burma, India, and Europe. In 1959, on another trip to Taiwan, he visited museums and architectural monuments in Europe and North Africa. All these travels certainly helped his later artistic development.

Works done during this period include some that continued the direction he had at Cambridge, All of them combined traditional landscape with nostalgia, and showed a very strong creative impulse, beautiful use of color, bold and fresh compositions, and freedom, in the treatment of time and space. Each of them is a lyrical poem, with fertile imagination and rich meaning.

In addition to other works showing nostalgia toward the China he knew, other work reflected a broadening of his viewpoint resulting from his travels in Japan, Southeast Asia, and Europe. Among these, the most representative is *Panorama* done in 1967. In a horizontal format, it depicts layers of mountains stretching from the foreground to the far distance on two sides in a patterned formation in a magnificent view. In both composition and brushwork, he made use of the achievement of modern science and technology to change traditional viewpoint and practice. Starting from the Chinese tradition in grasping the magnificent view of mountains and rivers, he pursued spirit consonance and self-identification in landscape, without resorting to traditional from and brushwork. It was a breakthrough in his development.

During his travels he came across many new subjects, such as *Vermilion Jungle* (1957) of Miyajima in Japan, *Piazza San Marco* (1956) and *Venice* (1957) in Italy, and *Cathedral* (1960) in France, all showing elements from Klee, Turner, and Monet. Another long hand scroll, Bather of 1957, is an abstract painting that reflects the influenced of Ingres, etc. He was also influenced by an English watercolor painter of the early twentieth century, William Russell Flint, whose works he first came across when he was a college student in Chungking. In this period he also painted works on objects of everyday life, including flowers, plants, fish and insects that have come down from the Chinese tradition. These were favorite subjects of some of the Ch'an painters in the Sung dynasty, usually done in quick and simple brushwork to reflect the view of "seeing a whole world in a grain of sand."

VII. At Tunghai University (1960-1980)

In 1960, Tunghai University was already five years old. [8] With three colleges of the arts, the sciences, and engineering, the university was busy recruiting faculty members to staff the departments. They were looking for someone to serve as chairman of the Department of Architecture in the College of Engineering. Dr. Wu Teh-yao, the president of Tunghai, finally offered the position to Chen. He decided to accept the appointment; thus began Chen's long stay in Taiwan. For Chen, the decision to stay in Taiwan came as a natural one in view of his personality. During the twelve years in America, he had already achieved high distinction in both his academic study and professional experience.

With this decision to stay in Taiwan, he became more identified with many of the activities and people. As chairman of the Department of Architecture, he gathered around him a number of able faculty members. Especially important were a number of the young assistants, including both young architects and painters, who later became prominent in their respective fields. In 1962, a special circumstance in the art world of Taiwan made him write an article that embodied his art theory of that time. It was *Natural Eye, Mechanical Eye, and Inner Eye and Abstract Painting*, which appeared in a periodical called Works.

This article was written in support of a number of young abstract painters who came under strong attack by some conservative painters. The atmosphere in the art world of Taiwan during the early 1960s was quite conservative. Native Taiwan artists continued Western oil or watercolor painting and the so called Tung-yang painting strongly influenced by the Japanese, and mainland artists gave a strong push for traditional literati painting through the two leading painters, P'u Hsin-yu and Huang Chun-pi. Many young artists turned to post- war Europe and America for their inspiration, especially Abstract Expressionism. Following some of the European examples, they began organizing themselves into art groups during the late 1950s. The Fifth Moon Group, the Tung-fang Art Association, the Four Seas Art Association, and the Modern Chinese Woodcut Association, and several others, quickly came into being. Although they made themselves known, they received neither support nor sympathy from well-established artists. In 1962 some of these groups came under strong attack from their critics, who accused them of treason. It was at the height of this struggle that Chen Chi-kwan wrote the article in support of abstract painting. It laid down the basic philosophical foundation of his theories on art. First he clarified the several new terms used in his title:

"We should not forget that we are living in the twentieth century, a scientific century. The boundaries of the things that we see through our "eye" are no longer the same as those seen by our previous eye, the "natural eye" (ju-yen, or fleshy eye). In addition to changes in the things that can be seen by our natural eye, modern tools resulting from scientific discoveries have extended the boundaries of our vision to the infinite. In other words, we now have the "mechanical eye". Furthermore, because of new scientific discoveries, new industrial achievements, quick social changes, and complex life patterns, there have been changes in our senses and in our mind. As a result, our" inner eye" will see things in a different way. To conclude, in our present century, science occupies a very important and influential position; it has influenced our vision, and also our painting.

With scientific tools, modern people can know about things in the world without going out of their houses. They can discover new worlds in their laboratories and in their travels. The invention of the x-ray, the microscope, the telescope, the camera has greatly expanded our vision, bringing a boundless realm in space, time, morphology, color, and feeling. In it, there is another world of "beauty" which has never been seen before... Even things that can be seen by our "natural eye" have gone though rapid changes because of scientific discoveries and mechanical advances in this century, bringing us to a new world. For example, the things that we can see from an airplane, although somewhat similar to what we can see from high ground, are quite different due to the speed it flies. This fast means of transportation has caused changes in our senses of sight and touch, making us aware of the problems of speed, time, motion, and mutual relationship....

Because of changes in what can be seen through our "natural eye" and "mechanical eye" there are correspondent changes in our psyche and spirit. As a result, we have new ways of seeing and thinking. We can simply call this our " inner eye " (I-yen, or idea-eye). The school of painting coming out of this "inner eye" thus cannot be clearly defined. First the painter paints what he sees with his "mechanical eye", and then he goes on to develop a new kind of painting, which can be a world out of his imagination, an expression of his will....

In summary, abstract painting is the product of different things seen by our "natural eye", "mechanical eye", and "inner eye" in our scientific century. It is rational and it is also emotional. Since it is still being developed, we cannot arbitrarily say whether it is right or wrong. As for me, I feel that it is definitely closely related to this century and is thus valuable". (Works, 1962)

In a conversation with Yip Wai-lim, professor of Chinese literature at the University of California at San Diego, he further explained what he meant by "inner eye": "The scope of "inner eye" is very broad, hard to define in a few words. It is easy to cite concrete characteristics for the "natural eye" and the "mechanical eye." But the "inner eye" is too broad to be defined. Historically, from the ancient past to the present, there have been all kinds of ideas and feelings. Horizontally, all geographical regions, Eastern and Western, scientific and philosophical, and others are also very broad, not easily explained in concrete terms. What does "inner eye" include? Of course, in my more than thirty years of painting, I have tried to present some feeling and viewpoints that have not been done before in the tradition of Chinese painting and that can represent the twentieth and even the twenty-first century." (The Artist, 1986/3) Chen's article is not only an important document for the understanding of his own works, but also serves as a starting point in the understanding of modern art of the world.

Chen's strong support for the Fifth Moon Group in particular and abstract painting in general, as expressed in this article, has some special reasons. In 1957, when he first visited Taiwan, he had seen the first exhibition of the Fifth Moon Group. Later he met several members of the group, including Liu Kuo-sung and Chuang Che. In 1960 he invited Liu to give a demonstration and lecture at the Department of Architecture of Tunghai University. In 1963 he also invited Chuang to teach in his department. Although he never joined any art group, he was very supportive of what the Fifth Moon Group was doing, since in theory he was very close to them. [10]

During the 1960s, Chen's energy was directed at two major goals. One was to establish a good and solid foundation for the Department of Architecture at Tunghai University. The other was to build up his own architectural practice in Taipei. But during this period, he never stopped painting in his spare time. Many of his important works were done in this period, including *Resonance* (1964), *Gore* (1966), *Arcadia* (1966), *Vertigo 2* (1967), *Evening* (1968), *Sunset* (1968), *Sun and Moon* (1969), *Noon* (1969), and *Vision* (1967). Most representative of this new change is *Noon*, done in a square format. In

the center is a bright red sun surrounded on the four sides by high peaks. The whole painting gives one the impression of looking up toward the sky from a deep valley. This kind of viewpoint is completely new in the history of Chinese painting. Chen got the initial idea from a trip along the Cross-island Highway from Taichung to Hualien in 1966. According to him, the angle of looking up from below came from what he saw in a photograph of New York skyscrapers taken from below. It was his idea to put a sun in the middle to link all the mountains together. Here he uses the result of modern civilization to bring changes in Chinese landscape painting.

Another major work of this period is the *Vertigo 2* of 1967, done in a long and narrow hanging scroll. It depicts a view of mountains and rivers from an airplane, recalling his very first experience in flying from China to India in 1944. Indeed, it captures the sensation of the swirling of the airplane by showing the mountain peaks turning one way or another, thus bringing another new approach to Chinese landscape painting through modern technology. Actually, this painting, besides offering a new way of seeing landscape from a distance, if examined very closely, also depicts many boats and the people in them in various activities. This is the combination of distant and close-up views typical of this work.

In the latter part of the 1960s, he was able to relinquish the chairmanship of the Department of Architecture at Thunghai University. Now he could devote more of his spare time to painting, trying out new methods and techniques. Many of his works during the 1970s show this development. *Forest* of 1971, *Deep Freeze* of 1977 portrays changes in nature with a very complex method, going beyond what he had done before. *Less Is More* of the same year shows the futility of two gold fish in two different Bowels trying to be together. A little mosquito trying to suck out as much juice as possible from a section of watermelon in Thirsty of the same year shows his sense of humor. *Torso II* of 1979 draws out the joining of a woman's breast, elbow, and knee by the simplest means of only three lines, with a mosquito also among them. All these works show his keen sense of capturing lively details in ordinary circumstances.

During his days at Tunghai University Chen's life went through a major change. Before then, he was a wanderer, traveling widely without a place that could really be called home. Late in the 1960's, he finally settled into married life and became a family man. The large number of paintings with monkeys seems to reflect the happy life he enjoyed during that period. Monkeys were depicted in his works of the 1950's at Cambridge, but now they were done with greater facility and freedom. *Son* of 1967 is a good representative of this phase of his art, fully reflecting his joy in having a son at middle age, Other works of the same subject, such as *Slave* of 1967, *Youth* of 1978, and *Acrobat* of 1980, all seem to be autobiographical in showing his happy family life.

VIII. A painter of both Macro and Micro - views (1980-1991)

Before 1980 Chen Chi-kwan's works were like the poems of traditional Chinese poets, with many short lyrical poems, but seldom epic works. Each of his paintings was the result of instant inspiration, with deep feeling and profound thoughts, but not the grandeur and monumentality of such masterpieces as Fan K'uan's *Travelers over Streams and Mountains* and Kuo His's Early *Spring* both at the National Palace Museum in Taipei. However, in recent years, his works have gradually taken up the epic form. In order to devote a greater amount of attention to his paintings, he resigned from his deanship of the College of Engineering at Tunghai University in 1986.

Beginning from the painting of *West Chamber* in 1982, Chen executed a series of works to show his attempt to capture the moods of ancient poetry. Recall of the same year is a painting in square form, depicting a view seen through the square form window of a Chinese garden. Undoubtedly both of these works were inspired by classical Chinese poetry.

This series of nostalgic works based on ancient poetry continues. A good example is *River South* of 1988. Inspired by a poem of Pai Chu-i of the T'ang dynasty, it has a composition of interlocking arches of Chinese gardens overlooking a scene of rivers and boats in the distance. Another painting, *Rhizome* of the same year, also in the square form, uses the lotus root as the major motif to evoke the nostalgic felling of autumn in the area, and at the same time depicts the lotus flowers and leaves to express the traditional symbolic meaning of the lotus rising above the mundane world. All these show how much old China was in his mind.

But Chen's major expression since 1980 lies in his paintings exploring the mystery of the universe. Although this is not entirely new, it became his main theme in 1983, furthering the direction of his *Panorama* of 1957 and *Vertigo 2* of 1967. Actually this pursuit is similar to that of many landscape painters of the Five Dynasties and Northern Sung. Now, however, Chen did not go back to imitate those masters, but took note of the expansion of the human vision in space explorations. A new "macro-view" was developed in his works, showing a new cosmic view, with which he imagines himself flying over the universe, looking at the earth, the sun, the moon, the stars, and all their changes and movements. This is the result of the expansion of his vision, from "natural eye" to "mechanical eye" and now to the "inner eye".

The beginning of this direction can be clearly seen in *Earth* of 1983. In which we seem to by flying above the middle point of a long river, which leads to two horizons, one above with the sun over it and one below with the moon over it, in this long and narrow format. We seem to be an astronaut seeing the roundness of the earth from two ends in a cosmic view. In *Beyond* of 1984, a similar composition, again with both the sun and the moon above and below, gives one the same cosmic view. In this view, there is no distinction of above and below, high and low, and east and west. Thus in his paintings, the sun and the moon, and night and day, can appear in the same painting.

In *Geomancy* of 1984, which has the Chinese title of Fang-hu. One of the Isles of Immortals in Chinese mythology, he shows a view again from outer space, looking at two rows of mountain ranges forming a circle. It is a strange combination of ancient mythology and modern science. Monism of the same year is an attempt to synthesize all these ideas into one in a painting of a round format, within which are found the sun and the moon and the mountains. It symbolizes the beginning of the cosmos, when everything is still in a state of flux from which all things and creatures in the universe seem to have come.

In Chen's view, his painting first begins from nature, then goes through transformation, restructuring, and re-integration, and then returns to the human world, in order to attain a mutual relationship between man, nature, and the universe. If things become too abstract and too individualized, it will not be easy to make the connections. His *Aurora* of 1985 seems to take us to outer space to look back at the earth. It makes us realize that the mountains and rivers are the cradle of civilization and the source of human life. It expands our cosmic view.

In *Wind* of 1986, we can still see rivers winding their way through mountain valleys. But the main movement of the painting is that of

the wind, forming an "S", Afar of 1988 and Soaring of 1989 and Yon of the same year all derive from the same theme, fully showing the fertile imagination of Chen Chi-kwan.

In *Venus* of 1988, he took up the square format instead of the long and narrow hanging scroll. The whole painting is filled with mountains and rivers, from the foreground to the horizon, with the sun and the moon in the sky. Some streaks of clouds cut across the mountains. In the same year he did another painting in the same square format, called *Peaceful Coexistence*, which still shows a primordial landscape of forest like mountains crossed by branch of trees. Although this looks somewhat like an ordinary landscape, on close examination one can find a large number of animals and birds enjoying their liver in this paradise. *Peaceful Coexistence* represents Chen's ideal land. With the regret that mankind has yet attained this idealized realm, Chen did this work at the time when the Communist world in Eastern Europe began to fall apart, an indication of the possibility for peaceful coexistence.

This idealized world has been a main theme in his recent works. Two recent works, *Heaven, Earth, and Man* of 1989 and *Old Chang An* of 1990, portray this idea in quire different ways. *Heaven, Earth, and Man* comes from his experience of traveling on a bus on highways between Chungking and Kunming, in which he saw some of the most spectacular mountain landscapes, especially the famous seventy-two turns. On some plateaus if those high mountains of Kweichow and Yunnan lived some of the lovely people, as if in paradise. *Old Chung An* began with an idea from one of the T'ang poet Tu Fu's famous poems which deals with a group of aristocratic ladies on an outing. In the course of working on the composition, he realized that Tu Fu's poem was written to expose the luxury and corruption of the T'ang court, and shifted his focus to the common people. Thus the painting depicts the happy and peaceful life of the people in the early reign of Emperor Minghuang. It is also a work that expresses his hope of seeing peace and happiness return to China in the neat future.

Between ideal and reality, Chen sometimes seems to be baffled by the cultural conflicts between China and the West. In his *Nature and Technology* of 1990 in a long and narrow format, he seems to express his concern. On the surface, the composition seems to be quite close to those "macro-views" of a few years before, with waterfalls coming down from above to the valley below. On closer examination, one can see the change from the waterfall above, which starts naturally, to the second level. When it branches out into two, and to the third level, into four, down to the bottom, into numerous small waterfalls. In this process, the waterfalls gradually change from natural beauty into mechanical devices, like patterns in a computer board. To Chen, this painting is open to interpretation. One can see it as anti-technology, or as a working together between nature and technology, or as an indication of technology making use of nature to enhance human life. In the West, Picasso, Klee, and Matta have expressed some of their fears of technology turning humans into mechanical beings. As a Chinese intellectual, Chen is trying to express the inner conflict of the modern man in his art.

Starting from the Chinese literati tradition, Chen Chi-kwan has maintained many of its characteristic elements: the ink plays in calligraphy and the spirit consonance of mountain landscape. But he also absorbed the essence of Western art, with its new ideas of space and time and its abstract form of expression. In the course of his development, he synthesized both Chinese and Western traditions into a very strong personal style. In this, he has broken the separation if geographical and national boundaries and reintegrated the essence of Chinese and Western culture. From this point of view, Chen is not only a modern painter, but also a creative international one.

IX. His Views on Art

In both architecture and art, Chen is mainly a practitioner, not a theorist. In his early years of teaching at Tunghai University he did write a number if articles for the architectural journal published by the Department of Architecture, but he seldom wrote about art. However, we cam say positively that he regarded theories as very important, although he did not want to go into any kind of philosophical system, but constantly explore something mew in his experience. During the past forty years of his artistic career, he produced only one article that was basically theoretical. This is the one already mentioned above, entitled *Natural Eye, Mechanical Eye, Inner Eye and Abstract Painting*, published some thirty years ago in the journal Work. We have mentioned what he meant by the three kinds of "eyes", but in the same article he not only emphasized the close relationship between art and its time. Especially our scientific century, but also the ideal environment for art:

"Another result of the industrial development is the increasing amount of leisure in people's lives, thus producing many 'weekend painters.' They paint for their self-amusement, not for a living. This attitude is quite similar to that of the traditional Chinese literati painters. They paint for no apparent purpose, they are under no restrictions, and they do not have a mission to fulfill. If they are living in a country of democracy and freedom, there should be nothing for them to worry about, such as whether there is any interference in their artistic directions and whether there is any criticism of their works. (Works, 1962)

As an architect, he naturally watched closely all the new developments in science, industry and technology. Many of the new ideas have been adopted by him not only in his architectural design, but also in his own artistic creations. He mentioned: "The invention of X-ray, microscope, telescope and camera has greatly expanded our vision, bringing in a boundless realm in space, time, morphology, color, and feeling. In it there is another world of beauty which has never been seen before." (Works, 1962)

This modern view of Chen Chi-kwan is unique not only among Chinese painters, but also among artists of the world. For all the new discoveries in science and technology, he reflects on how they can be utilized and shown in his works. As an architect, he never had the feeling of being confined or restricted materially and mechanically, but through his imagination and fancy created his new art. He gave up the single "level view" from the tradition, but took up such ways as "looking down", "looking up", "looking around", and even the "macro-view" and "cosmic view" in his paintings, with the vision of both the telescope and the microscope, to explore the mysteries of the vast earth and the universe as well as the minute activities of individuals in their lives.

Although he absorbed many new artistic concepts from America and Europe, he was never an imitator, but always insisted on his own direction. While he watched with fascination the attempt among many painters in the West to take departure from traditional flat surface and to explore such new ideas as conceptual art, earth art, environmental art, and even performance art, he showed neither inclination to follow nor any objection to their doings, for he felt that the realm of art was boundless, similar to the tao in Chuang-tzu, which is omnipresent. But to him, regardless of how ideas on art change and of how many new dimensions there are, art still basically depicts all the present world through a flat surface. Naturally in the realm of fine arts, architecture and sculpture work in three dimensions, but they are not in the same mainstream as painting, because in rendering objects in the three and

multi- dimensional world onto the two-dimensional flat surface painting thus in this process leaves the real world behind and enters an abstract world. With imagination and creative power, the painter breaks away from the restrictions of time, space, logic, scale, and others to form his new creation.

In his emphasis on the importance of the two-dimensional surface, Chen looks at painting not as a reproduction of things in nature but as formation of new relationships through the artist's keen thoughts and sharp eyes, with its own rules and systems, such as rhythm, pattern, structure and harmony. The beauty of art comes from variations of these elements. When he was still in high school, he was deeply impressed by an idea in an article written by a modern artist, Feng Tzu-k'ai (1898-1975), which said that "beauty" was to search for "unity in variation, and variation in unity". This idea has been kept in his mind all through his life as one of his basic convictions. Indeed, he regards this as the universal rule of the cosmos on which all life and the human world depend.

Another major characteristic, in his view, is inertia. Several years ago, in a symposium to welcome the visit of Zao Wu-ki from Paris, Chen expressed the following view in response to a question about why Western artists always approach art with a model: This is because in the human world the most beautiful object commonly seen is the female nude body. We would be offended or even frightened by someone with three eyes. If one day a man comes from outer space, he may look very ugly, because we are not used to his appearance. Those things that we become used to for a short period are called fashions. Ladies' dresses and automobiles change constantly, and everybody follows suit. When abstract painting is popular, realistic works will not be accepted by museums. One year the New York Times said that my paintings were "decorative," which was not a good comment during the 1950s. Now, with the arrival of Post -modernism, "decorativeness" in architecture, resulting from a mixing of various elements, has become the mainstream. When we have become accustomed to certain kinds of food, such as shaoping (a kind of cake), yu-tiao (a kind of doughnut-like food), and soy milk , we Chinese all like them very well. But when the Chinese first taste cheese, they usually do not like it, because they are not used to it. It will not do if we have shao-ping and yu-tiao for every meal, because there is a lack of variation.

This kind of approach to theoretical ideas with examples from everyday life is typical, not only of his views on art but also of his artistic expression.

To show large in small is another characteristic of his art. Although he has painted many works in cosmic or macro-views, his works are mostly in small format, sometimes about two feet square and sometimes in scrolls of one, by five or six feet. He never did anything as monumental as wallpaintings. This is a reflection of the concept of "small is beautiful," to which he has adhered all his life. Despite the smallness of his works, they seem to have everything. Though they look like ordinary landscapes in a general view, they show all kinds of human activities when seen in detail. These details reveal an inexhaustible wealth of joyfulness, aliveness, and beauty of the human world. In Chen's works, under the vast macro-view of his cosmos, there is the micro-view of myriads of objects and creatures all in harmony, full of vigor and warmth. This is the hidden power of his paintings.

"Small Is Beautiful" was the theme of an exhibition of Chen's paintings in 1977 in the Art Gallery of Victoria in British Columbia, Canada. This idea is actually a typical characteristic of Chinese poetry, since for centuries the Chinese wrote numerous short, lyrical poems, but few epics. In painting and calligraphy, the album, the handscroll, and even the hanging scroll have been mainly for the enjoyment of one or a few individuals, not of large crowds. On the other hand, "Small Is Beautiful" is a concept from the West, based on the English economist Schumacher's theory, which has been very influential during the last two decades. It coincided with Chen's way of thinking. When he traveled in Japan during the 1950s, he first noticed the basic principle of Japanese design, in presenting the sense of beauty in light, thin, short, and small objects. He also came to appreciate the Japanese waka poetic form, which limits a poem to fourteen words. One of the poems, with these words, "In a quiet, quiet pond, a frog plunges into the water," creating a profound feeling, deeply moved him. Among Western painters, Paul Klee was to him the one whose small works gave him endless flavor. Earlier, Nelson Wu referred to his painting as "seeing a vast world in a nutshell. " In 1980, Ho Hwai-shuo, a painter in Taiwan, also used the title, "To Hold Sumeru in a Nutshell," for an article discussing Chen's works. Mt. Sumeru is an Indian term for the Himalayas. His use of the term is similar to that of Nelson Wu. In his article, he took five terms, namely simplicity, harmony, smallness, length, and distinction, as characteristics of Chen's works. He recalled that during his visit to Washington he found a number of pieces of sculpture and painting in the East Wing of the National Gallery of Art too large to serve their purposes. In contrast, he was very comfortable with Chen's works:

"There is a profound reason for Mr. Chi-kwan to show his art in small paintings. For me, one reason is his very minute and delicate wisdom. Another is his interest in refined culture as a counterpoint to the "bigness" in America and those influenced by her." "To Hold Sumeru in a Nutshell" reveals the wisdom of the East." (The Paintings of Chen Chi-kwan, P.20)

As a painter himself, Ho Hwai-shuo shows a very keen observation and understanding of Chen's art. In his Chinese Art in the Twentieth Century, Michael Sulliven also said that he "remembered and observed (the country of his birth) with a delicacy and precision to which no reproduction can do justice." (P.58)

From the concept of "small is beautiful", one can further understand Chen's view of "beauty." As mentioned before, he began in the Chinese tradition, and mixed with it the modern point of view. He saw a great difference between the Chinese sense of beauty and the Western attempt at social reform by depicting the dark side of life. For the Chinese, art and painting have always been the highest expression of the human spirit. Thus their works are more symbolic and idealistic, in order to heighten the human character and morality, and to make people optimistic and conscious of beauty. To Chen, this is the main function of painting.

To attain this stage of beauty, Chen feels that Chinese artists must turn away from the overemphasis of imitation in the practice of Chinese painting. For him, he must continuously experiment, discover, break through, and revolt against his own past. He never joined any art group or association for joining a group would put restrictions on his creativity. He never insisted on adhering to one single style, for he wanted full express his own spirit and feeling. He does not want to emphasize the importance of "method", "manual", and "technique", for they will impose restrictions on his expression. He never talked about theories while painting, for they tend to fossilize his own style. Every day he has his own new inspirations and new discoveries. To him, instead of talking about theories, it is much more practical to grasp firmly these flashes of ideas and to transform them into his paintings.

In his depiction of rocks, mountains, rivers, streams, fields, houses, and other objects, he never tried to show the shiny flat surface of these

objects, but used his special technique of mixing dots, lines, and washes to achieve the effect of vague, undifferentiated and ever-changing appearance, as an extension of what traditional critics called "marks of water leaks from the roof". This kind of depiction arouses many different kinds of feeling and emotion in observers, something very close to what the Chinese refer to as "clumsiness (cho) " and the Japanese, as "shibui".

Form the discussions above, it is possible for us to understand his basic views on art. He has attempted to blend the Chinese and Western traditions into a new art of his own, to express his feeling for heaven, earth, and man or space, time, and the human world. This is the point that many critics and scholars have made during the last two decades. In his "Introduction" to the Paintings of Chen Chi-kwan (Taipei, Art Publishing Co., 1981), Nelson Wu concludes with the following paragraph:

"The space and time in Chen Chi-kwan's paintings can not be measured by "volume", but by "quality", they cannot be accumulated into calculable amounts or measured by inches or miles or accounted for in calamities and fortunes or in sorrow or happiness. They should be seen as a realization that comes from nowhere, in the form of surprised or exclamations in sympathy with the related to all creatures in the universe. In this respect, the Chinese flavor in his paintings is especially strong. But because of this his works are quite different from traditional Chinese paintings. Yet it is because of this dissimilarity that makes his artistic position close to that of the mainstream in the Chinese tradition." (P.11)

This view is close to that expressed by this author, in an essay entitled "The Visions of Chen Chi-kwan", written in 1977 and published in The Artist and later collected in the volume of The Paintings of Chen Chi-kwan. It reads: "Chen Chi-kwan was no imitator. The new concepts of design and expression that he learned in the West enhanced his Chinese spirit, but did not replace it. Chen Chi-kwan ought to be viewed as a pioneer in the transformation of traditional Chinese painting to the modern world. His art has sharpened our visual perception of nature, and sparks us with new insight into our own visual memory, or toward our present surroundings. He heightens emotional responses to pattern and texture. His art holds the power to lift us above the monopoly and drudgery of every day life into a world of pure joy and eternal bliss. Such is the mark of a great painter". (P.33)

With these comments in mind we can look at his recent works to realize his depiction of space, time, and the human world has not only blazed a new trail for traditional Chinese painting, but also brought this new spirit and expression to the artistic realm of the world.

Notes

1. The structure of these houses consisted of a series of courtyards, usually three to five, with houses around them serving as living room, study, guest room, dining room, kitchen, and living quarters of the family, usually with three or more generations living under one roof.

2. Since Chungking was the wartime capital, it was extensively bombed by Japanese planes during the early years of the war. After the attack on Pearl Harbor in December 1941, the Japanese began to direct their attention to the Pacific War with the United States and the land war in Southeast Asia, thus giving Chungking some quiet days... A considerable number of leading painters, including Hsu Pei-hung, Wu Tso-jen, Lu Ssu-pai, Ch'en Chih-fu, Chang Shu-ch'I Huang Chun-pi, and Fu Pao-shih, were there, all teaching in the Department of Art at National Central University. As a student of architecture, Chen Chi-kwan took some courses in drawing, sketching, and watercolor and often went to the Department of Art to study their exhibits.

3. It took him a total of eighteen days to cross the Pacific, from Shanghai to San Francisco, with stops at Yokohama and Honolulu, on the S.S. General Gordon of the American President Lines, which had served as a troop transport ship during the war.

4. What he learned from Gropius' office was much more than what he could have got from classes. He participated in all the discussion sessions at the Harvard Graduate School of Design, attended all the lectures by various speakers, and read many Harvard theses in the library. In addition to the graduate school at Harvard, Gropius formed an architectural cooperative known as TAC with seven of his pupils in response to the many requests for his designs. Chen felt extremely lucky to have been in this cooperative, since he was not one of Gropius' pupils. In fact, he got along extremely well with the master, and soon earned the respect of his colleagues for his work. As a result, in 1952, through Gropius' recommendation, he was appointed instructor in architectural design at the Massachusetts Institute of Technology, the leading institution in sciences and engineering in America.

5. The monkey has played an important role in the life of the Chinese since ancient times. In the China of old, there were many monkeys accompanying street performers traveling around the country. That kind of impression is still fresh in the mind of most of the Chinese of the older generation. Also, the image of the Monkey King in the famous novel The Way West has always fascinated generations of Chinese, because of his ability to transform himself seventy-two times, even though he has many human frailties. Chen could not understand why, in the long history of Chinese painting, the monkey was always depicted in the same way without change.

6. Before 1949, the United Board had thirteen Christian colleges in China. After the communist conquest of Mainland China in 1949, they were all incorporated into the new reorganization of the whole educational system, thus severing their connections with the American board. To deal with this new situation, the board changed its direction from China to the whole of Asia and established a number of new colleges outside China. Tunghai was one of its new projects. To any architect, this plan for a totally new campus was a great challenge.

7. Right at the beginning they wanted to search for the essence of traditional Chinese architecture in its design to serve the purpose of teaching. At the same time, to show its Christian affiliation, they planned to have a chapel right in the middle of campus. A donor, Henry R. Luce, publisher of Time and Life magazines, had already promised a sum of money for the building of this chapel. After more than three years of planning and more than ten changes in the design, it was decided that the Luce Chapel would be built with thin shell structure（Canoid system）very popular then in European and American architecture, which would make the chapel look like the letter "A" with two curving planes on both sides meeting at the top, thus creating a strong upward movement. It was simple, plain, and very modern. Upon its completion, the whole plan was first published in the March 1957 issue of Architecture Forum, which had published in the March 1956 issue of a public youth center in a competition sponsored by the Ferro Corporation, the largest ceramic company in America. It was a great honor for him to have two designs published in this prestigious magazine.

8. Although the campus had already taken the basic shape as designed by I.M. Pei and Chen Chi-kwan, there were still many construction projects going on that required the presence of Chen to supervise the work.

9. He had held a number of exhibitions in both Boston and New York and some other places; he had worked with two of the great architects of that time; he had won a number of prizes in architecture; he had done designs for an outstanding chapel and for a whole new campus. In addition, he had traveled in Japan, Southeast Asia, and Europe. This is something entirely unique among Chinese architects and painters. Looking back, he could have a sense of satisfaction regarding his achievements. Right at this point, he decided to stay in Taiwan for the future. One of the reasons was his desire to carry out the building of the Luce Chapel at Tunghai University.

10. An unexpected opportunity brought this writer to become acquainted with Chen as well as Liu Kuo-sung and Chuang Che. In the fall of 1963 I spent several months in Taichung to study paintings at the National Palace Museum. Both Chen and Chuang were in Taichung at that time, and Liu came to visit Chuang once in a while. After seeing some of their works, I began to organize an exhibition of paintings from these painters to travel in the U.S. The exhibition, called "The New Chinese Landscape," included works by six artists, three of them were members of the Fifth Moon Group, namely Liu, Chuang, and Fong Chung-ray, and three others, namely Chen Chi-kwan, Yu Cheng-yao, a retired general who began painting only after his retirement, and C.C. Wang, a traditional Chinese literati painter who at that time served as chairman of the Department of Fine Arts of New Asia College in Hong Kong. Chen's work, through this exhibit, was exposed to Boston and New York in which they had been shown before.

空靈的美感：陳其寬的建築與繪畫

漢寶德, 世界宗教博物館館長

陳其寬先生要在台北市立美術館作一次大規模的回顧展，囑我寫一篇導覽式的文字，我在過去曾寫過兩篇文章，分別介紹陳先生的繪畫與建築，一篇是陳先生舉辦七十回顧展的時候所寫的，那是繪畫的介紹；另一篇是在東海大學四十周年慶的時候所寫的，那是建築的介紹。這兩篇文章都發表在聯副上。因此，我對陳先生的繪畫與建築的看法都已說出來了，再寫文章，恐怕沒有甚麼新意，可是這一次陳先生把繪畫與建築合併起來展覽，可能是最盛大的一次展出，也有其特殊的意義，就嘗試把兩者合併起來寫，通觀陳先生在藝術上的成就。

一、校園的構想

我始終覺得，要了解陳先生的繪畫，必須了解他的建築，要了解他的建築，必須了解他的文化背景。要把他的文化背景、建築背景與繪畫疊在一起，才能真正了解他的創作風格，才能解開對他的作品理解的結。

舉個例子來說吧！在陳先生一生中，建築上最具有代表性的作品是東海大學與路思義教堂，可是東海大學及其教堂在正式文書上都認為是貝聿銘先生的作品。路思義教堂的照片曾掛在貝先生的辦公室裡，這幾乎是定論。不但如此，在東海大學開辦的期間，另一位貝聿銘派來的建築師是張肇康先生。據我了解，張先生晚年在香港，是把東海大學視為他的作品，而且在校園興建期間，他確在台幾年，實地督導建築完工。究竟今天我們能否把東海校園視為陳先生的作品呢？

在文獻上我找不到依據，在習慣上，貝先生自然是佔上風的。陳先生雖然一再的聲明，當時他參與東海校園規劃，並不是貝先生事務所的僱員，因此他的作品並不等於貝先生的作品。他是貝先生請來合作的近似合夥人的身份。這還是有爭議的；因為在美國的東海大學的聯合董事會委託了貝事務所。按照往例，陳先生的作品，仍然不免被視之為貝的作品；這是跳到了黃河裏洗不清的。

那麼要怎樣看才能認定陳其寬先生對東海校園的貢獻呢？

要從文化背景看。貝先生與陳先生都是從中國大陸到美國讀書的。貝先生是哈佛的畢業生，陳先生雖無哈佛的背景，卻也為葛羅培先生所賞識。但是貝先生來自上海，陳先生來自北平。貝先生年輕時住的是西化的洋房，陳先生住的是標準的四合院。貝先生早年去美，受的是西式教育，早就是美籍華人。陳先生在國內讀書，在家受傳統教育，對中國繪畫浸淫甚深，對中國建築與庭園自然也耳濡目染，相當熟悉的。這就是為什麼貝先生的作品國際色彩甚強的緣故。他的作品自始至終有強力的幾何性，是來自西方古典的精神。他怎麼可能規劃出東方自然意味濃厚的作品？貝先生的一生沒有設計過中國式或有中國精神的建築，他的《香山別館》的中國意味只是使用了一些裝飾的點綴而已，在空間與形式上與中國搭不上任何關係。實在很難相信貝先生會構思出以中國庭園空間為基礎的東海校園。

在過去，習慣上以為貝先生為葛羅培斯(Walter Gropius, 1883-1969)設計的上海華東大學是中國建築精神的表現。把一組組的建築放置在自然環境中，圍繞湖水而立，好像是中國園林的傳統，其實是一種誤解。這種崇尚自然的建築觀是葛羅培斯到美國後，用西方人的眼睛看到的東方文明。充其量是乾隆皇帝的圓明園式的配置，不是中國人所認知的園林。因為中國人所了解的人與自然的關係，是人走出建築，步入自然之中，並不是使建築空間與自然融為一體。對於中國人，建築之內是人倫的空間。

因此東海校園初期可能也是用這種修正的現代建築觀去構想的。要知道，這種融合建築於自然環境的觀念，在二次大戰後，已經使用在市鎮計畫中了。

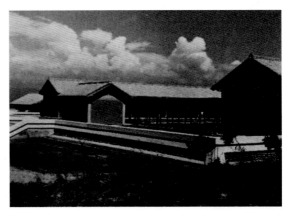

圖1. 東海大學文學院，翻拍自陳其寬提供之東海大學1965記事曆

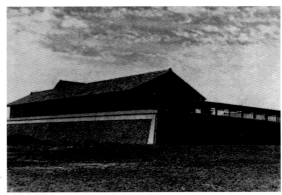

圖2. 東海大學理學院，翻拍自陳其寬提供之東海大學1965記事曆

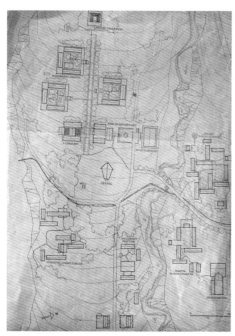
圖3. 東海大學女校園規劃校區平面圖, 陳其寬繪製, 1957

組成一個整體, 兩層樓的長條形單元, 基本上是一致的, 形成的空間雖亦為現代主義時代喜愛的流通感, 都是很呆板的。它的趣味源於圍牆的拱門。比較起來, 陳先生的女生宿舍就不同了, 他是由六直四橫組成的, 並明顯的分為三組, 長條形的建築單元又分為三種長短, 組合起來就顯得靈活而有生氣(圖4)。還有一個重要的特點, 即考慮了建築的座向, 依現代主義的原則, 建築要以其功能選擇座向。宿舍是居住建築, 應選坐北朝南的方向。可是如果完全南北向就如軍營一樣的呆板了。然而一直一橫的組合與座向的原則之間有明顯的矛盾。陳先生解決這個的方法是把大部分的宿舍, 也就是最長的單元座北朝南, 把附庸的建築, 也就是較短的單元, 打橫安排, 形成主從明顯的組合。再使用更短的單元, 點綴過份開敞的空間。比較起來, 陳先生的女生宿舍的配置圖更像一幅畫。當然了, 我們不要忘記, 在東海建校的五〇年代後期, 陳先生已經是頗有名聲的畫家了。

我推想東海校園有兩處可能是貝先生的構想。其一是東西向的林蔭道, 其二是方形的學院。林蔭道作為校園的中心軸線, 是巴洛克的規劃觀念。雖說軸線大道是傑菲遜在維吉尼亞校園中的發明, 在坡地上並不適用。它的目的應該是開闢一條可以遙望中央山脈的視覺道路。至於正方形的學院建築在平台上, 是受西方幾何美學的影響。據陳先生說, 學院的台與牆是貝先生看了日本皇宮得到的靈感(圖1, 2)。而日本的文化中, 最接近西方精神的正是城牆上的大石塊。除此之外, 應該都是陳先生的構想。東海的建築, 輕快的架構, 出跳的屋簷, 錯落的佈置, 廊道的連接, 座落在茂密的樹林中, 只有懂得性靈之美的東方建築師才能設想得出來。只要看看陳先生所畫的女生宿舍的透視圖, 就知道其意味所在了。

東海初創時的原始校園帶有濃厚的日本味是什麼原因呢? 因為把中國建築的傳統精神加以現代化, 就會自然有日本味, 並不是抄襲日本建築。中國傳統建築中的琉璃瓦, 畫樑彫棟, 曲線造形, 乃至畫彩, 在過去是制度, 今天看來俗氣, 不符合現代主義的重理性、講功能的原則。陳先生在現代建築高峰期, 到美國讀研究所, 又熟悉現代建築大師葛羅培斯先生, 因此在骨子裡是一位現代主義者, 喜歡簡單、乾淨、合理。中國建築經過現代主義的處理, 曲線沒有了, 顏色沒有了, 就有日本風。因為日本在接受中國影響之前, 建築是崇尚自然的, 所以後期的建築, 尤其是住宅, 非常符合現代建築的原理。這是葛羅培讚美日本傳統建築的主要原因。

東海初期的規劃, 在配置上是校區規整的三合院與宿舍區自由組合相配而成(圖3)。三合院是中國固有的傳統, 一橫一直的自由組合是包浩斯式的設計。陳先生的女生宿舍與張肇康先生的男生宿舍屬於同一類, 可是同一個原則也可以看出在不同的作者手中產生不同的效果。張先生的作品由五橫五直

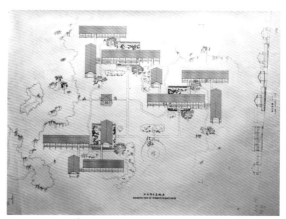
圖4. 東海大學女生宿舍平面圖, 陳其寬繪製

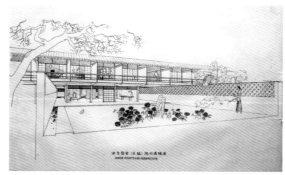
圖5. 東海大學女生宿舍透視圖, 陳其寬繪製

二、情境的創造

東海的女生宿舍是陳先生力作, 他畫的透視圖也以女生宿舍最有浪漫意味(圖5)。人人都可以看出來, 這是一位畫家建築師筆下的產物。大家應該注意到, 在一個現代主義作品的宿舍群中, 陳先生不忘記傳統趣味, 他在三組建築中都沒有忘記用圍牆圍出一個院子, 做為該組建築的進口。這是真正的中國園林的精神。到了東海校園初步完成, 校園建築完全信託陳先生執掌後, 他對中國園林的體會就更明顯的反映出來了。我在「情境的建築」一文中曾詳細說明。可是這一些與他在繪畫中所呈現的中國空間, 不過是九牛一毛而已。

陳其寬先生在五〇年代已經是知名的畫家。他的早期作品正是中國傳統與現代視覺設計的結合。他在麻省理工學院教書，當時該校有一位克普士(Gyorgy Kepes, 1906-)先生教授視覺美感的原理，應該對他造成深刻的影響。這些原理是現代主義時代藝術理論的基石。

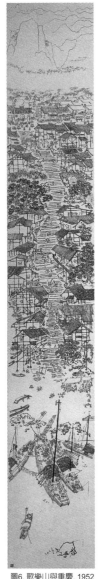

中國的傳統繪畫，自元代以後就丟棄了寫實的方向，完全走向意境的創造。這是完全唯心的。意境就是心中之境，也就是今天所說的造景。由於心無定向，後來的中國畫也迷失了方向，終於淪為因襲。這是因為過度的依賴心中之意念，缺乏外在自然的啟發的緣故。

西方的藝術到了二十世紀，也丟棄了寫實的方向。可是他們沒有道家思想做後盾，藝術的意念得不到理論的支持，只好從外在的自然轉到內在的自然，從客觀的自然轉到人類感官中的自然。我們是通過眼睛及其神經系統來接受外界景物的。因此眼睛所見，即使是幻覺，也是一種真實。視覺藝術是反映了我們眼中所見的世界。

陳先生在五〇年代就體會到照相所呈現的靜態世界，與通過視覺留在我們腦海中的世界是不一樣的。時空的交錯就形成動態的世界。要怎樣把不易掌握的動態世界留在靜態的畫面上，是那時候的陳先生著意的努力方向。這就是後來他所稱的「意眼」。眼是指賴以觀看的器官，但他的眼不是類似照相機的那具眼睛，而是掌握不可掌握的動態的那具超現實的眼。但他仍然是以眼之所見為基礎的，不是抽象的幻覺。

圖6. 歌樂山與重慶, 1952

因為他的意眼是自中國繪畫與園林傳統中，套上西方視覺理論，自然發展而成。中國文化是經驗與心意並重的文化。把一連串的視覺空間經驗在心意中作綜合的呈現，是中國的固有傳統。所以一幅用中國書法表現的足球賽的動態印象就感動了外國的評論家，他那幅使他成名的《歌樂山與重慶》(圖6)，使用中國山水畫的手法，成功的描述了山城的印象。但是如果他沒有學過建築，沒有受現代視覺理論的影響，他不可能用現代人所謂等角透視(isometric)的方法，結合中國的筆墨，把平面圖轉化為動人的繪畫。他的眼是建築家的眼；意是建築家的想像力。

回頭來看他的東海女生宿舍的配置圖。這張圖實際上是一幅畫，不只是工程圖樣。與繪畫不同處，只是多了比例尺，而且用器具畫出而已。用中國古人的讀法，這是界畫，同時也是中國古人畫地圖的方法。所以我把東海女生宿舍當成陳先生早期建築代表作。它結合了現

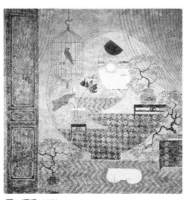

圖8. 深遠, 1979

化主義的簡單、合理的構造原則、流通的空間觀念與中國建築的簡單秩序與園景的曲折變化，再加上一些繪畫的想像力。它與《歌樂山與重慶》應該是屬於同一階段的。

視覺的印象沒有中國傳統空間觀念會產生怎樣的作品？其實陳先生在五〇年代中期的《聖馬可廣場》(圖7)上就表現出來了。我相信他受了當時紐約的抽象表現主義繪畫的影響。他用背後上彩的方法，把宣紙染成油畫的感覺，上面的鴿子，則用中國毛筆的筆法呈現。陳先生很喜歡這樣的畫，所以畫了幾幅以威尼斯為題的作品，只是水波代表了鴿子。直到在東海教書的六〇年代，他用同樣的方法畫了不少外國風景。

三、鄉愁的昇華

可是到了東海任教的時期，他的建築觀與繪畫走向有了重大的改變。

也許因為回到中國人的懷境，他的故鄉情思更加落實了吧，他的建築與繪畫都明顯的呈現中國園林空間的想像。在繪畫上，他開始不猶豫的用細緻的線條勾劃出園景。在建築上，他不再砌磚，改用園林的白灰牆。他對中國傳統的空間如何運用在建築與繪畫上，都有了更明確的看法。現代主義的色彩逐漸消褪了，傳統的情思逐漸濃厚起來。

在可以自由表現的繪畫上，他回到山水畫，開始進一步的開拓胸中的視覺世界。他畫凝重的山石早已有了根基，這時候開始以視覺變形來表達他心中的山水。由於他的繪畫原是自視覺出發的，所以我推想，他感受到飛機上觀察景物的影響。本來嗎，中國古人的山水畫就是心中臆想的、夢幻的境界，那是因為他們沒有經驗過凌空飛翔的真正經驗。飛機對我們的視覺世界有甚麼啟示呢。

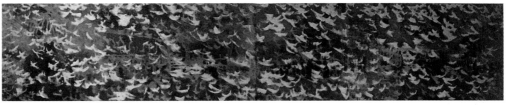

圖7. 聖馬可廣場, 1952

首先是快速接地的飛行，使我們感到地面縮短了。在飛機場降落的經驗如果加到山水畫上，也許就是陳先生所畫的《縮地術》(1957)。山川忽然像摺皺一樣緊密的疊在一起了。陳先生在五〇年代末就畫過了。

其次是特技飛行員所感受到的。這並不是一般人的經驗；我們只能在飛機起飛後旋轉到預定航向時略有所感。但是科學博物館中的大銀幕電影常常帶我們體驗低空迴旋飛行的感覺。在這樣的飛行器上迴旋所看到的山水是怎樣呢？可能是陳先生後來畫山水的思考方向。

最後是飛機的快速運動使我們生晨昏顛倒的事實。這一點我不確定有沒有影響陳先生的思維，可是六〇年代以後在他的繪畫中不斷有日月共同出現的畫面，使我推想時間因速度而產生的錯亂，是否因此啓發了他的新思。

在他看來，自飛行中看天下，也許是最合理的中國畫家承續中國繪畫傳統的思考方向。他很可能自中國的風水著作中體會到山川佈置的觀念，與理解自然的角度。因此他在以後的二、三十年間，不斷的產生這樣的作品。在他細長條的繪畫中，變形山水的作品可能是最重要的一部份，也可以說是他最花功夫與心思的主力作品。

然而在生活的層面，園林還是他最喜歡的主題。

八〇年代之後，他也感受到後現代的影響，在繪畫上，一方面更加返回傳統，一方面表現一些非理性的因素，其中特別值得注意的，是喜歡用裝飾意味濃厚的手法，幻化中國園林的空間 (圖8)。這樣的發展使得陳先生後期的作品更具有大眾性與民族性。

中國的傳統園林，包括空間與裝飾，是最接近中國人心靈的形象。這就是板橋林家花園開放以來遊客絡繹不絕的原因。因為園林是大家的夢想。根據記載，古代的中國私人園林大多對民眾開放，所以園林空間是我們的共同記憶。

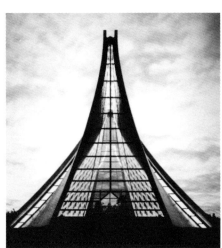
圖9. 東海大學路思義教堂

說來也是巧合，我在民國七十四年(1985)完成了南園，正是陳先生開始大量以園景入畫的時間。他用帶有詩情的畫題，把江南園林中的特色，特別是院落與拱門的交錯與穿透，結合了瓶花、竹簾、明式家具、花格窗，完成了不少具有詩意且畫有高度裝飾性的作品。也許為了大眾化吧，他把這類作品印成版畫，以便使中產階級也有機會購藏。

大陸開放後，江南有不少年輕畫家以園林景物為主題，畫一些啓人鄉愁的畫，頗受中產收藏家喜愛。可是陳先生的園林畫仍然是通過建築家的意眼，用園林元素組織而成，雖同為園林，境界是完全不同的。

四、曲線的解放

回顧陳先生的創作，不能不談談東海大學的路思義教堂 (圖9)。這是陳先生一生最重要的作品，是他一生的驕傲，也是一生的遺憾。直到最近，台中市政府有條路穿過校園之傳言，東海校長仍把貝先生抬出來抵擋。前文說過，貝先生如堅持，陳先生是有口難辯的，這就是為什麼今天的文化界非常重視著作權的原因。

作為一個觀察者，我們怎麼找到真正的創作者呢？還是要自作品的精神上著眼。陳先生回憶當年設計時的過程，貝先生並沒有參與意見，只是在開始構思時提出一個簡單磚砌尖形拱頂的觀念。通觀貝先生一生的作品，這樣的構想是很合乎他的風格的。如果依貝先生的想法建成，也會是很有特色的教堂，那是屬於西方宗教建築的現代化，不可能有中國的風味。

中國的藝術特色主要在於「氣韻生動」四字。說起來有點玄，看上去卻一目瞭然。在繪畫上，建築上莫不如此。我年輕時本不相信。可是七〇年代到倫敦看到Kew Garden中的中國塔，到歐陸數皇宮中看到中國式樣建築，如果一一描述，不覺有何不同，但看上去就覺生硬死板。如同清末外國人畫的中國畫，所缺的就是這四個字。

陳先生設計這座教堂，中間有許多人參加意見，而且所用的材料自早期的磚，發展為木材，最後用鋼筋水泥，過程曲折。可是真正的力量乃是他中心潛藏的氣韻。其實中國建築中的氣韻的精髓不過是善用曲線而已。試看東海早期的校園，正是因為缺少了曲線，才使國人感覺不到傳統的風味。但是濫用曲線，不免淪於流俗。東海教堂如何成功？曲線生動而已！這一點出乎貝先生一生的語彙之外。他在建築上多有貢獻，但我可斷定路思義教堂非出自他的構思。

陳先生很巧妙的找到立體幾何上的具有變化的曲面(Conoid)，實在是很運氣的，在當時，建築界流行雙曲拋物面，本來就有追求「合理的造型」的意思。可是幾何形的變化總是規律的，不免重覆單調。陳先生用Conoid的片斷，切成四片，重新組合，使得東海教堂內外均呈現優雅的曲線，

而且有「一線天」的採光效果。由於是幾何形,在設計、施工上都有規律可循。這是幾何與功能的巧妙契合,幾近乎天成。貝先生來東海時,很滿意這一作品,但我同意他的看法,在燈光上缺乏慎密的考慮。可是這樣一個半漂浮感覺的水泥帳棚,卻非貝先生的風格。貝先生喜歡有量感的建築,我記得在他辦公室中所掛的那幅照片,是教堂的側面,是兩面大牆壁,他所欣賞的並不是路思義教堂中優雅的曲線,與空靈的氣韻。

五、空靈的美感

以簡單的曲線表現空靈的美感,可能是陳先生藝術的極致。陳先生與一切西方藝術家一樣喜歡畫女體,可是他雖畫過各種姿態的女體,卻沒法融合東方的精神於其中。到了七〇年代的後期,他發現了用極簡的方式表達女體美的效果,才在女體中找到中國的韻致。較早的一幅是《秀色可餐》(圖11),很巧妙的用一根簡單的線條,勾劃出豐滿動人的女體輪廓的一部份。自這根線條可知,人類文明中很多美麗的線條是源自女體。

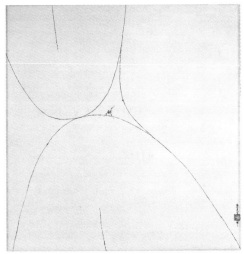

圖11.,秀色可餐, 1979

這根線條原無分乎內外,並無實體。陳先生很巧妙的使用一隻蚊子來確定這根線條是一個女體的輪廓。這樣的表現方法,把一個豔麗的想像化為空靈的抽象的美感,對陳先生只是遊戲之筆,並非他的力作,可是我卻覺得他把詼諧的人生轉化為靈巧的美感,一直是陳先生作品中的精髓所在。用簡單的一、二根曲線來表達深遠的內涵,正是把建築美的體會與繪畫充分結合的最佳說明。

我覺得路思義教堂上使用的簡單的立體幾何的曲線與女體上流暢的曲線在精神上是一致的。陳先生的一生藝業是瀟灑的、江南才子式的。他並不喜歡大塊文章。所以他永遠掌握了道家的靈的精神,也就是建築家所說的空間的實體。這也是中國文化的精髓。可惜的是,雖然今天的年輕人期待中國世紀的來臨,而了解體認中國文化精神的人卻少之又少了。

Dynamic Emptiness:
Chen Chi-kwan's Architecture and Art

Han Pao-teh, Director of the Museum of World Religions

Chen Chi-kwan is now being honored with a major retrospective exhibition at the Taipei Fine Arts Museum, and has entrusted me with writing an introduction in the manner of a guide. In the past I have written two articles introducing Mr. Chen's paintings and architecture, respectively. One-piece, written for a retrospective exhibition celebrating his 70th birthday, focused on his painting, while the other, written for Tunghai University's 40th anniversary celebrations, surveyed his architectural designs. Both of these articles were published in a United Daily News supplement. So I have already shared my thoughts on both Chen Chi-kwan's painting and his architecture. In writing this new article, I fear I have few new insights to offer. Yet this time, Chen Chi-kwan's painting and architecture have joined forces in a single exhibition. This may be his grandest exhibition of all, one of special significance, in that it attempts to merge these two elements and achieve a unified view of Chen Chi-kwan's artistic successes.

I. The conception of the campus

I have always felt that to understand the paintings of Chen Chi-kwan, one must understand his architecture. To understand his architecture, one must understand his cultural background. Only by placing his cultural background, architectural background and painting side-by-side is it possible to truly understand his creative style, and thus obtain the key to understanding his works.

Let me offer an example. Throughout Mr. Chen's life, the works most representative of his architecture are the Tunghai University campus and Luce Chapel. But according to official documents, these are considered to be the works of I.M. Pei. Indeed, Mr. Pei has a photograph of the Luce Chapel hanging in his office, and his authorship of its design is nearly an accepted fact. Moreover, in the initial period of Tunghai University's construction, I.M. Pei sent over another architect, Chang Jau-kang. According to my understanding, Mr. Chang in his later years living in Hong Kong considered the Tunghai campus to be his work. Furthermore, while the campus was being constructed, he undeniably did reside in Taiwan for several years, and did supervise the construction of the campus buildings. Today, can we actually view the Tunghai campus as the work of Chen Chi-kwan?

I can find no documentary evidence. Of course, force of habit certainly gives I.M. Pei the upper hand. Chen Chi-kwan has repeatedly declared that at the time he took part in the planning of the Tunghai campus, he was not an employee of I.M. Pei's firm, and his work does not equal the work of I.M. Pei. In fact, he was invited by Mr. Pei to collaborate on the project in the capacity of what amounts to a partner. Yet this is still a matter of dispute, because the United Board for Christian Higher Education in Asia, the American organization that founded Tunghai University, gave the commission to I.M. Pei's firm. According to conventional practice, Mr. Chen's work is still inevitably credited to I.M. Pei. This is a shadow from under which Chen Chi-kwan cannot escape.

How, then, can we ascertain Chen Chi-kwan's contribution to the Tunghai campus?

We must consider the cultural background. Both I.M. Pei and Chen Chi-kwan came from mainland China and went to the United States to study. I.M. Pei is a graduate of Harvard University. Although Chen Chi-kwan does not have a Harvard background, his merits were recognized by Walter Gropius. I.M. Pei came from Shanghai, while Chen Chi-kwan came from Beijing. When he was young, I.M. Pei lived in a Western-style house, while Chen Chi-kwan lived in a standard Chinese dwelling, with four wings encircling an inner courtyard. I.M. Pei went to the United States early in his life, received a Western education, and early on became an American citizen. Chen Chi-kwan, however, received a traditional Chinese home education in China. Chinese painting deeply permeated his consciousness, and he was thoroughly imbued with a familiarity with Chinese architecture and home-and-garden design.

This is the reason that I.M. Pei's works have such a strong international flavor. From beginning to end, his works have possessed a powerful sense of geometry; this comes from the Western classical spirit. How could he possibly plan a work with a potent sense of Oriental naturalism? Throughout his entire life, Mr. Pei never designed a Chinese-style building, or a building in the Chinese spirit. The Chinese aura of his Xiangshan Hotel in Beijing comes from the use of certain decorative embellishments; in terms of space and form, it has no relationship to China at all. It is truly hard to believe that Mr. Pei would conceive of the Chinese courted garden space as the foundation for the Tunghai University campus.

Shanghai's Huadong University campus, designed by I.M. Pei on behalf of Walter Gropius, was once generally considered to be an expression of the Chinese architectural spirit. It places a series of building clusters in a natural environment, surrounding a lake - apparently a traditional Chinese garden design. In fact, this is a misperception. This architectural viewpoint oriented toward nature was developed by Gropius after he came to America, viewing Eastern civilization through Western eyes. Especially in terms of volume, the arrangement of buildings according to the style of Emperor Qianlong's Summer Palace is not the kind of garden with which Chinese people are familiar. As the Chinese understand it, the relationship between human beings and nature is that when people leave a building, they enter nature. It is not that an architectural space should blend as one with nature. For Chinese people, the interior of a building is the space of human affairs.

Consequently, in its early period, the concept of the Tunghai campus made heavy use of this kind of revised modern architectural perspective. We should be aware that this viewpoint melding architecture with its natural environment was commonly used in city planning following World War II.

I would like to suggest two areas of the Tunghai campus that may have been conceived by I.M. Pei. One is the tree-lined Campus Mall running from east to west. The other is the area of quadrangular classroom buildings. The Campus Mall functions as the central axis of the campus. This is a baroque planning concept. Although it is said that the idea of a central promenade was invented by Thomas Jefferson at the University of Virginia campus, his was not placed on a slope. At Tunghai, its purpose is probably to open up a visual line revealing the distant Central Mountain Range. Square classroom buildings are situated on terraces; this clearly demonstrates the influence of Western geometry and aesthetics. According to Chen Chi-kwan, the terraces and walls of the classroom buildings were an inspiration I.M. Pei received when looking at Japanese palaces. And the aspect of Japanese

culture that most closely approaches the Western spirit is in fact the large stones in its city walls.

Other than these, the entire campus was probably the conception of Chen Chi-kwan. The architecture of Tunghai University - its light structure, its flying eaves, its staggered arrangement, its connected walkways, its being situated in the midst of lush woods - could only have been designed by an Oriental architect who understood the beauty of the natural spirit. One only needs to look at the perspective chart that Chen Chi-kwan drew of the girls' dormitories to know that he possessed this sensibility.

And why did the original Tunghai campus have such a strong Japanese flavor? Because if one adds a sense of modernity to the traditional spirit of Chinese architecture, the natural result is a Japanese style. It is not that anyone was copying Japanese architecture. By today's standards, the glazed tiles, painted beams, sculpted columns, curvilinear shapes and even the painted colors of traditional Chinese buildings built according to the system of the past seem gaudy and out of sync with the principles of modernism, with its emphasis on rationality and utility. Chen Chi-kwan undertook his graduate studies in the United States at the height of the modernist era of architecture, and was on familiar terms with the modernist master Walter Gropius. Structurally, he is a modernist who likes simple, clean, rational designs. Filtered through the sieve of modernism, Chinese architecture was stripped of its curved lines and bright colors. This is essentially the Japanese-style. Before Japan was influenced by China, its architecture glorified nature, and thus in later eras the designs of its buildings, especially its residential dwellings, dovetailed well with the principles of modern architecture. This is the main reason that Gropius praised traditional Japanese architecture.

In the plan's initial stage, the layout of the Tunghai campus called for a classroom building area of three-sided courted buildings and a contrasting dormitory area of freely combined forms. The three-sided building with central courtyard is a fundamental part of Chinese tradition. The free combination of vertical and horizontal lines is the legacy of Bauhaus. Chen Chi-kwan's design of the girls' dormitories and Chang Jau-kang's design of the boys' dormitories were similar in nature, yet the same principle produced different results in the hands of different architects. Chang Jau-kang's overall design was composed of five horizontal and five vertical units, and all the elongated two-story units were by and large identical. In terms of space, they formed a sense of fluidity much in favor during the modernist era, but all quite predictable. Their interesting aspect was the arched doorways of the enclosing walls. In comparison, the girls' dormitory complex designed by Chen Chi-kwan was quite different. It was composed of six vertical and four horizontal units, clearly divided into three groups. He also divided the elongated architectural units into three distinct lengths, combined in a way that brought out a sense of dexterity and animation. And there was another major special feature - its consideration of the geographical orientation of the buildings. Based on the principles of modernism, buildings should be situated according to their functions. Dormitories are residential buildings, and thus should run from north to south. Yet if they ran entirely from north to south, their arrangement would be dull and rigid, like a military camp. Nevertheless, a clear contradiction seems to exist between the combination of vertical and horizontal units and their orientation. The way that Chen Chi-kwan resolved this was to situate the majority of the dormitories (the longer units) north-to-south, and to arrange the secondary buildings (the shorter units) horizontally, forming an obvious hierarchy. He also used even shorter units, to embellish the overly wide-open spaces.

Comparatively, Chen Chi-kwan's perspective chart of the girls' dormitory complex looks like a painting. Of course, we should not forget that in the late 1950s, when the Tunghai campus was first built, Mr. Chen was already fairly well-known as a painter.

II. The creation of milieu

The Tunghai girls' dormitory design was one of Chen Chi-kwan's major works. The perspective chart he drew lends these dormitories a distinctly romantic air. Everyone can see that this comes from the pen of a painter-architect. And we should all note that Chen Chi-kwan did not forget to infuse this modernist dormitory design with a traditional flavor. In each of the three groups of buildings, he was careful to include a courtyard enclosed by walls, serving as the entrance to each building group. This is the true spirit of the Chinese garden. When the preliminary stage of the Tunghai campus was complete, the campus architecture was entirely entrusted to the management of Chen Chi-kwan. Afterward, his appreciation of the Chinese garden was even more noticeably reflected. In my article "The Milieu of Architecture," I have explained this aspect in greater detail.

But these expressions of the Chinese sense of space were just the tip of the iceberg compared to his paintings.

Chen Chi-kwan was already a renowned painter in the 1950s. His early works are a combination of Chinese tradition and modern visual design. When Chen Chi-kwan was teaching at the Massachusetts Institute of Technology, the principles of visual aesthetics taught by one of the professors there, Gyorgy Kepes (1906-), most likely had a profound influence on him. These principles were a cornerstone of art theory during the age of modernism.

Ever since the Yuan dynasty, traditional Chinese painting forsook the path of realism, and entirely pursued conceptual creation. This was completely idealized, an inner world of the mind, a virtual landscape, as it is phrased today. Because the mind has no fixed bearing, Chinese painting eventually lost its sense of direction, and ultimately became bogged down in convention. This is because it relied excessively on mental concepts, and lacked the inspiration of the external natural world.

In the 20th century, Western art also veered away from realism. But it lacked the underlying support of Taoist thought. The artistic ideas of the West lacked an underlying theoretical support, and could only turn from external nature to internal nature, from objective nature to the nature present in the human senses. We all receive the scenes of the outside world through our eyes and our neural systems. Consequently, what our eyes see - even if it is a hallucination - is still a form of reality. Visual art reflects the world our eyes perceive.

In the 1950s, Chen Chi-kwan comprehended that photographs present a static world, but the world that vision creates in our minds is different. The intersection of space and time form a dynamic universe. How to capture this elusive dynamic world in a static picture was the focus of Chen Chi-kwan's attention and energy during that period. This is what he later came to call to the "inner eye." The eye refers to the organ we all rely on for sight, but his eye does not resemble the lens of a camera. Rather, it is that surrealistic eye that captures ungraspable dynamism. But this is still based on what the eye sees; it is not an abstract phantasm.

His inner eye developed naturally from Chinese painting and gardening tradition, with the addition of Western visual theory. Chinese culture is derived from the superimposition of experience and

mental concepts. Expressing the combination of a series of visual-spatial experiences in the mind is intrinsic to the Chinese tradition. This is why one of Chen's paintings, which used Chinese calligraphic methods to express a dynamic impression of a football match, greatly moved one Western critic. The work that gained him fame, *Kolo Shang & Chung King* (1952), successfully uses Chinese landscape painting methods to depict an impression of a city set among mountains. However, if he had never studied architecture and had never been influenced by modern visual theory, he could not possibly have used what modern people refer to as the isometric method, incorporating Chinese ink painting and transforming a flat surface into an emotionally stirring painting. His eyes were those of an architect, his inner world an architect's imagination.

Let us consider for a minute Chen Chi-kwan's perspective chart of the Tunghai girls' dormitories. This illustration is in reality a picture, not an engineering diagram. It is different from a painting only in that it is done to scale, and it is rendered with measuring instruments. If interpreted from an ancient Chinese perspective, this is an example of jiehua, a standardized method of illustration used by the ancients to draw maps.

This is why I consider the Tunghai girls' dormitory design a representative work of Chen Chi-kwan's early architectural career. It combines the creative principles of simplicity and rationality and the idea of fluid space found in modernism with the simple procedures and twisting changes of gardenscapes found in Chinese architecture, adding an imaginative element found in painting. It most likely was completed during the same period as *Kolo Shang & Chung King*.

What kind of art would result from visual impressions if divorced from a traditional Chinese spatial perspective? Actually, Chen Chi-kwan achieved this in his *Piazza San Marco*, completed in the mid-1950s. I'm sure that he was influenced by the abstract impressionism prevalent in New York at that time. He used the method of applying colors to the back of the paper, dying his traditional xuan calligraphic paper in a way reminiscent of oil painting. The pigeons in the picture are painted with a traditional Chinese brush. Mr. Chen liked this kind of painting very much, so he painted several of them, using Venice as the subject matter. However, in these other paintings, waves of water took the place of pigeons. Up until the 1960s, when he began to teach at Tunghai University, he painted a considerable number of scenes from foreign countries using this method.

III. The sublimation of nostalgia

But during the period when he taught at Tunghai University, his architectural views and the direction of his painting shifted dramatically. Perhaps because he had returned to a Chinese social environment, his emotional and intellectual identification with his homeland became more pronounced, and both his architecture and his painting became noticeably more imaginative regarding Chinese garden spaces. In his painting, he began to unhesitantly portray garden scenes with slender, refined lines. In his architecture, he dispensed with the use of bricks, and began to design his gardens with walls made of lime. He developed a much clearer perspective on how to use traditional Chinese spatial concepts in both architecture and painting. Modernist overtones gradually faded, and traditional feelings and outlooks gradually came to the fore.

In his paintings, where he could freely express himself, he returned to landscapes, and began to further explore the visual world of his own mind. He began early on to paint imposing mountains and rocks. But at this time he began to express the landscapes in his mind through

shifting visual forms. Because his painting had originally begun from a visual perspective, I suggest that he was influenced by scenes he observed when flying in airplanes. Originally, the landscape paintings of ancient China were mental impressions, fantasized worlds. That was because they never had the genuine experience of flying over mountain ranges. What kinds of revelations has the airplane endowed our visual world?

Firstly, being able to fly swiftly from one location to another makes the earth feel smaller. If the experience of landing at an airport were added to a landscape painting, the result might be *Chen's Panorama* (1957). Mountains and rivers are suddenly piled closely on top of one another like wrinkles. This is what Chen Chi-kwan painted in the late 1950s.

The second revelation is the sensation stunt flyers experience of the sky and earth revolving around each other. This is not the experience of ordinary people; we can only gain a slight impression of this when an airplane turns sharply after takeoff to achieve its designated flight path. But the big-screen theaters in science museums often give us the feeling of flight in which the sky and the earth spin round and round. What would a natural landscape look like if viewed from a spinning aircraft? Perhaps this was the direction of thought in Chen Chi-kwan's later landscapes.

Finally, the swift movement of airplanes lets us experience day and night turned on their heads. I am not sure whether this point has had any influence on Chen Chi-kwan's thinking, but after the 1960s his paintings constantly featured the sun and the moon appearing at the same time. This leads me to feel that speed creating the juxtaposition of different time zones may have inspired his new mode of thought.

It appears that for him, viewing the world while flying was perhaps the most reasonable direction of thought for a Chinese painter to continue the tradition of Chinese painting. He very likely gained his understanding of the lay of mountains and rivers and his perspective on nature from writings on Chinese fengshui. Therefore, he has constantly produced this kind of work over the last 20 or 30 years. Among his paintings composed of long, slender lines, natural landscapes of shifting forms perhaps play the most dominant role, and indeed may be described as the main body of his work, in which he has invested the greatest amount of effort and thought.

Nevertheless, at the level of daily life, the garden is still his favorite subject.

Beginning in the 1980s, he has also reflected the influence of postmodernism. In his paintings, he returned to tradition to a greater extent, while simultaneously introducing a number of irrational elements. Particularly noteworthy is his fondness for strongly decorative methods that transform Chinese gardening spaces into dreamscapes. These developments have made the works of Chen Chi-kwan's later period more accessible to the general public and given them a greater ethnic flavor.

Both the spatial and decorative arrangement of the Chinese garden are the images closest to Chinese people's souls. This is why the Lin Family Gardens in Panchiao, Taipei County, have experienced an uninterrupted flow of visitors since they were opened to the public. The garden is everyone's dream. Historical records reveal that in ancient China, most private gardens were open to the public. So garden spaces are the collective memory of us all.

As a matter of coincidence, I completed the Nan Yuan ("Southern Garden") complex in 1985 - the very year that Chen Chi-kwan began

to make gardens the dominant motif of his paintings. Using highly poetic visual subjects and the special features of the gardens of southern China, particularly the interspersing and interpenetration of courtyards and arched doorways, combined with flowers in vases, bamboo curtains, Ming-style furniture and lattice windows, he has completed a good number of poetic and highly decorative works. Perhaps in order to reach a larger audience, he has produced many of these as prints, so that middle-class art aficionados have had the chance to purchase and collect them.

After mainland China opened up, many young artists of southern China began to use garden scenes as the subjects of their paintings, producing pictures that inspire a sense of nostalgia. These became quite popular with middle-class collectors. But Chen Chi-kwan's garden paintings are rendered through the conceptual perspective of an architect, constructed, as it were, with garden elements. Although both are gardens, they inhabit entirely different worlds.

IV. The liberation of curved lines

To look back to the creative achievements of Chen Chi-kwan, one would be remiss not to discuss Tunghai University's Luce Chapel. This is the most important work of Chen Chi-kwan's life. It is the greatest pride of his life, and also the greatest regret. Even recently, when rumors began circulating that the Taichung City government would build a road transecting the campus, the president of Tunghai University still invoked the name of I.M. Pei to block the project.

As I said in my introductory comments, if Mr. Pei stands firm, Mr. Chen has few means to challenge him. This is why today the cultural community places such importance on copyright.

As outside observers, how do we uncover the true author of this design? We must delve into the spirit of the work itself. As Chen Chi-kwan recalls the process of design back in those days, I.M. Pei contributed no opinions at all, but only at the initial conceptual stage presented the simple idea of a brick structure rising to a peak with an arched pinnacle. Looking at Mr. Pei's lifetime body of works, this sort of concept fits in very well with his style. If it had been built according to Mr. Pei's thoughts, it would have been a very special chapel. It would have counted as a modernized application of Western ecclesiastical architecture. But it certainly would not have had a Chinese feel.

The unique quality of Chinese art can be defined as rhythmic vitality and a sense of animation. Such a description sounds a little arcane, but as soon as one sees it, one can fully understand it right away. No one else achieves this effect in either painting or architecture. When I was young I did not believe this. But in the 1970s I went to London and saw the Chinese Pagoda in Kew Garden. I saw a number of Chinese-style buildings in the royal palaces of Continental Europe as well. Looking at each individual part, one would feel there was no difference, but the overall visual effect was awkward and rigid. Similarly, Chinese-style paintings by Westerners around the end of the Qing dynasty also lacked precisely the same thing: this animated sense of rhythm.

Chen Chi-kwan designed this chapel, and during the process many people contributed opinions. The process of determining the materials used was also circuitous, evolving from the initial choice of brick to wood, and finally to reinforced cement. But the true force was still the hidden rhythmic vitality that lay at its heart. Actually, the essence of rhythmic vitality in Chinese architecture is nothing more than the beneficial use of curved lines. Consider the early-period Tunghai campus. It is precisely because it lacked curved lines that Chinese

people could sense no traditional feeling in it. Of course, if curved lines are abused, they will inevitably result in triteness. How did the Luce Chapel succeed? Merely through the lively use of curved lines! This feature lay outside the purview of I.M. Pei's lifelong vocabulary. He has made many contributions in the field of architecture, but I would assess that the Luce Chapel was not his concept.

Chen Chi-kwan ingeniously arrived at a three-dimensional geometric shape, a shifting conoid. This was truly fortuitous. At the time, hyperbolic paraboloids were quite popular in the world of architecture, originally part of the pursuit of "rational shape." But changes in geometrical shapes are always regular, and cannot help but be repetitive and monotonous. Chen Chi-kwan divided his conoid into four segments, then pieced them back together, allowing the Luce Chapel to exhibit elegant curves within and without. It also created a "line of sky" allowing a marvelous lighting effect. Because it was a geometrical shape, it was regular and orderly both in design and construction. This was a magical, almost organic, harmony of geometry and utility. When I.M. Pei visited Tunghai, he was pleased with this work, but felt it lacked thorough consideration of lighting, an insight to which I agree. But this sort of halfway floating cement teepee is not Pei's style. Mr. Pei likes buildings with a feeling of substance. As I recall, the photograph of the Luce Chapel hanging in his office is taken from a side view, showing two large walls. What he appreciated was not the elegant curved lines of the Luce Chapel, nor its dynamically empty rhythmic vitality.

V. The beauty of dynamic emptiness

Expressing the beauty of dynamic emptiness with the use of simple curved lines may be Mr. Chen's ultimate artistic achievement. Like all Western artists, Chen Chi-kwan likes to draw the female form. But even though he has painted the female body in a variety of poses, he was unable to blend an Oriental spirit into these paintings - until the latter 1970s, when he discovered an extremely simple method to portray the beauty of a woman's body, thus achieving a female form in an extremely Chinese mode. One of the earlier paintings of this ilk was *Torso*, which ingeniously used one simple line to sketch out a luxuriously proportioned, emotionally moving silhouette of part of a woman's body. This line demonstrated that many beautiful lines in human civilization are derived from the female form.

This line originally did not demarcate interior from exterior, neither did it have any substance of its own. Chen Chi-kwan ingeniously used a mosquito to clearly show that this line was the silhouette of a woman's body. This method of expression transformed an elaborate imagination into an abstract form of beauty charged with dynamic emptiness. To Chen Chi-kwan it was only a game he played with his brush, not the work to which he dedicated his greatest energies. Nevertheless, I feel that converting the humor of human life into an ingenious sense of beauty has always been the essence of Chen Chi-kwan's work. Expressing something profound with one or two simple lines is the best explanation of his understanding of architectural beauty and its full integration in his paintings.

I feel that in spirit, the simple, three-dimensional, geometrical curved lines of the Luce Chapel and the floating curved lines of his female forms are one and the same. Throughout his life, Chen's work has been elegant and refined, the work of a brilliant talent from southern China. He is not fond of lengthy essays. And thus, he has always grasped the spirit of Taoism, which is - as architects would phrase it - the substance of space. This is the essence of Chinese culture. Regretfully, although the young people of today look forward to the arrival of the "Chinese century," those who understand and intuitively appreciate the spirit of Chinese culture are few and far between.

東海心‧大度情

羅時瑋 /東海大學建築系副教授

前言

四十多年前，於台中市西郊大度山上，在一片紅土
荒野間，由美國基督教聯合董事會捐助成立東海大
學。當時邀請了貝聿銘、陳其寬與張肇康三位先生
負責校園規劃設計與施工，也引進那時台灣建築界
的新銳們（如華昌宜、漢寶德、胡宏述、李祖原
等），他們為這所新大學設計實現了前所未有的新
空間形式，至今在台灣似乎仍沒有其他大學的規劃
設計，能超越這種校園的格局與品味。

這個新大學中心校園區的配置，就顯出相當恢宏的
氣度。文理大道是教學區的主軸，除在入口處相對
地配置行政中心與(舊)圖書館外，文理工三學院錯
落開來配置在大道兩旁。教堂作為全校的精神中
心，卻不是佔在文理大道的軸線末端，而是讓開文
理大道的軸線，使文理大道上有開闊的視野，讓來
往師生可以無阻地看到遙遠的山脈與天空；教堂所
在之處，則擁有另一個獨立的天空與草地，提供教
學之外的自由遐想空間。光這一點，就讓人佩服當
年參與創校的基督徒與主持規劃的建築師，基督徒
們無私地贊助教育，建築師們也不諂媚當權者，以
今天來看要做到這樣是不太容易的。

這個大學的空間基調是素樸的、鄉野的，房子使用
的材料都是不加修飾的本來顏色，灰瓦、白牆、清
水磚牆、清水混凝土與各種樹木等構成一個單純內
斂的校園景觀，學校只是一人文舞台，人才是舞台
上的主角，所以走在校園裡，放眼所見，活動或不
活動的人是被凸顯的主體，校園是安靜的背景。
而校園處處顯露鄉野的趣味，不只房子與土地親切
的長在一起，如舊宗教中心、男女生宿舍等，很多
戶外的階梯、駁坎、矮牆等構造，以卵石、灰漿粗
砌而成，部份施作還逐漸沒入土裡，真正地落實天
人合一的理想，但今天回過頭來看這一切，還真切
合創校校訓「求真、篤信、力行」的質樸理念。

這些早期的東海校園建設，已是眾所公認的台灣近
代建築發展的重要里程碑，其中有些時代意義值得
溫習；今天東海大學面對內部擴張與外界競爭，亟
思因應轉型，也必須正視這些空間遺產，重新考量
其價值。只是對所有東海人以及喜愛東海的人而
言，東海校園讓人珍惜與懷念，在於它的與眾不
同，它是唯一，無可比擬；天地間只此一處，它是
讓人從生命根本處來學習的地方。

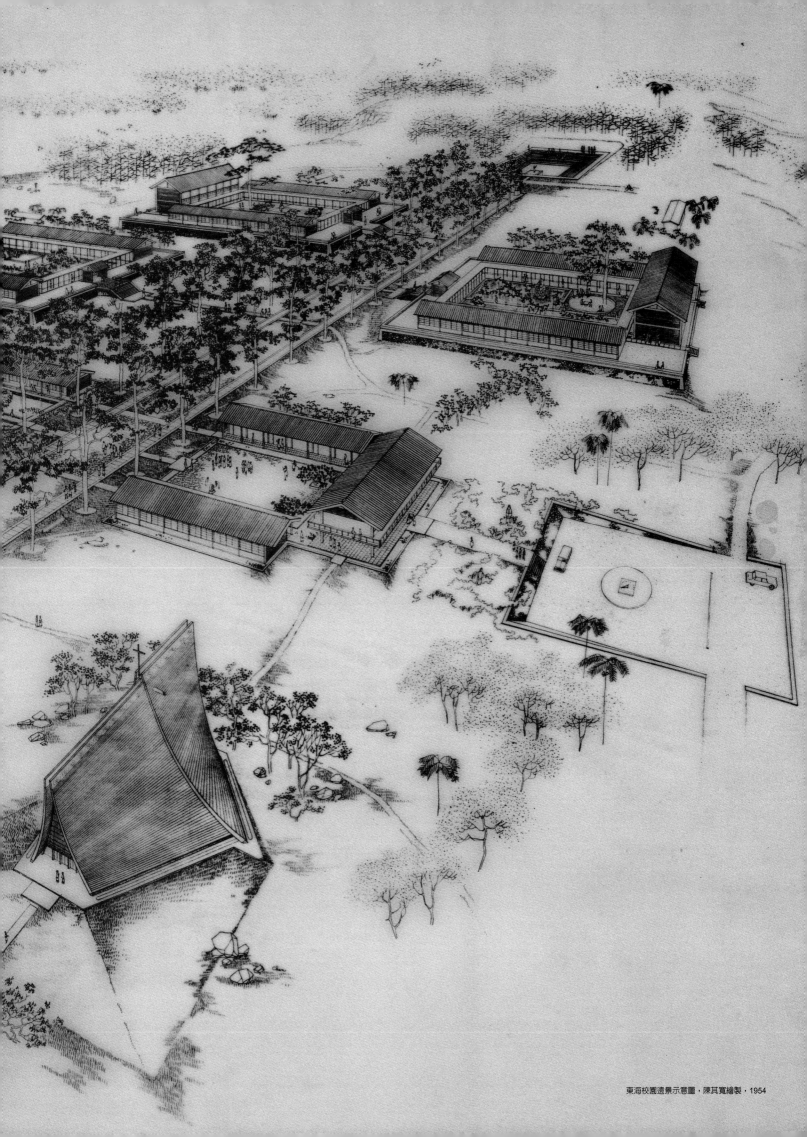

東海校園遠景示意圖，陳其寬繪製，1954

合院與迴廊

文理大道兩旁的合院建築群，包括文、理、工學院，圖書館 (今行政部門使用) 及行政大樓等，大道外還有男女生宿舍、學生活動中心等建築群和體育館等，構成早期校園主要建築空間，這些建築物的形式相當統一，皆是兩披水灰瓦屋頂、清水混凝土柱樑框架、正面開間為木質門窗與清水紅磚填滿側牆的作法，教學與行政部份皆採三合院形式配置，宿舍與活動中心則是各棟相互平行垂直錯落配置。文理大道連貫主要教學區與行政區，是大家最熟悉的地方，兩旁的榕樹經四十年成長，已是綠蔭夾道、清涼滿地，早期校友大概很難想像當年黃土飛揚的文理大道，今天可以綠的這麼飽滿。

余秋雨在「山居筆記」書中，寫他如何在文化大革命中「大串連」活動的一個夜晚，誤闖長沙岳麓書院，一開始他根本不知身在何處，只覺得在暗夜裡的牆與院落間：「也許…曾經允許停駐一顆顆獨立的靈魂，…這兒肯定出現過一種寧靜的聚會，一種無法言說的斯文，…這個庭院，不知怎麼撞到了我心靈深處連自己也不大知道的某個層面。」應該有很多人像我一樣，每次夜裡走過文理大道，逛進老學院的迴廊，都會感受到那種無法言說的斯文，禁不住遙想無數靈魂在此寧靜聚會的光與熱。四十年的東海自然無法與岳麓的千年滄桑比擬，但建築師的心靈深度，在空間的經驗中賦予千年的質地，讓人在庭院間只覺自在、從容，忘記了時間的差異，也忘記了外在世界的煩囂。

文理大道兩旁的合院建築群呈現東海校園空間最重要的美質一虛靜之美。水平線是最主要的線條，一條條長長的水平線，低低地壓近地平面，是一種貼地的實在與寧靜；水平的牆線、簷線、窗台線，與蚵曲伸張的榕樹枝椏，幾何的與自然的水平線，形成文理大道的獨特景觀。合院空間的虛透，使人走在文理大道上，看往學院的視線可一層層地穿透樹列、台階、門樓、迴廊、中庭，一直到最後面的二樓主屋立面，主屋與兩棟側屋間也不連接，可穿透到後面兩個小角落。每一合院建築間錯落配置，虛實相生，實中有虛，空間處處流暢，很少窒礙擁擠的地方。

然而虛中也有實，所有構造細部上的講究，與對材料本質表現的堅持，反映出一種篤實的精神。這種細部處理上的實在，使人接近建築時，產生一種觸覺的舒適，願意觸摸、貼靠、或坐或躺地使用這些建築。建築元素的表面也會積下塵泥，長出青苔，留下歲月的痕跡。就像大道旁的榕樹，這些合院與迴廊也似有生命，與活動其間的師生員工深情相守。

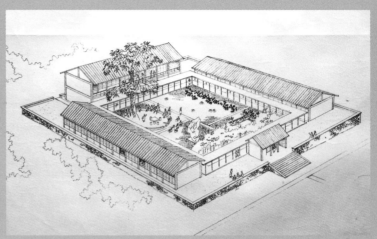

東海大學文學院，陳其寬繪製，1954

東海文理大道兩旁文理法學院透視圖 (西望)，陳其寬繪製，1954

東海大學文學院庭園與迴廊，陳其寬繪製，1954

教堂的曲線

東海教堂是大度山上的奇蹟降臨，一個偉大靈感的實現，一個無盡風情的姿態。它的設計與興建過程，已經成為建築史上的一則傳奇。它的粗胚，是年輕的陳其寬先生，在貝聿銘先生事務所以一個又一個的模型發展出來，期間加入貝先生及其他同事的各種意見，最後在圖書館找到圓錐雙曲面的幾何形式，才將設計初步定案。但具體的實現，還有待在台灣找到鳳後三先生做出結構計算，以及敬業的吳艮宗先生帶領光源營造廠的投入。據說在施工中吳老闆發現薄殼部份裡外兩層鋼筋間未標示繫筋，特地到台中市城隍廟擲筊求問，結果神筊落地，居然有一隻立著，不肯躺平；害吳老闆緊張地坐夜車趕上台北，找鳳先生商量，結果由吳老闆自掏腰包把繫筋補上。對後人而言，不管是雙曲面頂上的十字架，或城隍廟的筊示，都是至誠與天地感通的見證，是所有參與者的勇氣與創意的昇華。

在早年的校園裡，教堂是唯一的曲線，這曲線是它獨一無二的姿勢。它從地底拔起，優雅地旋向天空，以那麼複雜的曲面變化，來完成那麼單純的整體造型，它不但是一個工程上的饗宴，也是心靈上的境界。它的圍被與靈透，只有依靠當代技術才可完成，但技術與巧思之外的心靈意向，才是讓這教堂成為聖所的主要因素。

近四十年來，路思義教堂不只在大度山上吞吐日月精華，它更在所有東海人的記憶裡銘刻成永恆的意象，它是東海人走遍世界後心中的唯一。多少東海兒女，在霧濃的夜晚，將自己身影印上教堂牆面，許給自己一個縹緲的未來。將近四十次的子夜鐘聲，在教堂對面響起，從中送出多少祈禱，捎來多少福音；在那雙曲格子樑下，又有多少的人間幸福從這裡開始，多少尊貴的生命在此獲得安息。四十年人間種種成長的喜悅與哀傷，化成雙曲面的記憶；路思義教堂已是東海人的精神圖騰，神聖又深奧，暗藏著無數只有星星還記得的祕密。

在建築專業上，它是台灣在過去一百年來，少見的具創意性的傑作，但比起它在人心裡的份量，它是建築傑作的事實只是一個小小註腳。它是大度山生活的歸零點，所有人來到這裡都接近自己存在的原點，重拾與自己、與天地對話的習慣。

東海大學路思義教堂，1963，陳其寬拍攝

白牆的質感

一九六零年代在校區較外圍地區，由陳其寬先生主持設計，興建了好幾棟白牆圍塑的建築，如校長公館、招待所、舊建築系館、藝術中心 (今音樂系使用)、女性單身教職員宿舍 (簡稱女白宮) 等，這些建築皆是以白牆包被主要結構，形成其量體塑形特色。

最早完成的校長公館與招待所外裝形式，包括圓形陶管漏牆或屏牆、木質落地窗扇等，不只是一種本土構材的再發揮，也帶出很有家居味的生活想像。早期東海校園建築是一項「屋」的形式轉化的實驗，初期以清水混凝土框架、清水磚牆與兩批水屋頂做出新時代的「屋─院」的基本形式，而這兩棟白牆建築呈現的是「私」的新意境與新趣味；假如文理學院是東海校園中的「大調」音樂，校長公館與招待所這兩所與眾不同的白牆房子，則開啓了校園「小調」的序曲，這一步及之後的白牆建築，使校園空間多了細膩層次，使大度山不僅從荒蕪中闢出人文格局，而且自此更增嫵媚情境。

然而陳先生的貢獻不僅在新情調的引進，還把那一時代的創意帶進來，路思義教堂是偉大創意，舊建築系館與藝術中心也是創意傑作，尤其是藝術中心利用混凝土倒傘狀結構做出尺度動人的庭院，將現代結構形式與傳統合院建築類型巧妙地結合起來，加上月洞門與花瓶門的形狀，在現代空間體驗中也有思古之幽情。庭院與表演廳舞台間有一捲門，有時捲門拉起，庭院與表演廳則連通一起，室內外打成一氣的場景格外令人懷念；鋼琴獨奏會的清雅，現代舞表演的狂野，坐在室內或室外，各有不同享受。

此外女白宮 (女單身教職員宿舍) 也是一個有深度的作品，客餐廳利用坡地形勢做出的高差變化，是東海校園內的空間一絶；另有男白宮 (男單生教職員宿舍)，爲胡宏述先生設計，簡單經濟中也見不少巧思。這些早期白牆建築，是六零年代的美感經驗，就像當時盛行的水墨抽象畫，留白也是畫的重要部份，不畫而留白，白是空間，是虛的空間，與有畫的部份積極作用。白牆建築以白爲色，強調一種虛靈的情境，牆內的虛空間變化更是設計的重點。

斜角的嘗試

漢寶德先生在七零年代擔任系主任期間，設計與建視聽大樓與建築系館，陳邁先生也主持新餐廳 (今紅林餐廳) 的設計，這三棟建築是新一代的白牆建築，量體增大，形式風格也異於從前。視聽大樓與新餐廳對當時校園環境皆是叛逆之作，以45度與60度大斜角切出新的空間思維方向，建築系館西側也沿著45度斜軸鋸齒狀退縮，這些在東海校園都是全新的嘗試。前兩者皆圍出廣場，而且是硬鋪面廣場，這也是創舉，標示東海逐漸自鄉野型大學轉變爲都市型大學；它們提出了全新的公共空間形式，因爲廣場與庭院不同，庭院是讓人繞著走的，廣場則是引人走進去，而且可從四面八方走來走去。視聽大樓廣場在辦活動時就熱鬧起來，而餐廳廣場則成爲日常活動聚集場所，於是在原來銘賢堂旁邊鄉野型廣場之外，校園裡又多了兩處活絡的公共節點。

早期校園建築，使用有色瓷磚的只有教堂和校門立柱及警衛室，都用橙黃色瓷磚。視聽大樓與新餐廳首度使用與它們一樣的橙黃色瓷磚，打破校園裡教堂與校門獨尊的迷思，從此

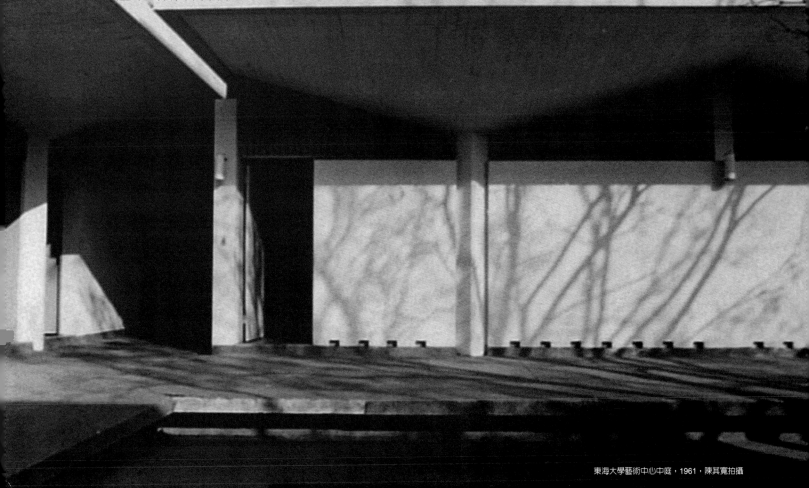

東海大學藝術中心中庭，1961，陳其寬拍攝

校園開始增添起橙黃的活潑色彩。它們在量體上的變化也是活潑的，它在外觀上完全擺脫傳統房屋的形式，再也不被斜屋頂或合院形式所拘限，斜的屋面與廊頂是量體切割的效果，而不是傳統屋頂的再現。可以說，視聽大樓與其後的新餐廳與建築系館，憑藉的是抽象的現代美感與合理主義。

為大度山立心

視聽大樓因過度老舊，已於2001年暑假拆除，原地正興建新的教學大樓。在拆除前校園內也曾因此事有過一段時間的爭論，試圖在發展與保存、滿足空間需求與維護環境品質間找到平衡點，這似乎是擁有美麗校園的大學，在發展導向的進程中無可避免的難題，但也因為有過那陣子的論辯，應作為校園空間資產的部分與可作為校園發展資源的部分，在東海人心中約略也交疊出共同的區劃版圖。

數年前有一晚，剛讀過近思錄，獨自走在校園裡，心中還想著橫渠先生的志向：「為天地立心，為生民立命…」；月下經過教堂，走過視聽大樓，走過行政大樓，走上文理大道，在走近工學院時，眼光飄向黯黯的學院迴廊，看到清水磚牆與混凝土柱圍出的門廊，突然心中一亮，被點起來；原來大度山本來無心，是東海大學給了它一個心，原來這山上莽莽蒼蒼、枯榮由天，原本無心也無情，只是當年那幾位懷抱理想的年輕前輩們，在這無心山上立下一片人文的心，從此這面山名為東海，以東海為心。

那一夜在東海校園，我稍稍體會到宋朝儒者的胸襟與意志。原來這社會本無心，人來人往、汲汲營營，但有志者就是要窮一己之力，為這樣的社會立下一個心；原來這天地本無心，天地不仁，以萬物為芻狗，但也要為這樣的天地立下一個心，要為天地找回仁心。這真是了不得的大志向，是何等莊嚴、強勢的積極意圖。東海大學立校之初，那些可敬的女士先生們，在有意無意間，為大度山做出不得了的改造，之後在歷任主其事者經營與維持下，在無數師生的護持下，大度山成為有心有情的世界。行政中心樓上，還掛有當年于右老的法書：「清夷君子風，博大聖人心」，東海之能成其為東海，蓋其來有自乎！

橫渠先生所謂「為學大益，在自求變化氣質」，而東海校園嘉惠無數東海人的精神資產即是作用在此，在就讀校園四五年，求得一技之長外，環境給予的薰陶，在潛移默化之中成就東海人的靈魂。這種由校園環境累積而成的精神資產，是真正人格教育的活水泉源；這樣的環境，放眼台灣，幾處能夠？東海心牽繫著一代代東海的讀書人，也維繫住向著大度山的情感，這份校園資產其實是無盡的大學資源啊！

（本文原載於「文訊」2003年四月號）

東海大學藝術中心屋頂，1961，陳其寬拍攝

The Heart of Tunghai, the Spirit of Tatu Mountain

Luo Shih-wei, Associate Professor of Architecture, Tunghai University

More than 40 years ago, on the slopes of Tatu Mountain in the western outskirts of Taichung City, on a stretch of barren, red soil, Tunghai University was founded, from donations by the United Board for Christian Higher Education in Asia. I.M. Pei, Chen Chi-kwan and Chang Jau-kang oversaw the planning, design and construction of the campus, and recruited several rising stars of Taiwanese architecture, such as Hua Chang-yi, Han Pao-te, Hu Heng-shu and CY Lee. For this new university, they designed and completed and new form of architectural space never seen before. To this day in Taiwan nearly no university's design can exceed this campus either in form or in taste.

The location of this new university's core campus area evinces a rather expansive air. The "Campus Mall" is the central axis of the campus's educational area. The entrance and exit areas are situated in coordination with the administrative center and the (old) library. In addition, the three Colleges of Arts, Science and Engineering are situated on either side of the Campus Mall. The chapel serves as the spiritual center of the entire campus. However, it does not stand at the extreme end of the Campus Mall's central line, but instead leaves it open, giving the Mall a broad and expansive field of vision, and allowing students and teachers walking back and forth to be able to view the faraway mountain range and sky without obstruction. The chapel occupies a separate patch of sky and an independent grassy area, providing a space for free reverie apart from educational activities. This point alone is cause for admiring both the Christian believers and the architects helping to plan the campus at that time. The religious organizers selflessly supported education, and the architects refrained from pandering to those in authority. From today's perspective, this was no meager achievement.

The spatial tone of this university is simple and rustic. The materials used on the grounds are in their original colors without added embellishments. Gray tiles, white walls, drywall and brick, drywall and cement, and various kinds of wood form a pure, minimalist visual theme for the campus. The school is merely a stage for the human drama; people are the main actors on that stage. What one sees when walking and looking around the campus is people. Human beings, either moving or at rest, are the main subjects that stand out; the campus is a quiet backdrop. Every part of the campus exudes an inviting countryside feel. The buildings and the land grow up together intimately, and such buildings as the old religious center and both the boys' and girls' dormitories feature many structures, such as outdoor stairways, terrace wall and low-lying walls, built of unpolished cobblestone and mortar. Some of the structures have sunken down into the soil, truly realizing the ideal of unity between nature and human beings. Moreover, in retrospect the entire design truly cleaves close to the simple idea of creating the school according to its motto "Seek the Truth, Keep the Faith, Act with Might."

The early-period Tunghai campus design has become generally recognized as a major milestone in contemporary Taiwanese architecture. Some aspects of significance to the age are worthy of review. Today Tunghai University faces internal expansion and external competition. While urgently considering ways to respond and transform itself, it must also focus on this architectural legacy, and reassess its value. Yet for all the people of Tunghai and those who love Tunghai, what is precious about the campus and what fills one with fond recollection is its uniqueness. It is one of a kind, incomparable.

There is only one place like it in the world. It is a place that allows people to learn rooted in the most fundamental elements of life.

Courted buildings and walkways

The group of courted buildings on either side of the Campus Mall includes the Colleges of Arts, Science and Engineering, the library (currently used as administrative offices) and the administration building. Along with buildings situated away from the Campus Mall such as the boys' and girls' dormitories, the student activity center and the gymnasium, they form the major architectural spaces of the early-period campus. These buildings possess a relatively unified architectural style. All have double-sloped gray tile roofs for draining water, pillars, beams and frames of drywall and cement, wooden doors and windows along the width of their facades, and side walls filled in with drywall and red brick. Classrooms and administrative offices are laid out in the form of three-sided buildings surrounding the court. The dormitories and activity center, however, are arranged in staggered positions relative to each other, both horizontally and vertically. The Campus Mall links together the two major areas - the classroom area and the administrative area. It is the place with which everyone is most familiar. Banyan trees have been growing on either side of the Campus Mall for 40 years, and already cover the area with cooling shade. Visitors to the campus in its early days probably could not have imagined that this Mall filled with flying dust at the time would today be so lush with greenery.

In his book Notes in a Mountain Villa, Yu Qiuyu writes how one night during a mass rally in the days of the Cultural Revolution, he mistakenly rushed into the Yuelu Academy in Changsha. At first he simply did not know where he was, but only felt the dark night in between the walls and the courtyard, in which "perhaps... once a long line of independent spirits were permitted to stop here... To be sure, a gathering of tranquility appeared here in the past, a kind of ineffable cultured refinement. It's hard to say how this courtyard collided with a deep level of my soul, of which even I was unaware." There are probably many people who feel like me every time I go to the Campus Mall at night and stroll into the walkways of the old classroom buildings, always sensing a certain inexpressible cultured refinement, irresistibly imagining countless spirits in the light and heat of this gathering of tranquility. Naturally, 40-year-old Tunghai cannot compare with Yuelu, which has weathered a thousand years, but the spiritual depth of the architects lends a millennia-old quality to its spatial experience, making one feel inside these courtyards completely content, relaxed and forgetful of the difference in time, forgetful of the noisy vexations of the outside world.

The groups of courted buildings on either side of the Campus Mall demonstrate the most important aesthetic quality of the Tunghai campus -- the beauty of still serenity. Horizontal lines are the principal linear form. One long, long horizontal line after another, pressing the horizontal plane down low to the ground -- a kind of substantive, quiet proximity to the earth. Horizontal walls, eaves and windowsills, the twisting, stretching branches of the banyan trees, and geometrical and natural horizontal lines form the unique visual elements of the Campus Mall. The open permeability of the courted buildings allow the line of sight of people walking along the Campus Mall to penetrate through multiple layers of tree rows, steps, doorway arches, walkways and

central courtyards, all the way to the very last two-floor courted building's front facade. The main section and the two side sections are not connected, so one can see all the way to the two little corners in the back. The irregular arrangement of every courted building creates an interplay of objects and emptiness, of emptiness in the midst of substance. Everywhere one looks, the spaces are fluid. Rarely are there any obstructions or cramped places.

Yet there is substance within the emptiness. All the care in the construction of detail and the insistence upon expressing the basic nature of the materials reflects a spirit of honesty. When one approaches these buildings, this substantiveness in the treatment of detail creates a kind of tactile comfort, a willingness to touch, to draw near to, or to use these buildings by sitting or lying down next to them. The surfaces of these architectural elements are also gathering dust and growing moss, leaving behind the marks of time. Just like the banyan trees at the sides of the Campus Mall, these courted buildings and colonnades seem to have life, to have deep emotions, to care for and receive care from the students, faculty and staff going about their business amongst them.

The curved lines of the chapel

The Luce Chapel was a miracle descended to Tatu Mountain, a great realization of inspiration, the expression of limitless grace. Its design and construction have already become a legend of architectural history. Its embryonic form was the brainchild of a young Chen Chi-kwan, working for the firm of I.M. Pei. Chen developed an entire series of models, and during this process Mr. Pei and other colleagues contributed a variety of opinions. Finally, in a library they arrived at the geometrical form of a cone with double curvilinear sides; only then did they agree on the preliminary design. However, the concrete realization in Taiwan still had to wait for Feng Hou-san to calculate the structure, and for Wu Lang-tsung, highly respected among his architect peers, to direct the Kuangyuan Construction Co. It is said that during the construction project Mr. Wu discovered that the rebar between the inner and outer layers of the shell was not tied, so he made a special trip to Chenghuang Temple in Taichung to toss divination blocks in search of advice from the spirits. In fact, the divination blocks spoke: one of the two blocks landed on its edge and did not lie flat - an omen that made Mr. Wu so anxious he took an overnight bus to Taipei City to discuss the problem with Mr. Feng. In the end Mr. Wu spent his own money to have the rebar reinforced. For those observing the structure after the fact, both the cross at the crest of the two curvilinear sides and the prophetic omens of Chenghuang Temple are testimonies to the sincerity and sensitivity to the ways of the universe of all who took part. They are sublimations of their courage and creativity.

The chapel contained the only curved lines in the original campus design. They graced the chapel with a pose unlike any other. It rises up from the ground and elegantly arches toward heaven, and with such complex changes in the curved surfaces completing such a simple overall design, it is not only a feast of engineering, but also a realm of the spirit. Its wrap-around design and inspired sense of permeability could only be achieved through contemporary technology, but beyond technology and ingenious design, its spiritual concept was what made this chapel the principal element of a holy place.

For the past 40 years, the Luce Chapel has not only swallowed up the essence of the sun and moon on Tatu Mountain, it has also been engraved as an eternal image in the memories of all the people of Tunghai University. It is the single thing in the hearts of Tunghai alumni as they go out into the world. How many sons and daughters of Tunghai, on a night thick with fog, have imprinted their own shadows

on the walls of the chapel, to wish for themselves a dreamlike future. Nearly 40 times the midnight bell has resounded opposite the chapel, sending forth countless prayers, and bringing countless tidings of joy. And underneath those two curved roof slopes, countless people's happiness began. Countless people's noble lives gained peace here. Through the joys and sorrows of 40 years, many different kinds of interpersonal growth have been transformed into memories of those twin curving surfaces. Luce Chapel has become the spiritual totem of Tunghai University. Holy and mysterious, it hides countless secrets that only the stars remember.

In terms of the profession of architecture, it is one of the few rare masterpieces of creativity to appear in Taiwan in the last one hundred years. But compared to the impact it has had on people's hearts, its status as an architectural masterpiece is only a tiny footnote. It is the fulcrum of life on Tatu Mountain. All who come here draw close to the point of origin of their own existence, and reacquire the habit of maintaining a dialogue with themselves, and with heaven and earth.

The texture of white walls

In the 1960s the university extended the campus. With Chen Chi-kwan acting as the principal designer, the team constructed many buildings encircled by white walls, such as the president's office, the reception hall, the old architecture department, the art center (used today by the music department), the dormitory for single female teachers (known simply as "the women's White House"), etc. All of these architectural designs wrapped white walls around the main structures of the buildings, giving them a special sense of volume.

The exterior structures of the president's office and the reception hall were the earliest to be completed. These included walls with patterned holes, some formed of round ceramic pipes, and wooden French doors. This figured not only as a new expression of native construction methods, but also as a highly imaginative lifestyle statement with a strong flavor of domesticity. The original Tunghai University campus architecture was an experiment in altering the form of the "house," an early, fundamental form of a "house-academy" for a new age, achieved through the use of drywall-and-cement frames, drywall-and-brick walls and double-sloped roofs. And these new white-walled buildings demonstrate a new meaning and appealing sensibility for what is "private." If the Colleges of Arts and Science were Tunghai University's "major key" musical theme, then the starkly contrasting white walls of the president's office and reception hall comprised the campus's "minor key" prelude. These white-walled buildings and those that came after gave the campus space a new, subtle layer, carving out the shape of civilized culture from the wilderness of Tatu Mountain, and adding to it an extra level of loveliness.

Nevertheless, Chen Chi-kwan's contribution was not limited to a new emotive tone: he also introduced many of the creative concepts of his era. The Luce Chapel is a great creation. The old architecture building and art center are also creative masterpieces. The art center's courtyard, formed by the use of a cement structure in an inverted parasol shape, is particularly moving, ingeniously merging modern structures and forms with the traditional Chinese courted building archetype. With the addition of perfectly circular "moon hole" doors and "flower vase" doors, a contemplative sense of antiquity has been added to this modern spatial experience. The courtyard and the stage of the performance hall are separated by a roll-down door. Whenever the rolling door is lifted, the courtyard and the performance wall are joined together. The sight of interior and exterior harmoniously blended together is the source of particularly fond memories. Whether one is taking in the elegance of a piano recital or the wild frenzy of a modern

dance performance, sitting either inside or outside is its own unique form of enjoyment.

In addition, the "women's White House" (single female teachers' dormitory) is also a work of considerable depth. The earth's sloping shape is used to produce a dramatic change between the dining hall and kitchen -- a unique accomplishment of spatial design on the Tunghai campus. Considerable ingenuities also readily apparent in the simple economy of the "men's White House" (single male teachers' dormitory), designed by Hu Heng-shu. These early-period white-walled buildings were an aesthetic experiment of the 1960s. Much like the abstract water-and-ink paintings in vogue at the time, intentional blank spaces are also an essential part of the picture: not painting, but instead leaving whiteness, using whiteness as unoccupied space, and making intensive use of the part of the painting where color is applied. The white color of these buildings emphasizes a realm of spiritual weightlessness. The changes of empty space within the walls are the central point of the design.

Experiments with oblique angles

In the 1970s when Han Pao-te served as architecture department director, he designed and oversaw construction of the audiovisual building and the architecture department. Mei Cheng also supported the design of the new cafeteria (today the Red Forest Restaurant). These three buildings were the new generation of white-walled architectural designs, larger in scale, and different from their predecessors both in form and style.

The audiovisual building and the new cafeteria were both works of rebellion against the campus environment of the day. With large oblique angles of 45 and 60 degrees, they carved out a new direction in thinking about spatial design. The western side of the architecture department also recedes along a serrated 45-degree oblique axis. These were all brand-new experiments on the Tunghai campus. The first two encircle plazas, and also hard paved. This was also unprecedented, and demonstrated that Tunghai was gradually evolving from a rural university to an urban university. They presented a completely new form of public space, because the plazas are different from courtyards, in that courtyards cause people to walk around them, while plazas invite people to walk through, and people can come and go from a number of different directions. When events are held at the audiovisual building plaza, it becomes animated with activity, and the cafeteria plaza has become a gathering place for everyday activities. Thus, in addition to the original pasture-like plaza next to Ming Cen Hall, two loosely defined public gathering points have been added to the campus.

Among the early campus architectural designs, only the chapel, the main columns of the university gate and the security guard house made use of colored (orange) tiles. The audiovisual building and the new cafeteria for the first time used the same orange tiles, breaking the campus superstition that the school buildings and the gate must remain distinct. From this point onward, the campus began to add lively hues of orange. Changes in volume also became livelier. Their exterior appearances completely broke free from traditional building forms. No longer were they restricted by the forms of sloped roofs or courted dwellings. The slanted roof surfaces and ridges achieved the effect of transecting volumes, and were not mere reincarnations of traditional roofs. It could be said that the audiovisual building, and the new cafeteria and architecture department building which followed it, derived from the abstract aesthetic of contemporary art and rationalism.

Hearts dedicated to Tatu Mountain

Because the audiovisual building became too old, it was torn down in 2001. A classroom building is currently being constructed in its place. Before it was torn down, a period of dispute went on at Tunghai, in an attempt to find a balancing point between development and preservation, and between fulfilling demands for space and preserving the quality of the environment. This seems to be an inevitable problem that a university with such a beautiful campus will encounter in managing development. However, because the university went through that period of debate, the people of Tunghai sketched out in their minds and formed a commonly held plan for how to differentiate between the part of the campus to be reserved as space and the part to be developed.

One night several years ago, I had just finished reading the Confucian classic Jin Si Lu ("Reflections on Things at Hand") and was walking alone through campus. My mind was still drawing upon the words of aspiration voiced by the Song-era Confucian Zhang Zai: "To dedicate my heart to the world, to dedicate my life to the people..." Underneath the moon, I passed the chapel. I walked by the audiovisual building, by the administrative building, along the Campus Mall. As I was approaching the College of Engineering, my eyes floated toward pitch-dark walkway, and saw its portico encircled by walls of drywall and brick and columns of cement. Suddenly, a light went off in my head. I realized that Tatu Mountain had no heart of its own -- Tunghai University had giving it a heart. I realized that the wild, untended greenery of this mountain had no heart and no feelings. It was only that in days gone by, those members of the previous generation in their youth embraced an ideal. On this unthinking mountain they erected a heart of humanity and culture. Thenceforth, the name and the heart of this mountain was Tunghai.

That night on the Tunghai campus I gained a slight comprehension of the aspirations and wishes of the Confucians of the Song dynasty. At first, society had no heart. People came and went, anxiously going about their business. But those with noble aspirations used up all their energies and dedicated their hearts to such a society. At first the world had no heart, and no benevolence. All the creatures of the world were worthless, expendable things. But it is for the sake of such a world that we must dedicate our hearts. We must regain the spirit of humanity for the sake of the world. This is a great, insuperable aspiration. It is such a solemn, powerful and active intention. When Tunghai University was first established, those ladies and gentlemen so worthy of respect, half intentionally and half unintentionally, made an extreme change to Tatu Mountain. Afterwards, through the efforts and insistence of those who planned and built the campus, and through the caregiving of countless teachers and students, Tatu Mountain became a world with a heart and with feelings. On a wall of the administrative center, there still hangs a work of calligraphy by Yu You-lao from those early years: "The pure ways of a good person, the heart of a sage." This is why Tunghai has been able to become Tunghai.

As Zhang Zai said, "To benefit greatly from learning, seek to change your own disposition." And the spiritual assets of the Tunghai campus that have benefited countless Tunghai people are made use of in this way. When students live on this campus for four or five years, they do more than gain the chance to learn - their souls also imperceptibly form, cultivated by their surroundings. These spiritual assets that have accumulated and changed in shape within the campus environment are the true fount of living water for cultivating character. How many places in Taiwan enjoy such conditions? The heart of Tunghai binds generation after generation of its alumni and its friends, and binds together our feelings toward Tatu Mountain. The assets of this campus are in fact the university's limitless resources!

圖版
Plates

山城泊頭 Market Day

陳其寬自1952年開始以業餘的畫家從事水墨創作,迄至1960年代,他在繪畫上進行不少的試驗,從較實景到較抽象,從高到低,從橫卷到長軸,從中國書法到西洋素描,都具有他個人的特徵。題材仍多是中國的,技巧則仍一半傳統、一半現代,觀點則接近西方,構成一種新的作風。此外,他更採用新的時空觀點來畫中國的山水,令人感受到生活趣味與純線條與色彩之美。《歌樂山與重慶》與《山城泊頭》同樣描繪重慶相同的景致,是根據在中國的回憶和中國山水的傳統演變而來,但都有極強烈的現代感,造型大膽而新鮮,自由的改變固有的時空觀念。

In 1952 Chen Chi-kwan began, as an amateur artist, to paint in water-and-ink. By the 1960s, he was exploring a wide variety of experimental painting styles, from realistic to relatively abstract, from low, horizontal paintings to long, vertical scrolls, from Chinese calligraphic methods to Western sketching - always rendered in his own unique manner. The materials he used were still principally Chinese, but his techniques were half traditional and half modern, while his perspective was closer to that of Western art. This combination of influences converged to form an altogether new style. Moreover, he painted Chinese landscapes with a new perspective of time and space, conveying the charm of life and the beauty of pure lines and colors. Kolo Shang & Chung King and Market Day both depict the same scenic viewpoint of Chungking, based on his memories of China, and using methods evolved from traditional Chinese landscape painting. However, both possess an intensely modern feeling, a bold and fresh creative form, and a freely shifting intrinsic viewpoint of space and time.

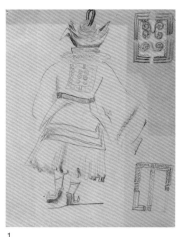

1

3

2

4

貴州苗族跳月服飾 - 1, 2, 3, 4
1944
色筆・紙本
21 x 17.7 公分 (1~3)
16 x 17.7 公分 (4)
藝術家自藏

Miao Tribes (I~IV)
1944
Pencil on paper
21 x 17.7 cm (1~3)
16 x 17.7 cm (4)
Collection of the Artist

滇緬印象 - 1, 2
1944
色筆・紙本
22 x 17.7 公分
藝術家自藏

Myitkyina, Burma (I, II)
1944
Pencil on paper
22 x 17.7 cm
Colloction of the Artist

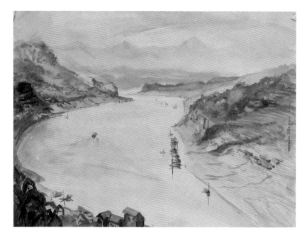

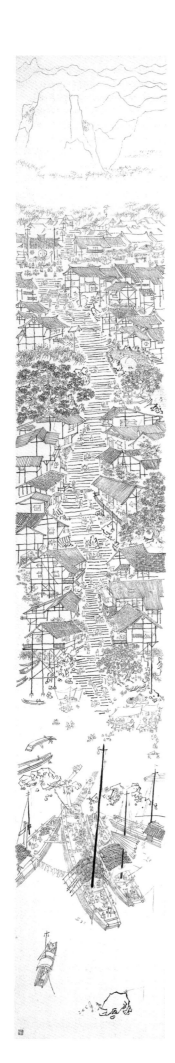

歌樂山與重慶
1952
水墨紙本
186 x 32 公分
藝術家自藏

Kolo Shang & Chung King
1952
Ink on paper
186 x 32 cm
Collection of the Artist

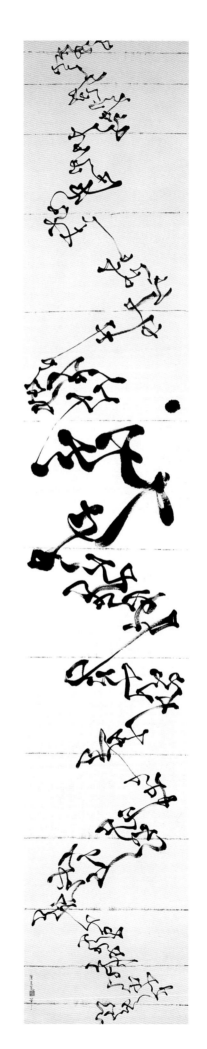

球賽 -5
1980
水墨紙本
186 x 30 公分
藝術家自藏

Ball Game (V)
1980
Ink on paper
186 x 30 cm
Collection of the
Artist

貼紙工
1957
水墨設色紙本
24 x 120 公分
國立台灣美術館典藏

Collage
1957
Ink and color on paper
24 x 120 cm
National Taiwan Museum of Fine Arts

威尼斯-2
1958
水墨設色紙本
120 x 24 公分
國立台灣美術館典藏

Venice (II)
1958
Ink and color on paper
120 x 24 cm
National Taiwan Museum of Fine Arts

有求必應-2
1958
水墨設色紙本
23 x 119 公分
水松石山房收藏

Faith (II)
1958
Ink and color on paper
23 x 119 cm
Shuisongshi Shanfang Collection

夕舟

1957
水墨設色紙本
120 x 30 cm
國立台灣美術館典藏

Evening Boat
1957
Ink and color on paper
120 x 30 cm
National Taiwan Museum of Fine Arts

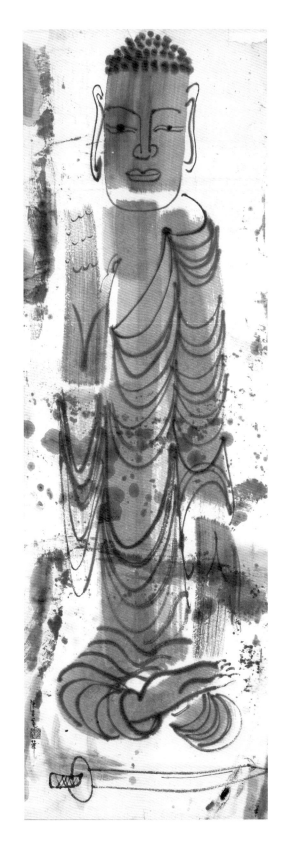

放下屠刀立地成佛
1959
水墨設色紙本
60 x 30 公分
藝術家自藏

Put Down Sword, Become Buddha Instantly
1959
Ink and color on paper
60 x 30 cm
Collection of the Artist

教堂
1960
水墨設色紙本
182.5 x 30.5 公分
水松石山房收藏

Cathedral
1960
Ink and color on paper
182.5 x 30.5 cm
Shuisongshi Shanfang Collection

燈節-2

1961
水墨設色紙本
30.5 x 120 公分
水松石山房收藏

Lantern Festival (II)

1961
Ink and color on paper
30.5 x 120 cm
Shuisongshi Shanfang
Collection

今夕是何夕
1961
水墨設色紙本
122 x 24 公分
水松石山房收藏

Heaven is Eternal
1961
Ink and color on paper
122 x 24 cm
Shuisongshi Shanfang Collection

仙源何處

1962
水墨設色紙本
92.5 x 22.5 公分
太平洋東方藝術公司

Where is Arcadia
1962
Ink and color on paper
92.5 x 22.5 cm
Pacific and Oriental Arts
Ltd.

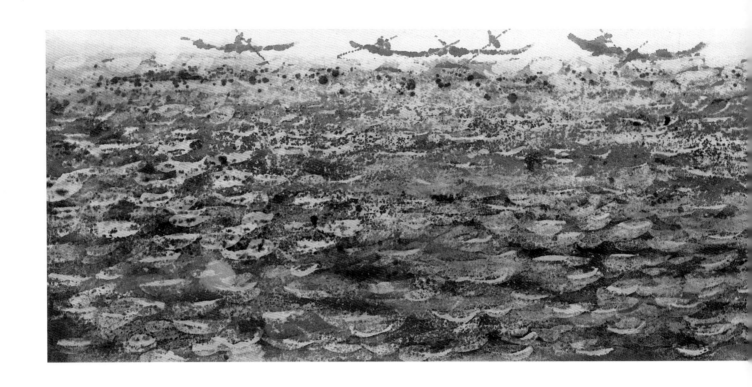

泛舟
1962
水墨設色紙本
22.5 x 91 公分
太平洋東方藝術公司

Afloat
1962
Ink and color on paper
22.5 x 91 cm
Pacific and Oriental Arts Ltd.

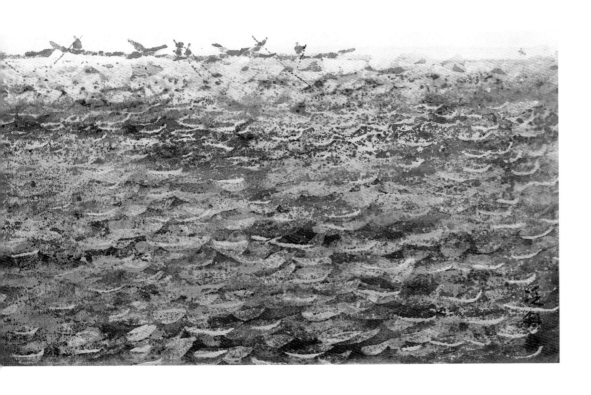

冰封
1965
水墨設色紙本
22.7 x 119 公分
太平洋東方藝術公司

Frost
1965
Ink and color on paper
22.7 x 119 cm
Pacific and Oriental Arts Ltd.

雪魚
1965
水墨設色紙本
120.5 x 22 公分
水松石山房收藏

Snowfish
1965
Ink and color on paper
120.5 x 22 cm
Shuisongshi Shanfang Collection

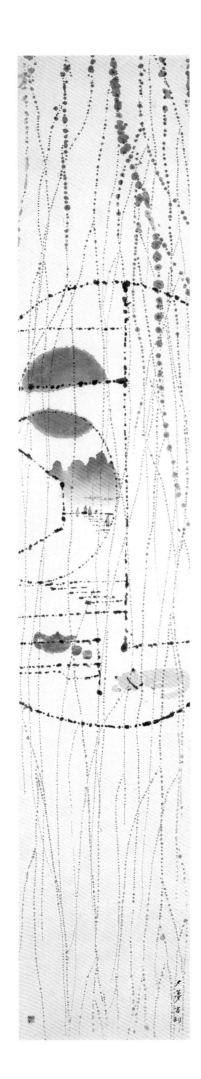

夕夢客別

1965
水墨設色紙本
121.5 x 22.2 公分
太平洋東方藝術公司

Farewell
1965
Ink and color on paper
121.5 x 22.2 cm
Pacific and Oriental Arts Ltd.

通衢
1967
水墨設色紙本
120.9 x 22.6 公分
水松石山房收藏

Thoroughfare
1967
Ink and color on paper
120.9 x 22.6 cm
Shuisongshi Shanfang
Collection

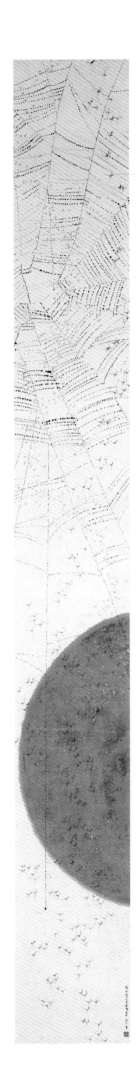

蜉�/蝣半日-1

1967
水墨設色紙本
183.5 x 23.5 公分
水松石山房收藏

Ephemera (I)
1967
Ink and color on paper
183.5 x 23.5 cm
Shuisongshi Shanfang Collection

沙
1973
水墨設色紙本
120 x 30 公分
藝術家自藏

Beach
1973
Ink and color on
paper
120 x 30 cm
Collection of the Artist

天旋地轉 Vertigo

八十年代，陳其寬的繪畫已有趨於史詩的傾向，經過了數十年對實景的抽象化與記憶印象化的追求，他又更深一層的探索宇宙的奧秘。陳其寬的畫達到了他所謂的「宏觀」的境界。「宏觀」也可說是一種宇宙觀。他想像自己似乎就飛翔在天空中，觀賞著地球、宇宙、日月星辰、早晚、晨昏的時節變化；是將「肉眼」及「物眼」昇華到「意眼」的階段。這種「宏觀」是他多年來擴大眼界的合理的發展。1957年的《縮地術》便有了這種感覺，把遠近景物全都「擠在一個平面上」，同時採用了多視點的效果。1967年的《迴旋#2》已由靜態的山水轉變成動態的宇宙，橫觀豎賞皆得宜。(李鑄晉)

In the 1980s, Chen Chi-kwan began to produce paintings of an epic nature. After several decades of attempting to portray realistic scenes abstractly and memories impressionistically, he began to explore the mysteries of the universe at an even deeper level. Chen Chi-kwan's paintings attained the level of a "macro-view" - a cosmological perspective. He imagined himself flying through space, observing the earth, the universe, the sun, moon and stars, the rhythmic variations of morning and night, dawn and dusk. This reflected a transformation from a "natural eye" to a "mechanical eye" and finally to a sublimated "inner eye." This "macro-view" was a rational development over several years in which Chen expanded his scope of vision. His Panorama of 1957 had this feeling, "squeezing" both distant and nearby scenes onto a single plane, and also employing the effect of multiple reference points. 1967's Vertigo #2 transformed the static state of landscapes into a dynamic universe, which looks right from every imaginable angle. (Li Chu-tsing)

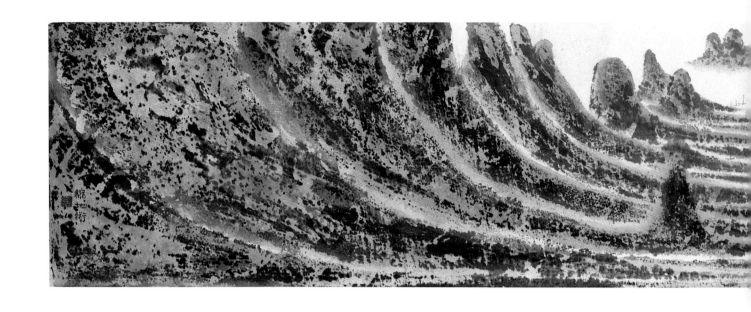

縮地術
1957
水墨設色紙本
23 x 122 cm
太平洋東方藝術公司

Panorama
1957
Ink and color on paper
23 x 122 cm
Pacific and Oriental Arts Ltd.

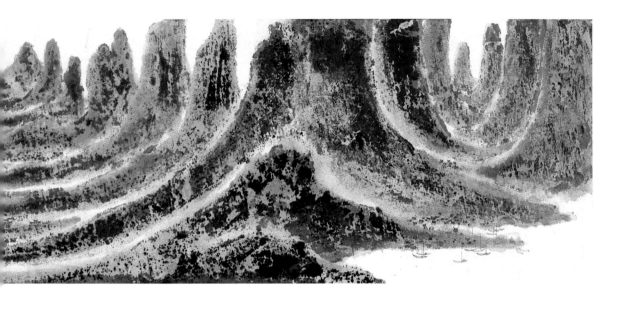

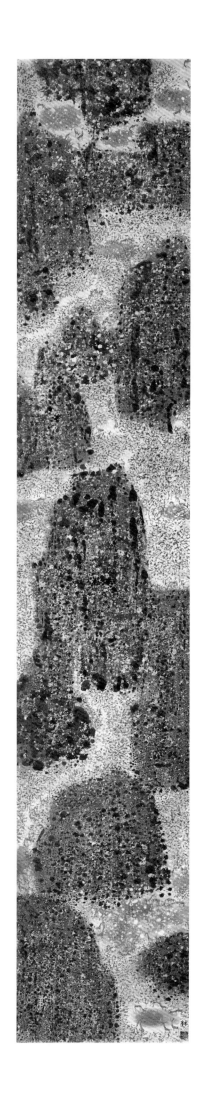

移

1964
水墨設色紙本
180.8 x 22 公分
水松石山房收藏

Wood

1964
Ink and color on paper
180.8 x 22 cm
Shuisongshi Shanfang Collection

山水之間

1966
水墨設色紙本
22.5 x 120.4 公分
水松石山房收藏

Monkeyscape
1966
Ink and color on paper
22.5 x 120.4 cm
Shuisongshi Shanfang Collection

澗

1966
水墨設色紙本
119 x 32 公分
水松石山房收藏

Gorge
1966
Ink and color on paper
119 x 32 cm
Shuisongshi Shanfang Collection

夢遊
1967
水墨設色紙本
183.5 x 22.3 公分
水松石山房收藏

Vision
1967
Ink and color on paper
183.5 x 22.3 cm
Shuisongshi Shanfang Collection

迴旋 #2
1967
水墨設色紙本
197 x 22 公分
水松石山房收藏

Vertigo #2
1967
Ink and color on paper
197 x 22 cm
Shuisongshi Shanfang Collection

飛
1983
水墨設色紙本
182 x 31 公分
私人收藏

Hovering
1983
Ink and color on
paper
31 x 182 cm
Private Collection

巔

1986
水墨設色紙本
186 x 32 公分
藝術家自藏

Watershed

1986
Ink and color on paper
186 x 32 cm
Collection of the Artist

遙
1988
水墨設色紙本
181 x 31 公分
藝術家自藏

Afar
1988
Ink and color on
paper
181 x 31 cm
Collection of the Artist

霧鳴

1988左右
水墨設色紙本
186 x 30 公分
水松石山房收藏

Sound of Fog

ca.1988
Ink and color on paper
186 x 30 cm
Shuisongshi Shanfang Collection

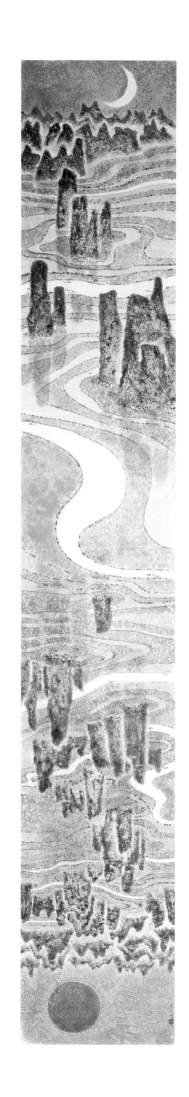

遠
1989
水墨設色紙本
186 x 30 公分
水松石山房收藏

Yon
1989
Ink and color on paper
186 x 30 cm
Shuisongshi Shanfang
Collection

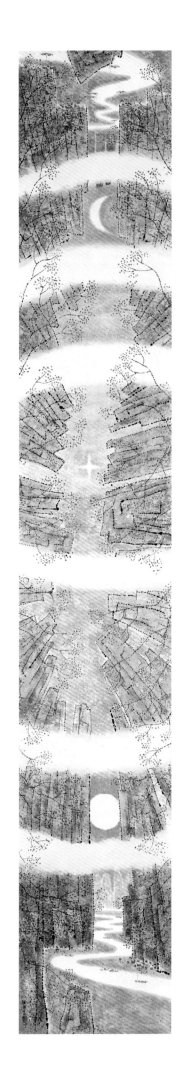

北辰

1991
水墨設色紙本
185 x 30 公分
藝術家自藏

Polaris

1991
Ink and color on paper
185 x 30 cm
Collection of the Artist

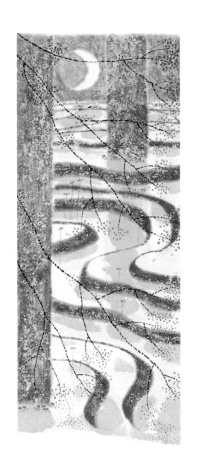

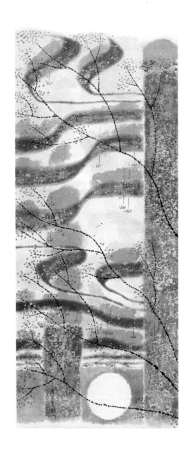

田外有田
1992
水墨設色紙本
185 x 30 公分
私人收藏

Field Beyond
1992
Ink and color on paper
185 x 30 cm
Private Collection

趕集
1994
水墨設色紙本
186 x 32 公分
藝術家自藏

Market Day
1994
Ink and color on paper
186 x 32 cm
Collection of the Artist

黃河之水天上來
1995
水墨設色紙本
186 x 32 公分
藝術家自藏

Yellow River from Heaven
1995
Ink and color on paper
186 x 32 cm
Collection of the Artist

天旋地轉

1996
水墨設色紙本
186 x 32 公分
藝術家自藏

Vertigo #3
1996
Ink and color on paper
186 x 32 cm
Collection of the Artist

地球村
1998
水墨設色紙本
186 x 32 公分
藝術家自藏

Floating Planet
1998
Ink and color on paper
186 x 32 cm
Collection of the Artist

洗凝脂 Bather

以簡單的曲線表現空靈的美感,可能是陳先生藝術的極致。陳先生與一切西方藝術家一樣喜歡畫女體,可是他雖畫過各種姿態的女體,卻沒法融合東方的精神於其中。到了七〇年代的後期,他發現了用極簡的方式表達女體美的效果,才在女體中找到中國的韻致。較早的一幅是《秀色可餐》,很巧妙的用一根簡單的線條,勾劃出豐滿動人讀女體輪廓的一部份。自這根線條可知,人類文明中很多美麗的線條是源自女體。(漢寶德)

Expressing the beauty of dynamic emptiness with the use of simple curved lines may be Mr. Chen's ultimate artistic achievement. Like all Western artists, Chen Chi-kwan likes to draw the female form. But even though he has painted the female body in a variety of poses, he was unable to blend an Oriental spirit into these paintings, until the latter 1970s, when he discovered an extremely simple method to portray the beauty of a woman's body, thus achieving a female form in an extremely Chinese mode. One of the earlier paintings of this ilk was Torso (1979) which ingeniously used one simple line to sketch out a luxuriously proportioned, emotionally moving silhouette of part of a woman's body. This line demonstrated that many beautiful lines in human civilization are derived from the female form. (Han Pao-teh)

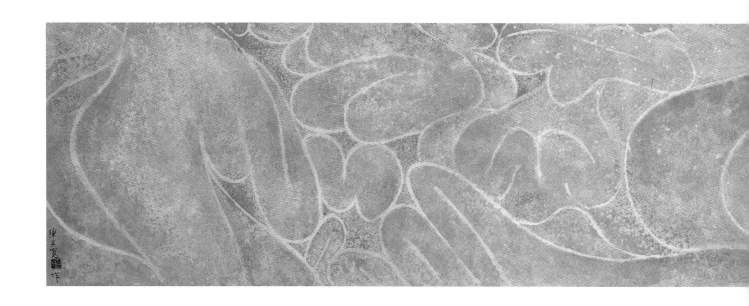

洗凝脂
1957
水墨設色紙本
23 x 120 公分
藝術家自藏

Bather
1957
Ink and color on paper
23 x 120 cm
Collection of the Artist

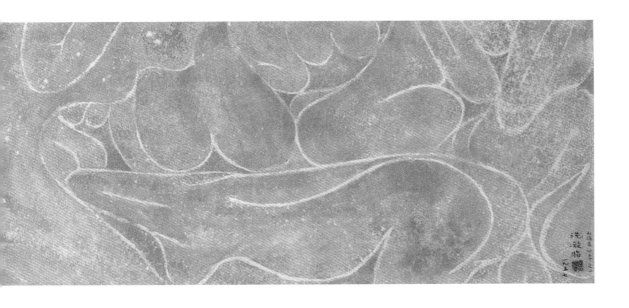

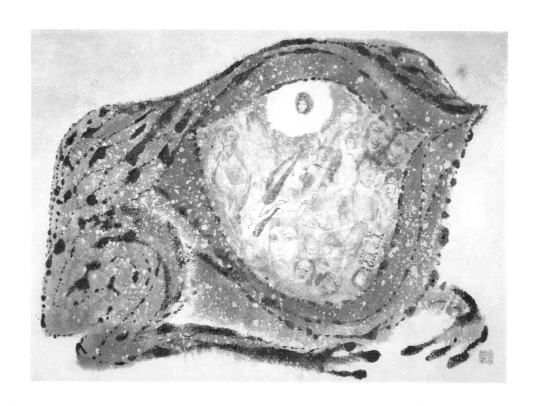

慾
1957
水墨設色紙本
23 x 30 公分
藝術家自藏

Lust
1957
Ink and color on paper
23 x 30 cm
Collection of the Artist

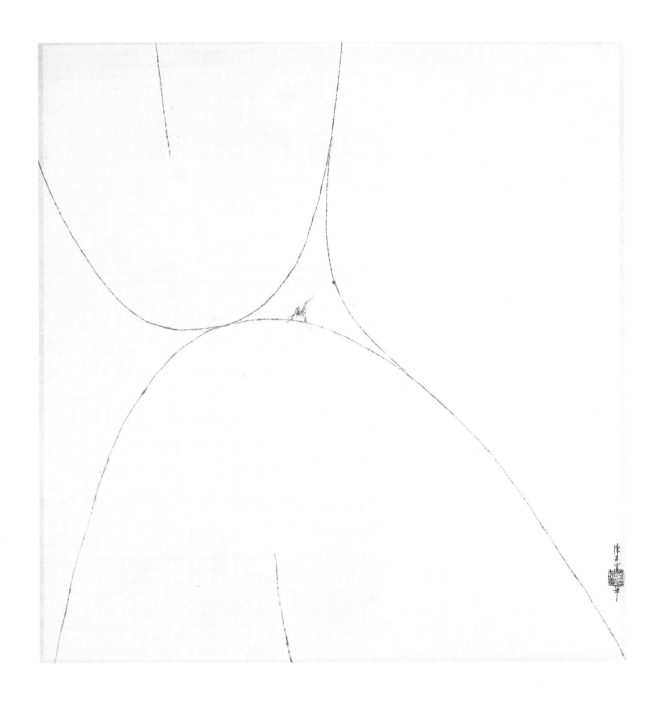

秀色可餐
1979
水墨設色紙本
35.9 x 36.7 公分
藝術家自藏

Torso
1979
Ink and color on paper
35.9 x 36.7 cm
Collection of the Artist

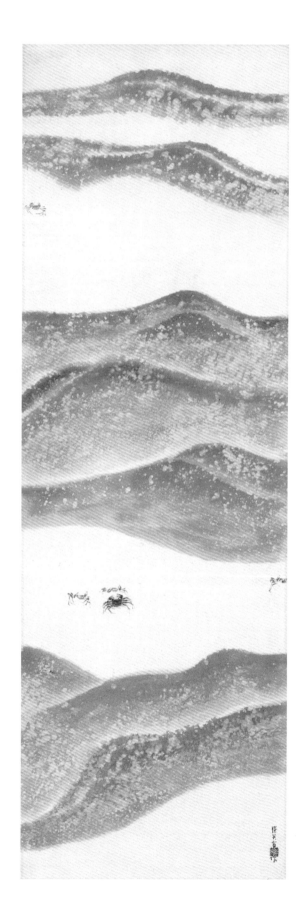

灘
1982
水墨設色紙本
92 x 30 公分
藝術家收藏

Beach Scene
1982
Ink and color on paper
92 x 30 cm
Collection of the Artist

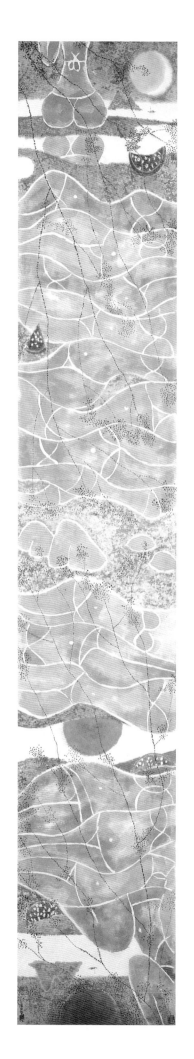

地景 No. 3
1994
水墨設色紙本
186 x 32 公分
藝術家自藏

Earth Form No.3
1994
Ink and color on paper
186 x 32 cm
Collection of the Artist

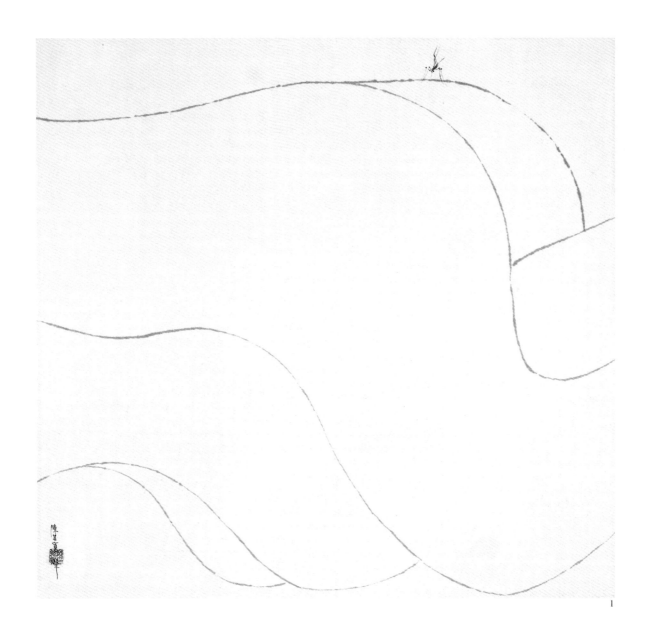

1

軀（上下左右）
1988
水墨紙本
35 x 36 公分
水松石山房收藏

Torso (I~IV)
1988
Ink on paper
35 x 36 cm
Shuisongshi Shanfang Collection

2

3

4

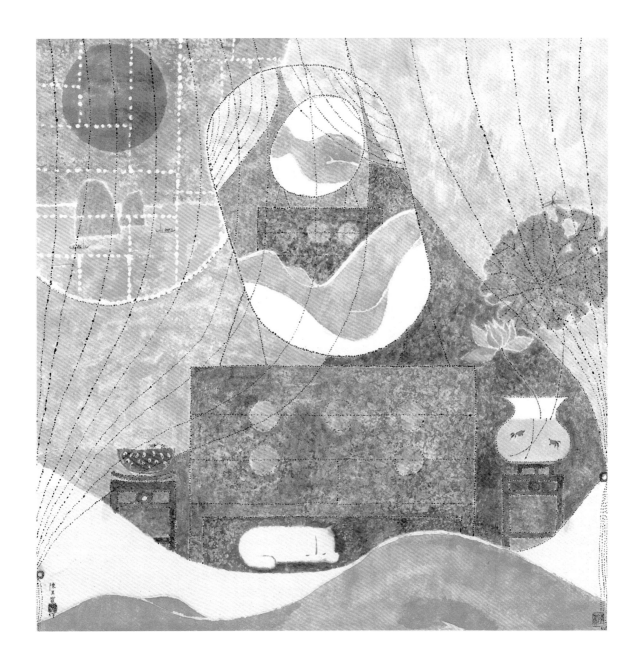

思凡
1998
水墨設色紙本
62 x 62 公分
藝術家自藏

Long for Things
1998
Ink and color on paper
62 x 62 cm
Collection of the Artist

世外桃源 Arcadia

《和平共存》是反映陳其寬的理想的作品。這也是一張方形的構圖，看似一幅普通的山水，中有一排山嶺峭壁，其間有瀑布，飛流直下，畫中充滿動物，悠遊於大自然中。《和平共存》是描寫一個理想的自由天地，一切動物都可快樂的共存於此環境中。這是陳其寬的理想境界。他也深深為人類社會永遠不能達到這種境界引以為憾。他也想用這張畫提醒世人要追求和平共處。(李鑄晉)

Peaceful Coexistence shows a primordial landscape of forest like mountains crossed by branch of trees. Although this looks somewhat like an ordinary landscape, on close examination one can find a large number of animals and birds enjoying their liver in this paradise. Peaceful Coexistence represents Chen's ideal land. With the regret that mankind has yet attained this idealized realm, Chen did this work at the time when the Communist world in Eastern Europe began to fall apart, an indication of the possibility for peaceful coexistence. (Li Chu-tsing)

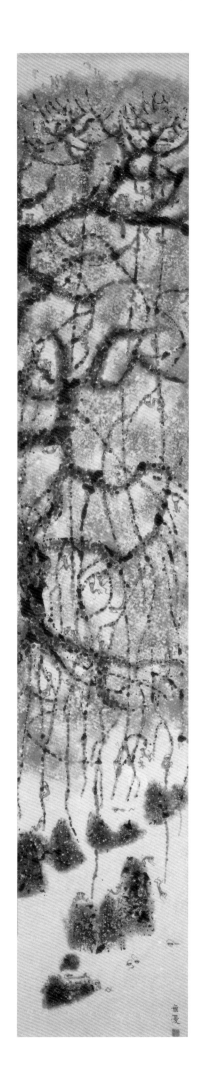

無憂
1965
水墨設色紙本
115 x 23 公分
私人收藏

Leisure
1965
Ink and color on paper
115 x 23 cm
Private Collection

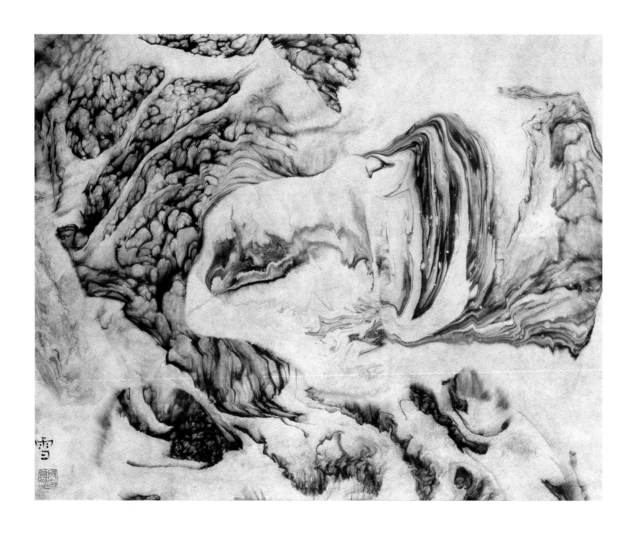

雪 -2
1973
水墨紙本
22 x 28 公分
藝術家自藏

Snow (II)
1973
Ink on paper
22 x 28 cm
Collection of the Artist

河套
1977
水墨設色紙本
23 x 30 公分
藝術家自藏

River Bend
1977
Ink and color on paper
23 x 30 cm
Collection of the Artist

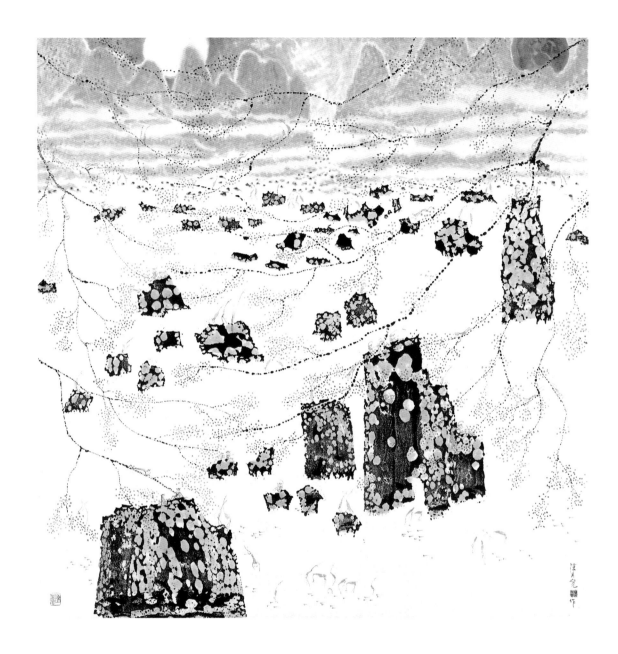

細水長流
1980
水墨設色紙本
68 x 69.5 公分
私人收藏

Long Last
1980
Ink and color on paper
68 x 69.5 cm
Private Collection

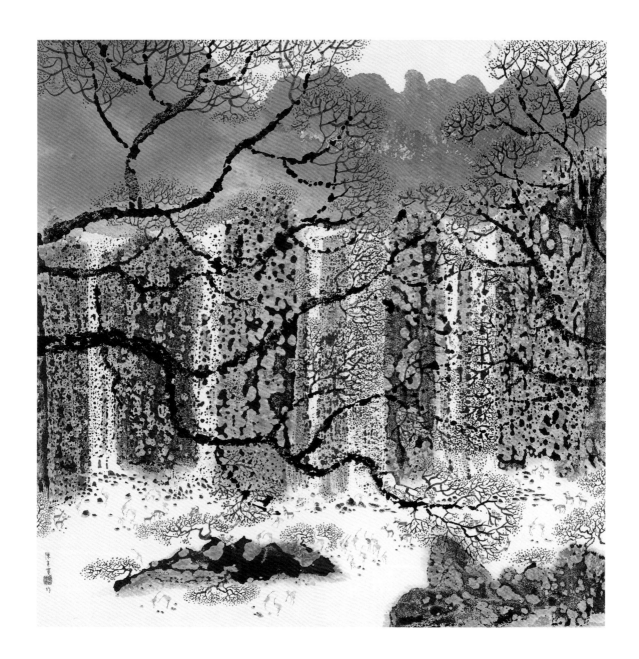

和平共存
1988
石印版畫
61.5 x 61.5 公分
藝術家自藏

Peaceful Coexistence
1988
Lithography
61.5 x 61.5 cm
Collection of the Artist

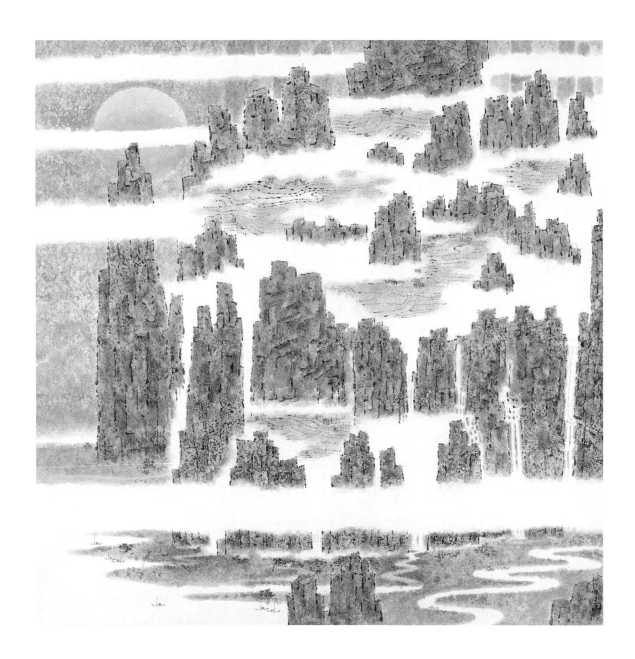

高原
1988
水墨設色紙本
61.5 x 61 公分
私人收藏

Plateau
1988
Ink and color on paper
61.5 x 61 cm
Private Collection

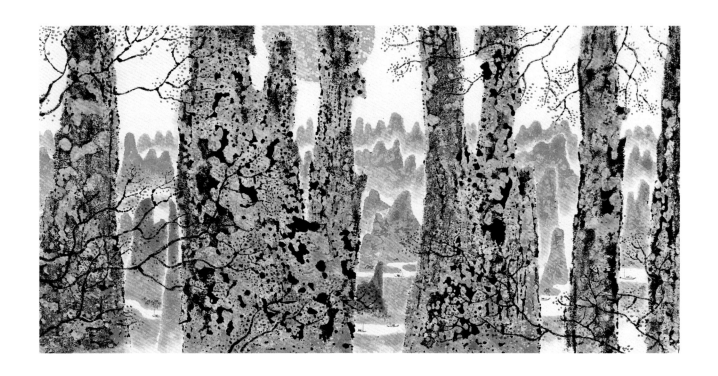

晴川

1990
水墨設色紙本
30 x 62 公分
藝術家自藏

Clear Day

1990
Ink and color on paper
30 x 62 cm
Collection of the Artist

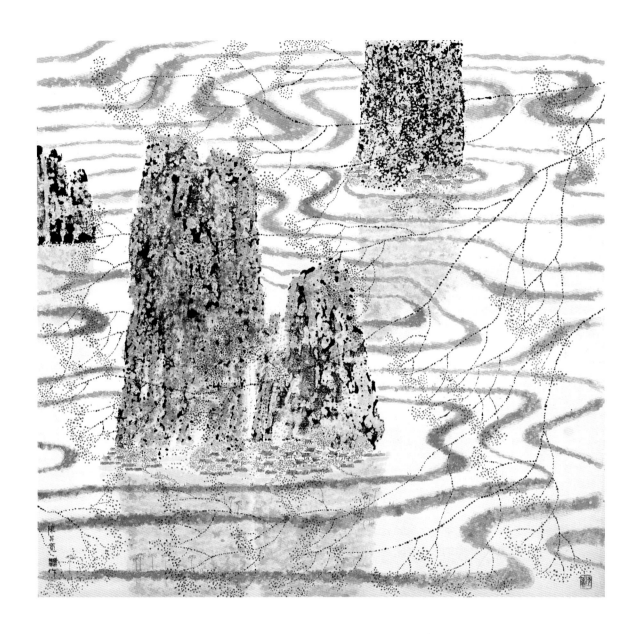

紫氣東來
1992
水墨設色紙本
60 x 62 公分
藝術家自藏

Fairyland
1992
Ink and color on paper
60 x 62 cm
Collection of the Artist

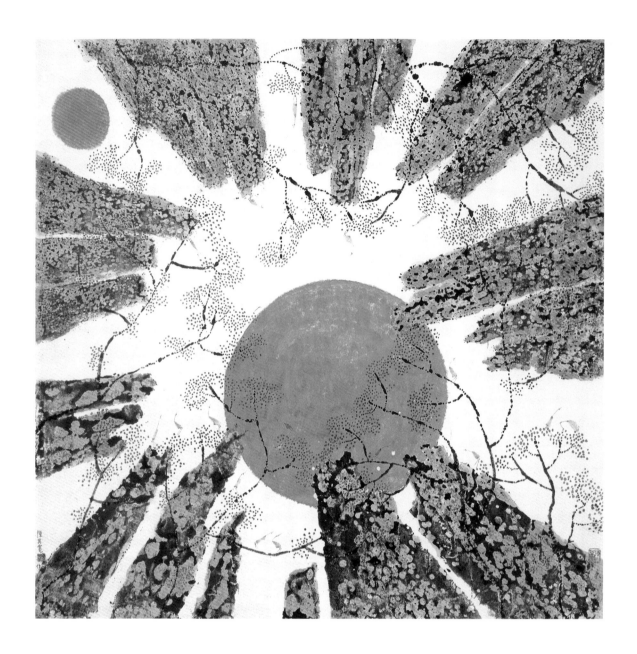

午陽

1995
水墨設色紙本
62 x 62 公分
藝術家自藏

Noon

1995
Ink and color on paper
62 x 62 cm
Collection of the Artist

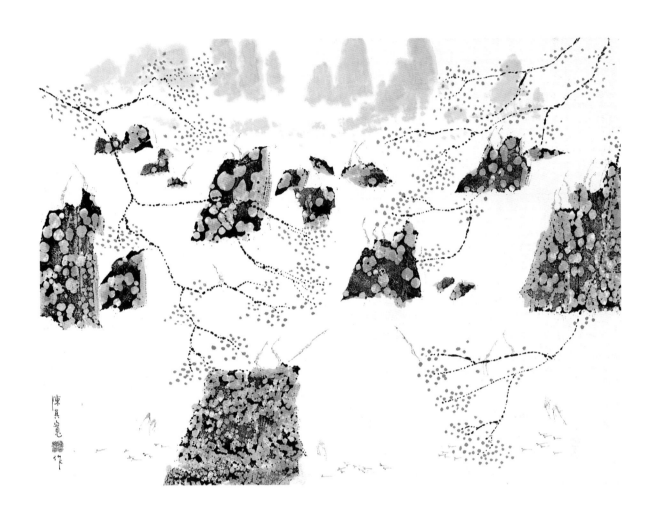

柏溪
1995
水墨設色紙本
34 x 46 公分
藝術家自藏

Stream
1995
Ink and color on paper
34 x 46 cm
Collection of the Artist

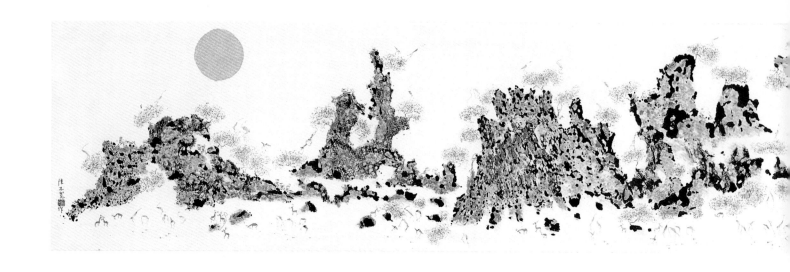

世外桃源
2002
水墨設色紙本
32 x186 公分
台北市立美術館典藏

Arcadia
1997
Ink and color on paper
32 x186 cm
Taipei Fine Arts Museum

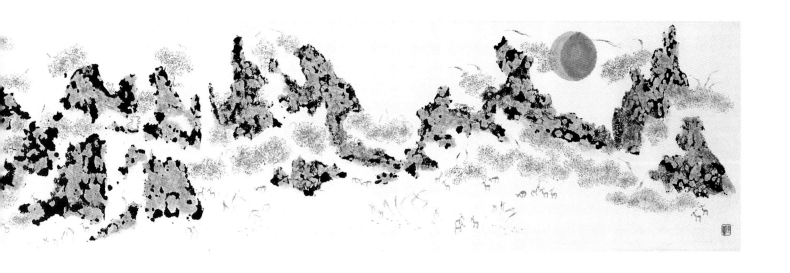

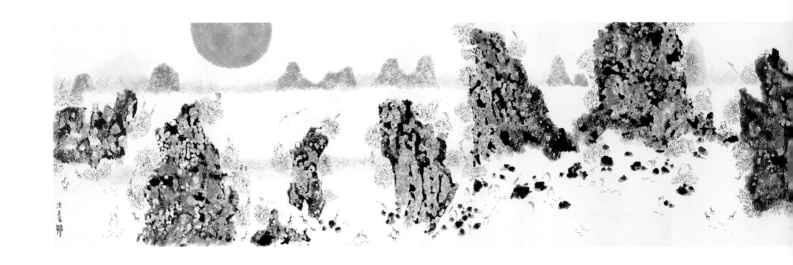

獨立共存
2001
水墨設色紙本
217.8 x 31.3 公分
藝術家自藏

Coexistence
2001
Ink and color on paper
217.8 x 31.3 cm
Collection of the Artist

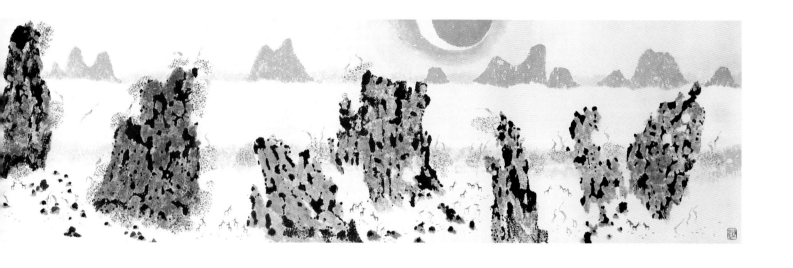

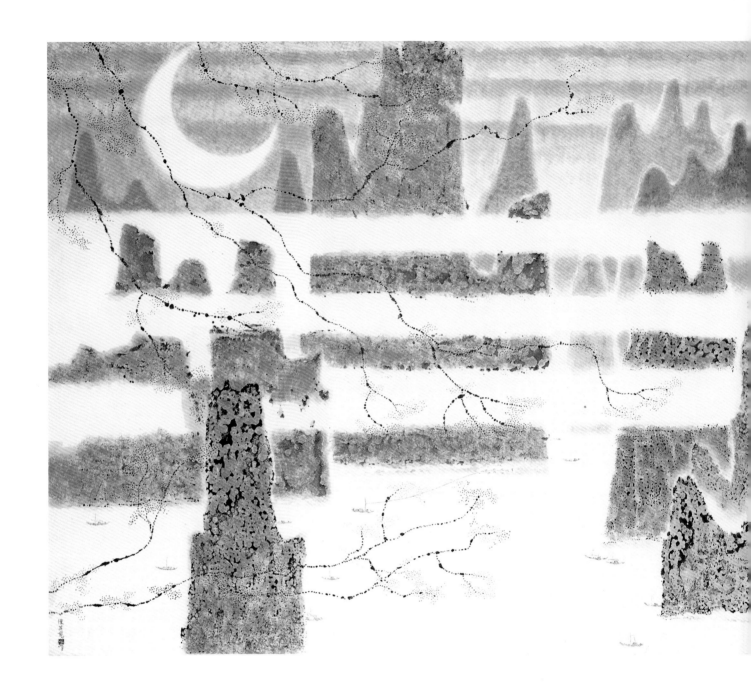

憶三峽1973
1996
水墨設色紙本
93 x 186 公分
私人收藏

Memory on Three Canals in 1973
1996
Ink and color on paper
93 x 186 cm
Private Collection

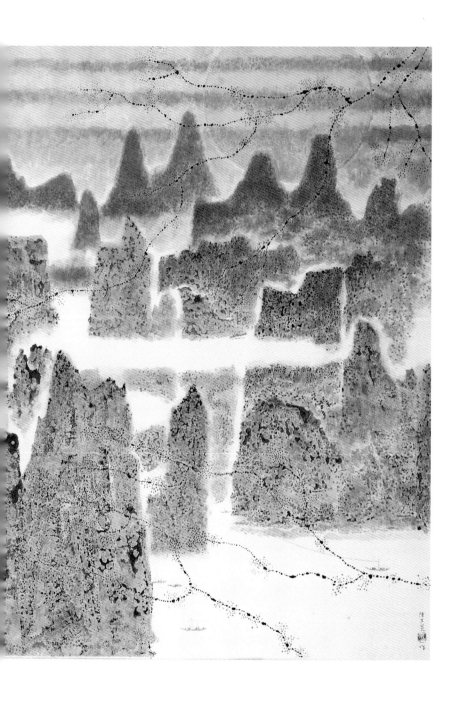

內外交融 Interpenetration

《陰陽》這幅畫是陳其寬以一位建築師的學識，構想出一座曲折的中國宅院，時而宅門，時而深院，時而房櫳，時而閨閣，時而曲池，時而遠山，時而夜月，時而朝陽…這是一個現代畫家設想、中國特有的樓臺庭宇，是現代人審美感覺下誕生的作品…這幅陰陽使人感覺到畫家只是運用東方人的思想感情、運用藝術感染，使人在簡練的線型、曲折和諧的節奏，在一種靜的空間，感受陰陽變化的美妙。(黃苗子)

The painting Yin Yang is Chen Chi-kwan's conceptualization of a twisting Chinese villa, based on his specialized knowledge as an architect. Gates, courtyards, windows, women's quarters, curving pools, distant mountains, the nighttime moon and the morning sun all appear here and there... These towers and dwellings, conceived by a modern painter in a uniquely Chinese style, constitute a work of truly modern aesthetic sensibilities... This painting Yin Yang makes one feel that Collection of the Artist is only using Oriental people's thinking and emotions, using the infectiousness of art, to make people feel the exquisite beauty of variations between Yin and Yang in the rhythmic interplay of minimalist lines and harmonious curves, in a kind of still space. (Huang Miaozi)

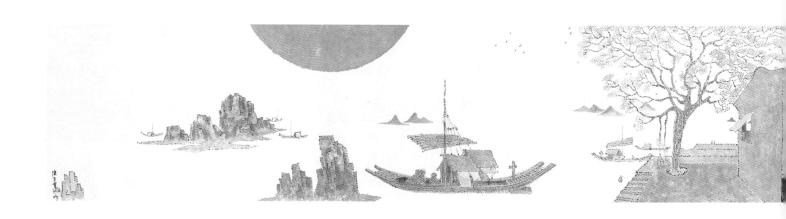

陰陽2

1985

水墨設色紙本

30 x 540 公分

藝術家自藏

Yin Yang No.2

1985

Ink and color on paper

30 x 540 cm

Collection of the Artist

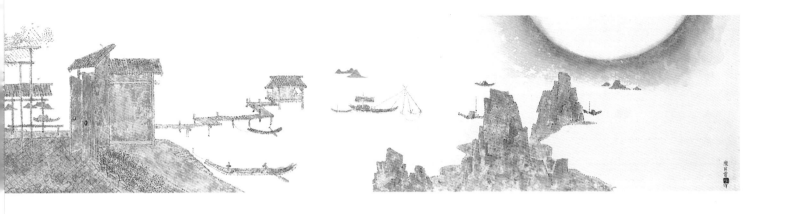

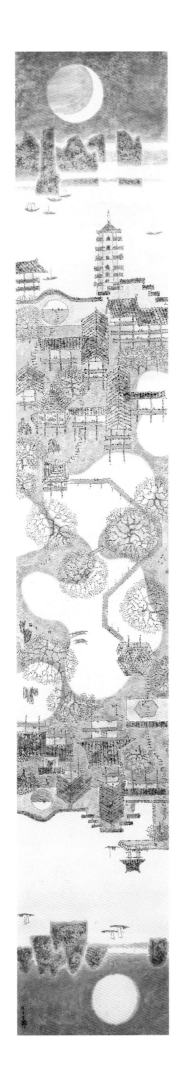

湖
1992
水墨設色紙本
186 x 30 公分
私人收藏

Lake
1992
Ink and color on paper
186 x 30 cm
Private Collection

雙境
1992
水墨設色紙本
186 x 32 公分
藝術家自藏

Antipole
1992
Ink and color on paper
186 x 32 cm
Collection of the Artist

內外交融

1993
水墨設色紙本
186 x 31 公分
藝術家自藏

Interpenetrat Tration
1993
Ink and color on paper
186 x 31 cm
Collection of the Artist

隱地
1995
水墨設色紙本
186 x 32 公分
私人收藏

Seclusion
1995
Ink and color on paper
186 x 32 cm
Private Collection

徑欲曲
1997
水墨設色紙本
186 x 32 公分
藝術家自藏

Path Tends to Bend
1997
Ink and color on paper
186 x 32 cm
Collection of the Artist

昇
1978
水墨設色紙本
60 x 60 公分
藝術家自藏

Ascend
1978
Ink and color on paper
60 x 60 cm
Collection of the Artist

深遠
1979
水墨設色紙本
62 x 62 公分
藝術家自藏

Depth
1979
Ink and color on paper
62 x 62 cm
Collection of the Artist

靜
1987
水墨設色紙本
62 x 62 公分
私人收藏

Quiescence
1987
Lithograph
62 x 62 cm
Private Collection

宴 - 3
1988
水墨設色紙本
32 x 62 公分
私人收藏

Banquet (III)
1988
Ink and color on paper
32 x 62 cm
Private Collection

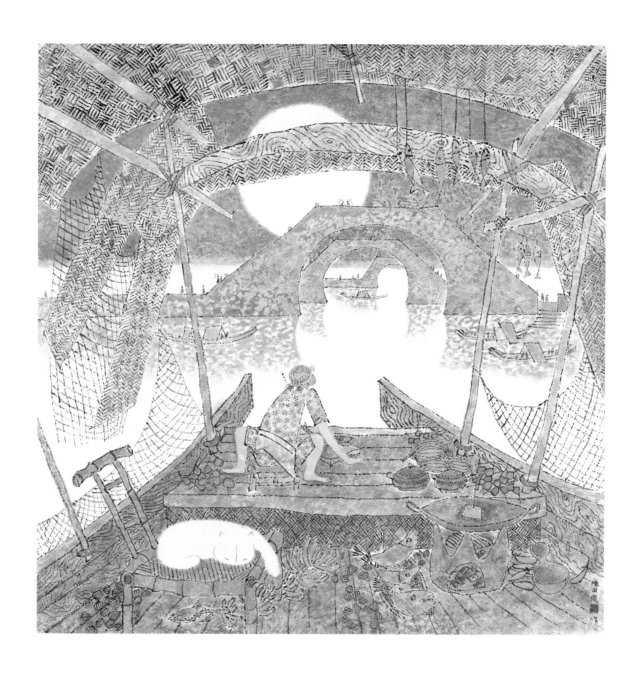

遙盼
1992
水墨設色紙本
62 x 62 公分
私人收藏

Longing
1992
Ink and color on paper
62 x 62 cm
Private Collection

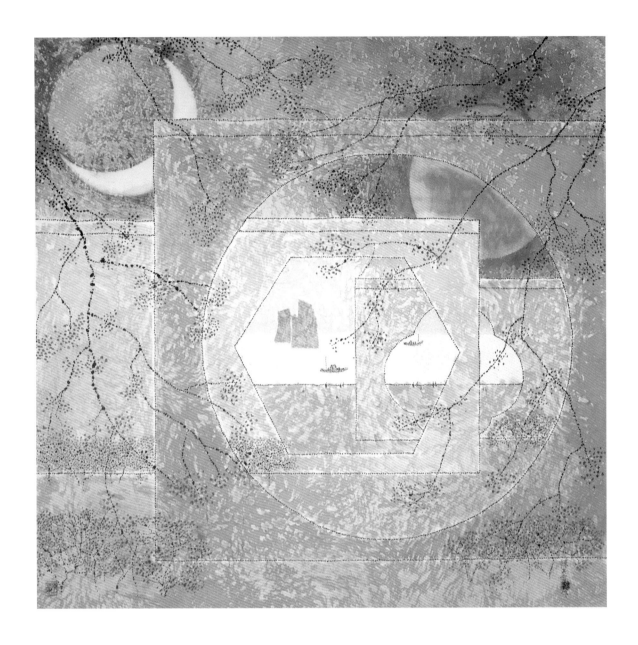

步移景動
1994
水墨設色紙本
62 x 62 公分
藝術家自藏

Moving Scenery
1994
Ink and color on paper
62 x 62 cm
Collection of the Artist

迷宮 Labyrinth

《迷宮》看似單純，實則複雜。缸的橢圓，窗的圓與太陽的圓構成了幾個相間的圓；與遠山的弧，荷葉的弧相共鳴，產生不少韻律感；將近與遠，室內與室外，有機與無機相交疊，形成「物物相關」之感。正如其英文標題：Labyrinth（即迷宮之意），引人遐思。

Labyrinth in the square form, uses the lotus root as the major motif to evoke the nostalgic felling of autumn in the area, and at the same time depicts the lotus flowers and leaves to express the traditional symbolic meaning of the lotus rising above the mundane world. All these show how much old China was in his mind.

影

1959

水墨設色紙本

120 x 24 cm

國立台灣美術館典藏

Shadow

1959

Ink and color on paper

120 x 24 cm

National Taiwan Museum of Fine Arts

立荷
1965
水墨設色紙本
121 x 23 公分
藝術家自藏

Lotus
1965
Ink and color on paper
121 x 23 cm
Collection of the Artist

生

1983
水墨設色紙本
67 x 34 公分
藝術家自藏

Life
1983
Ink and color on paper
67 x 34 cm
Collection of the Artist

雨 - 2
1989
水墨設色紙本
31 x 62 公分
台北市立美術館典藏

Rain (II)
1989
Ink and color on paper
31 x 62 cm
Taipei Fine Arts Museum

迷宮
1989
水墨設色紙本
61 x 61 公分
藝術家自藏

Labyrinth
1989
Ink and color on paper
61 x 61 cm
Collection of the Artist

荷雨-1
1990
水墨設色紙本
30 x 62 公分
藝術家自藏

Lotus Rain (I)
1990
Ink and color on paper
30 x 62 cm
Collection of the Artist

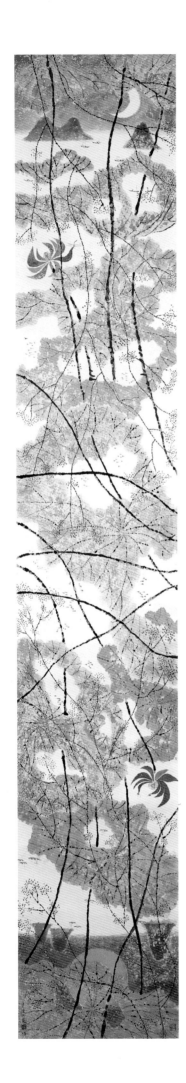

光陰過隙
1996
水墨設色紙本
186 x 32 公分
藝術家自藏

Time Goes By
1996
Ink and color on paper
186 x 32 cm
Collection of the Artist

墨戲 Play of Brushwork

猴子是他多年常用的題材……這種簡筆的方法,是他自己獨創的作
風,用猴子來反映人間的生活趣味。他的筆法運用自如,很簡單的點
出眾猴的表情……1967年的《眾生相》,就可說是這種題材的大成,其
百猴的狀態,洋洋大觀,有喜悅、嬉戲、幽默和純真,是他看人間的
縮影。其他的常見作風,是他的簡筆畫,一方面有禪宗的意味,另一
方面也有現代繪畫的抽象表現有關。(李鑄晉)

For many years, monkeys have frequently served as the subject matter of Chen
Chi-kwan's works... This simple painting method is his own unique style, in
which he uses monkeys to reflect the interesting features of human life. With
the free application of his painting method, he simply depicts the expressions of
a group of monkeys... 1967's Phase may be described as a very successful
application of this subject matter. Its presentation of a multitude of monkeys in
various poses is magnificent, demonstrating joy, playfulness, humor and naivete.
It is a reflection in miniature of his view of human society. Other oft-glimpsed
aspects include his simple brushwork, which demonstrates a Zenlike sensibility,
and is also related to the abstract expressions of modern painting. (Li Chu-tsing)

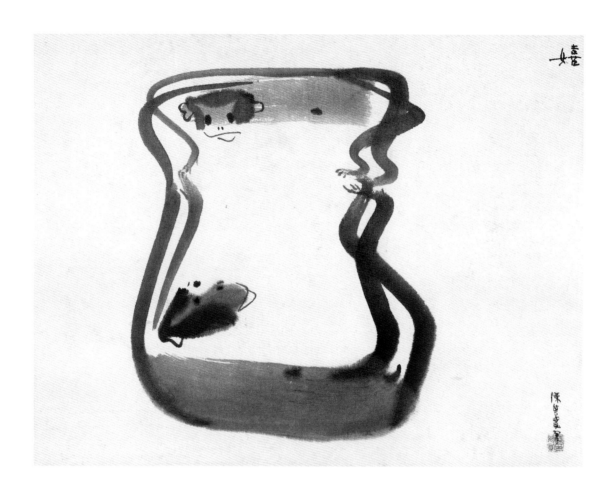

嬉
1957
水墨紙本
23 x 30 公分
藝術家自藏

Joy
1957
Ink on paper
23 x 30 cm
Collection of the Artist

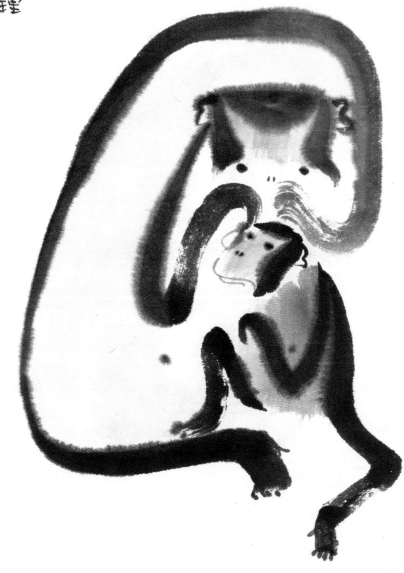

閒不住-2
1964
水墨紙本
30 x 23 公分
水松石山房收藏

Busy (II)
1964
Ink on paper
30 x 23 cm
Shuisongshi Shanfang Collection

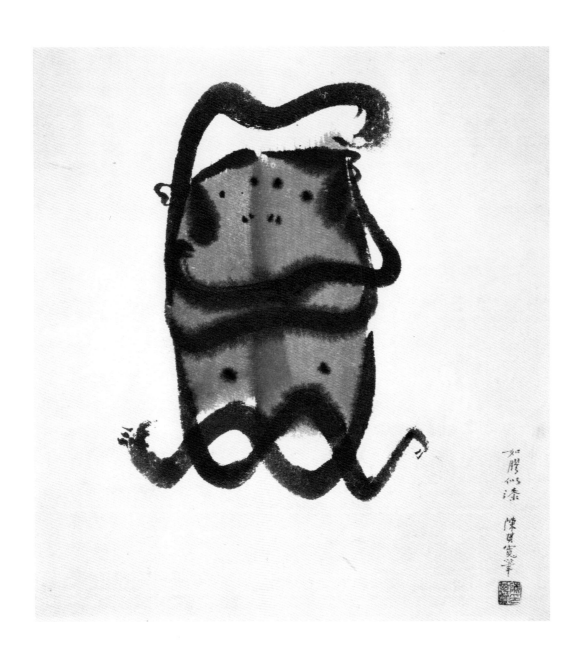

如膠似漆
1966
水墨紙本
23 x 22 公分
藝術家自藏

Tie
1966
Ink on paper
23 x 22 cm
Collection of the Artist

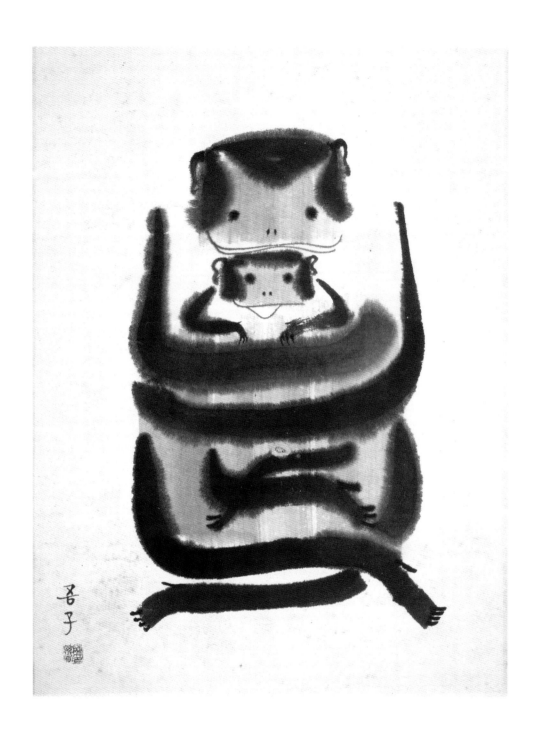

吾子
1967
水墨紙本
30 x 22.7 公分
水松石山房收藏

Son
1967
Ink on paper
30 x 22.7 cm
Shuisongshi Shanfang Collection

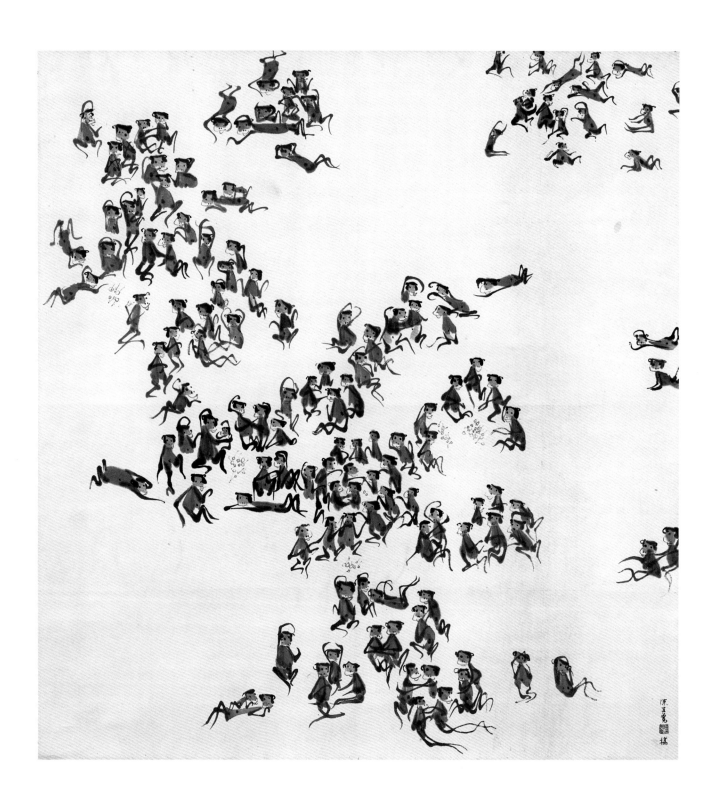

眾生相（稿）
1967
水墨紙本
70 x 65 公分
藝術家自藏

Phase (Sketch)
1967
Ink on paper
70 x 65 cm
Collection of the Artist

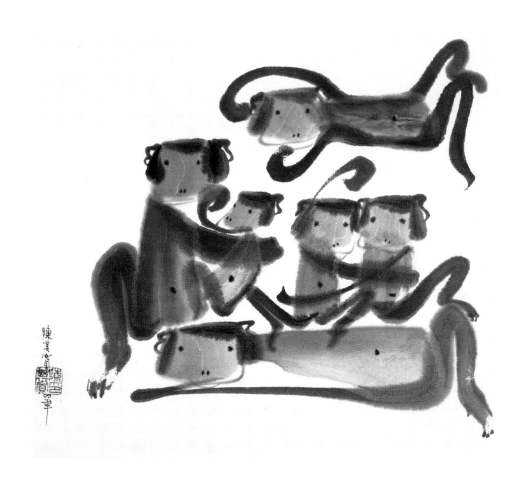

家（小是美）- 1
1968
水墨紙本
14 x 17 公分
藝術家自藏

Family (I)
1968
Ink on paper
14 x 17 cm
Collection of the Artist

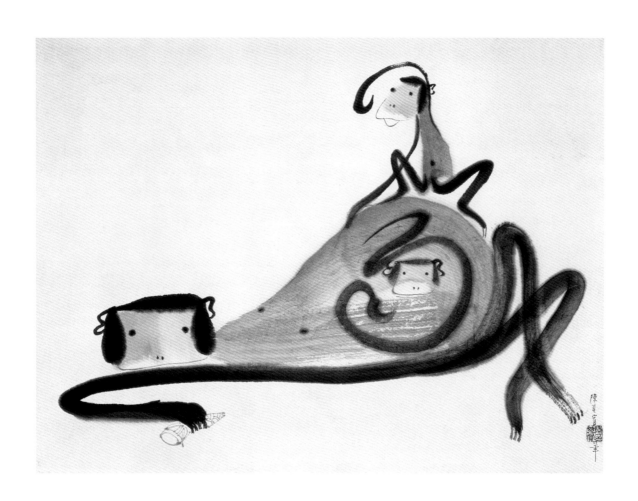

孕
1969
水墨紙本
25 x 34 公分
私人收藏

Conception
1969
Ink on paper
25 x 34 cm
Private Collection

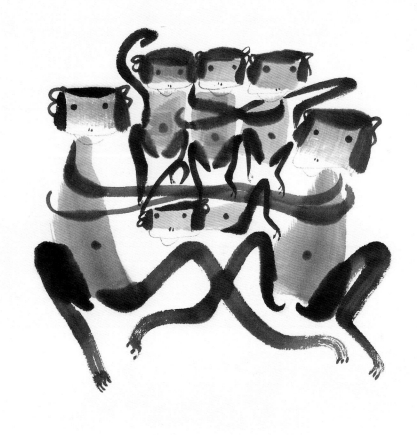

舉

1970年代
水墨紙本
26 x 31 公分
藝術家自藏

Lifting
1970s
Ink on paper
26 x 31 cm
Collection of the Artist

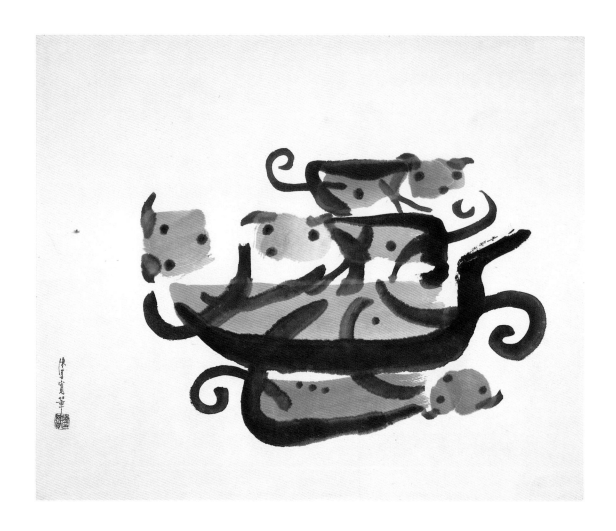

情
1970
水墨紙本
25 x 35 公分
藝術家自藏

Caress
1970
Ink on paper
25 x 35 cm
Collection of the Artist

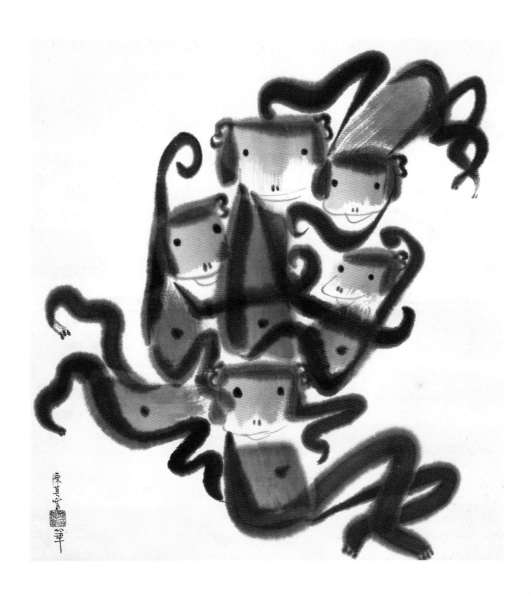

童心 -2
1979
水墨紙本
30.5 x 29 公分
藝術家自藏

Youth (II)
1979
Ink on paper
30.5 x 29 cm
Collection of the Artist

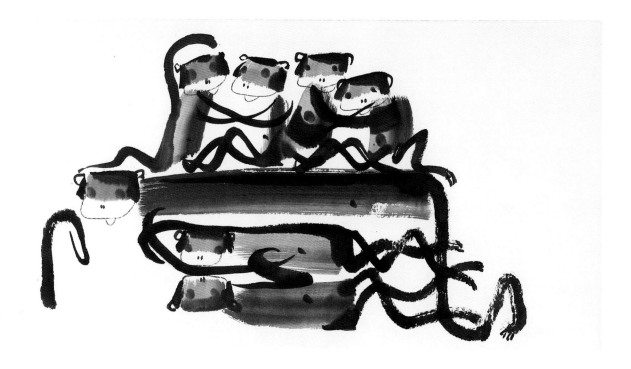

負擔-2
1980年代
水墨紙本
30 x 61 公分
藝術家自藏

Weight (II)
1980s
Ink on paper
30 x 61 cm
Collection of the Artist

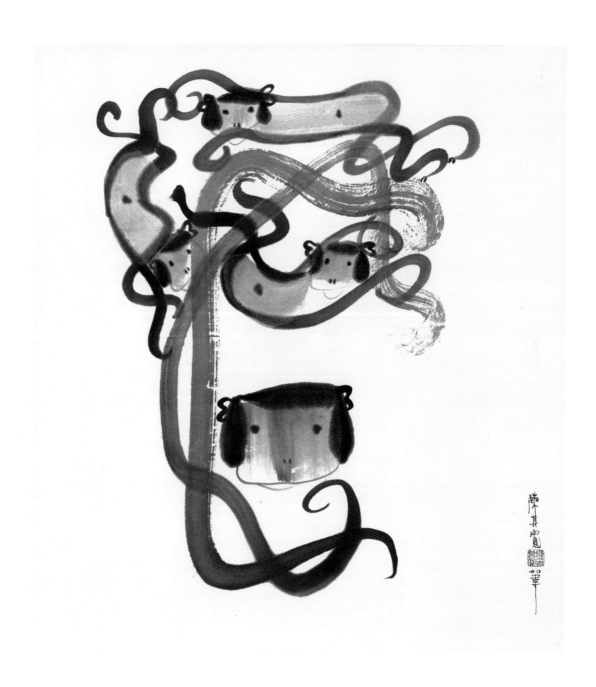

舞
1980
水墨紙本
34 x 31 公分
藝術家自藏

Acrobat
1980
Ink on paper
34 x 31 cm
Collection of the Artist

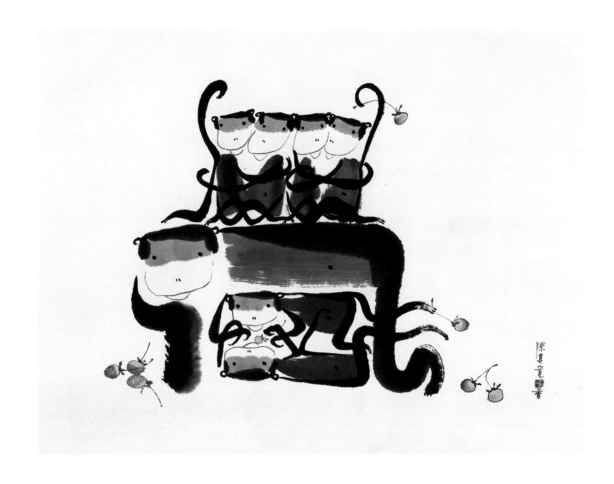

老奴 -2
1990
水墨局部設色紙本
45 x 48 公分
藝術家自藏

Supporting
1990
Ink and color on paper
45 x 48 cm
Collection of the Artist

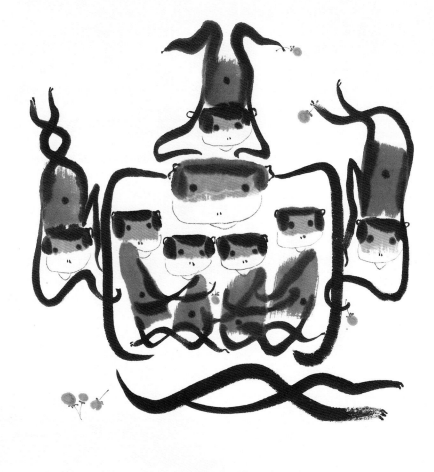

團聚

1990
水墨局部設色紙本
45.5 x 46 公分
私人收藏

Getting Together
1990
Ink and color on paper
45.5 x 46 cm
Private Collection

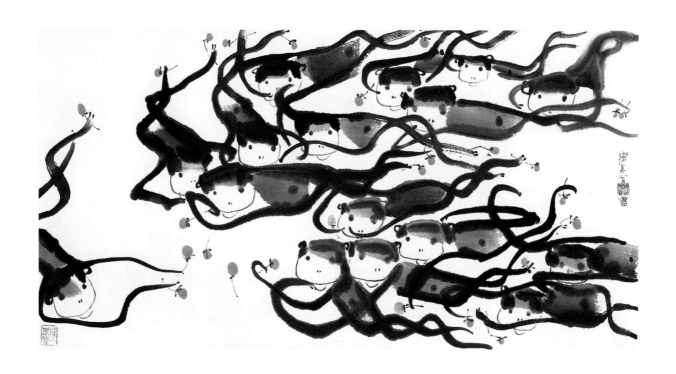

均富

1990

水墨局部設色紙本

24 x 46 公分

藝術家自藏

Common Wealth

1990

Ink and color on paper

24 x 46 cm

Collection of the Artist

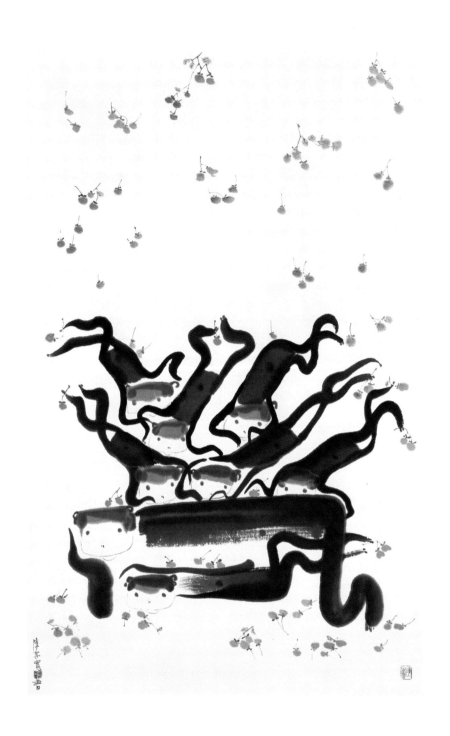

豐收
1992
水墨局部設色紙本
70 x 45 公分
藝術家自藏

Harvest
1992
Ink and color on paper
70 x 45 cm
Collection of the Artist

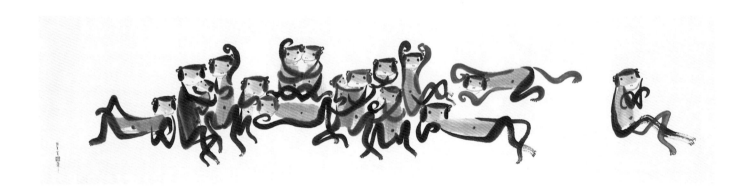

緣

1993
水墨紙本
143 x 35 公分
私人收藏

Fate

1993
Ink on paper
143 x 35 cm
Private Collection

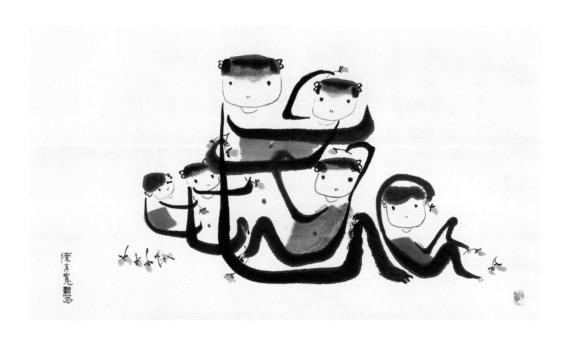

一點紅
1997
水墨局部設色紙本
33 x 60 公分
藝術家自藏

Red Fruit
1997
Ink and color on paper
33 x 60 cm
Collection of the Artist

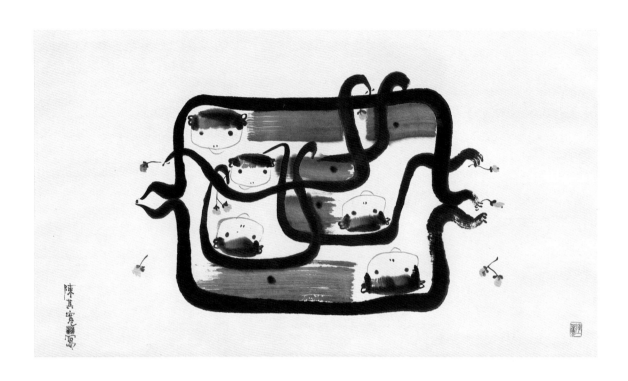

包容-2
1997
水墨局部設色紙本
34 x 60 公分
藝術家自藏

Caress (II)
1997
Ink and color on paper
34 x 60 cm
Collection of the Artist

生命線 Vital

他的畫風亦是自中國的繪畫與書法的傳統中來，但不拘泥於文人畫的範疇，而是廣納古今中外潮流所成。1954年的《生命線》是描寫農村常見的小豬依著母親吃奶的情景，筆法簡潔明快，也許是受到了南宋梁楷、牧谿、明末四僧以及近代齊白石的影響。陳其寬溶合了他特有的幽默感，中國人豐富的人情味，傳統筆墨之情趣，以及西方現代抽象主義之形式於一爐，而創造出這一張佳作。

Third, his style came from traditional Chinese painting and calligraphy. However, he did not limit himself to the literati tradition, but combined elements from old and new and from Chinese and Western Painting. His painting, Vital depicting a group of piglets nursing from their mother, is done with a few simple and quick strokes of the brush. It probably came from some of the elements of Liang Kai and Mu Chi of Southern Sung, but also from the Four Monks of late Ming and early Ching, and from the modern painter Chi Pai-shih. It is a happy blending of traditional Chinese brush-work, Western abstraction, Chinese human interest, and his own sense of humor.

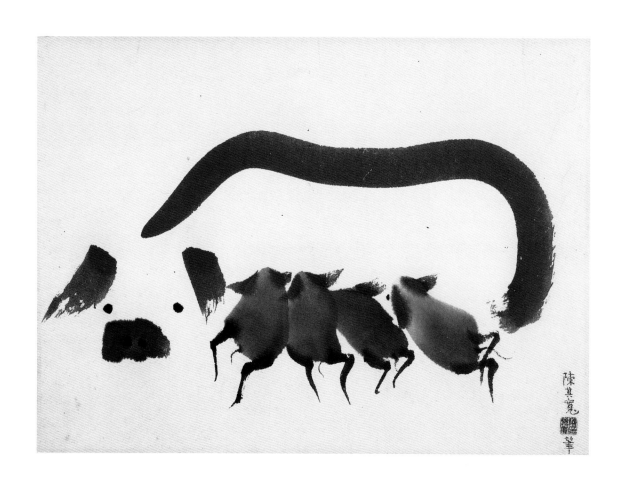

生命線
1953
水墨紙本
22.6 x 29.7 公分
藝術家自藏

Vital
1953
Ink on paper
22.6 x 29.7 cm
Collection of the Artist

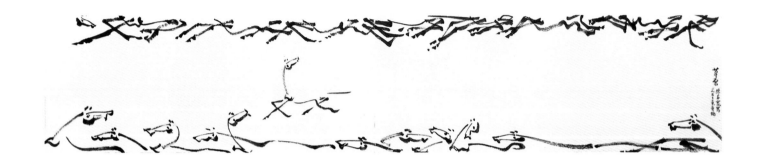

草原
1953
水墨紙本
25 x 120 公分
藝術家自藏

Prairie
1953
Ink on paper
25 x 120 cm
Collection of the Artist

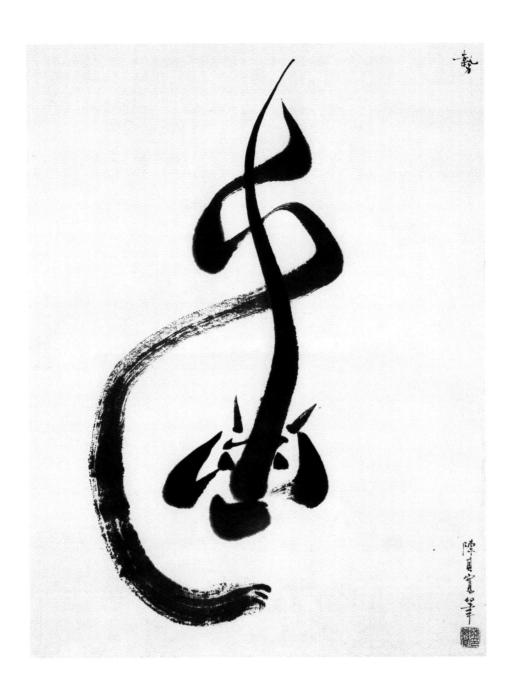

勢
1959
水墨紙本
29 x 22 公分
藝術家自藏

Potential
1959
Ink on paper
29 x 22 cm
Collection of the Artist

蔭
1964
水墨紙本
23 x 30 公分
藝術家自藏

Shelter
1964
Ink on paper
23 x 30 cm
Collection of the Artist

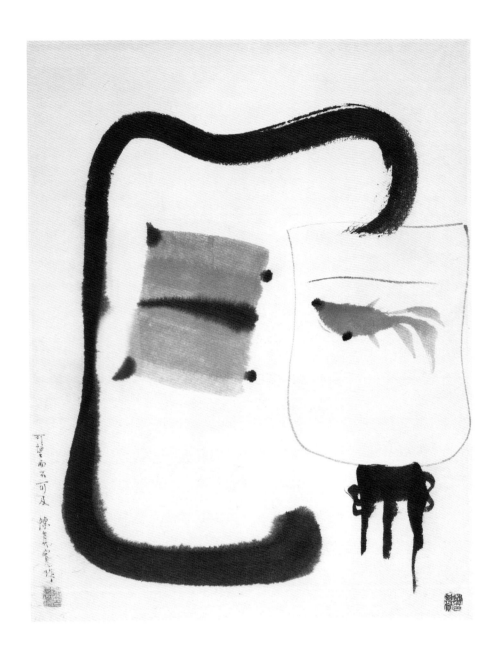

惑(可望而不可及)
1967
水墨紙本
29 x 22 公分
藝術家自藏

Untouchable
1967
Ink on paper
29 x 22 cm
Collection of the Artist

憩 -2
1972
水墨局部設色紙本
24 x 45 公分
藝術家自藏

Nap (II)
1972
Ink and color on paper
24 x 45 cm
Collection of the Artist

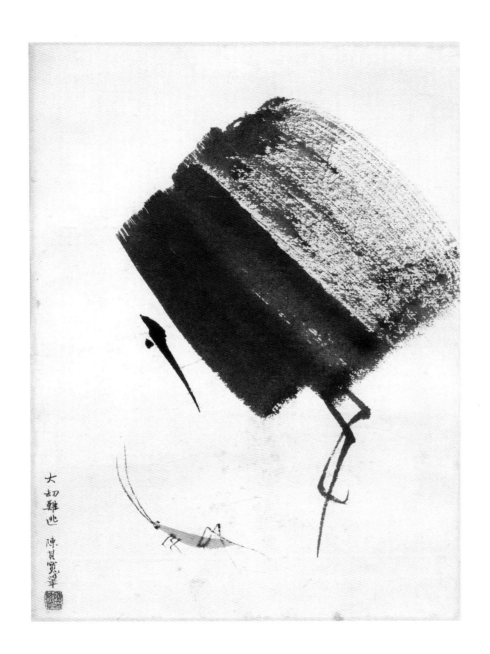

大劫難逃
1973
水墨紙本
29 x 22 公分
藝術家自藏

Fatal
1973
Ink on paper
29 x 22 cm
Collection of the Artist

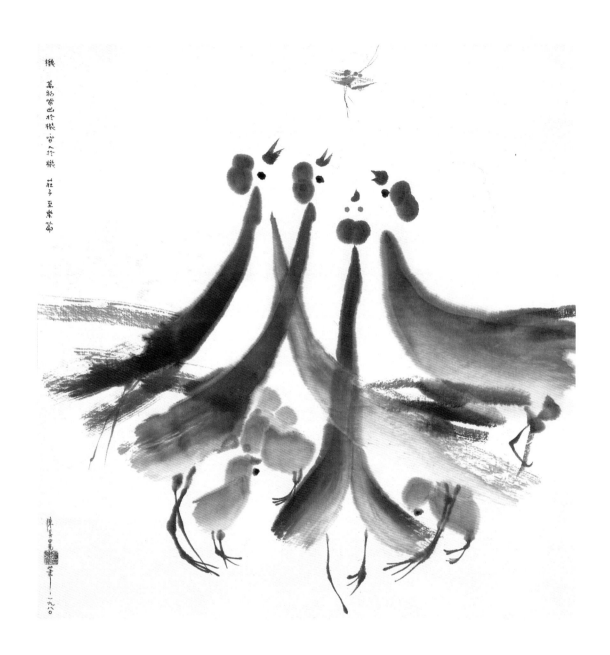

機

1980
水墨紙本
38.5 x 37 公分
藝術家自藏

Chance
1980
Ink on paper
38.5 x 37 cm
Collection of the Artist

放鶴圖
1981
水墨紙本
7.8 x 360.5 公分
水松石山房收藏

The Returning Cranes
1981
Ink on paper
7.8 x 360.5 cm
Shuisongshi Shanfang Collection

放鶴圖

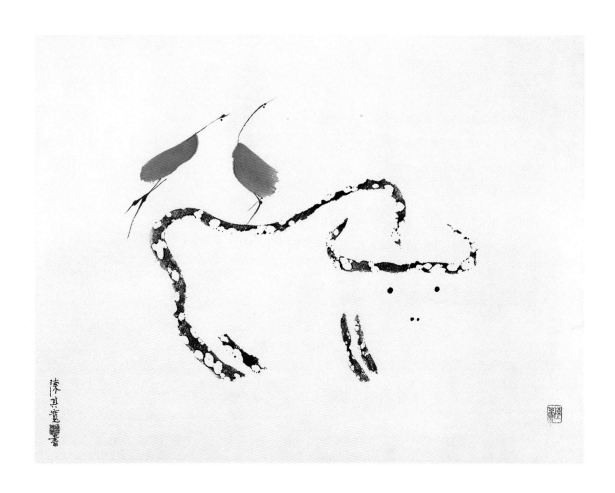

浮生半日閒-2
1990
水墨紙本
36 x 47.5 公分
藝術家自藏

Leisure (II)
1990
Ink on paper
36 x 47.5 cm
Collection of the Artist

少則得 Less is More

其寬先生的畫，高度收斂，精煉提純，往往有引人暇想的魅力。「簡」
字在他而言，是以少勝多，不僅是形式的疏簡而已。(何懷碩)

Chen Chi-kwan's paintings are extremely restrained, refined and pure, and
frequently possess an allure conducive to reverie. For him, the word simplicity
means gaining much with little, and not merely a minimalism of form. (Ho
Huai-shuo)

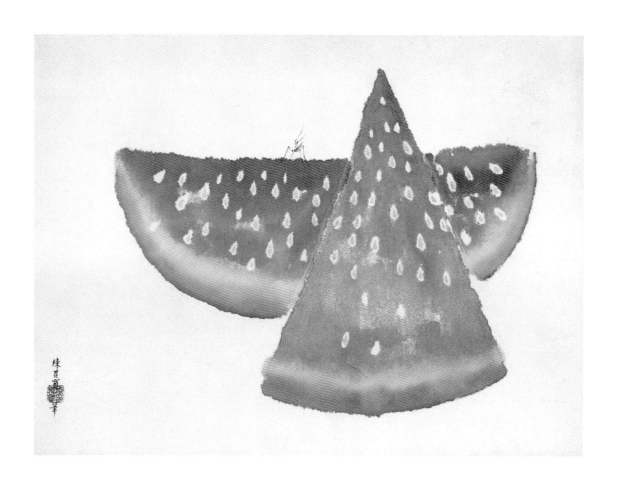

渴

1967
水墨設色紙本
22 x 23 公分
藝術家自藏

Thirsty
1967
Ink and color on paper
22 x 23 cm
Collection of the Artist

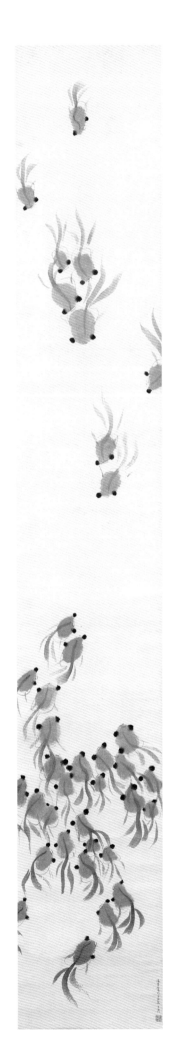

有朋自遠方來
1969
水墨設色紙本
183 x 23 公分
藝術家自藏

Visitors
1969
Ink and color on paper
183 x 23 cm
Collection of the Artist

孿

1973
水墨設色紙本
24 x 18 公分
藝術家自藏

Twins

1973
Ink and color on paper
24 x 18 cm
Collection of the Artist

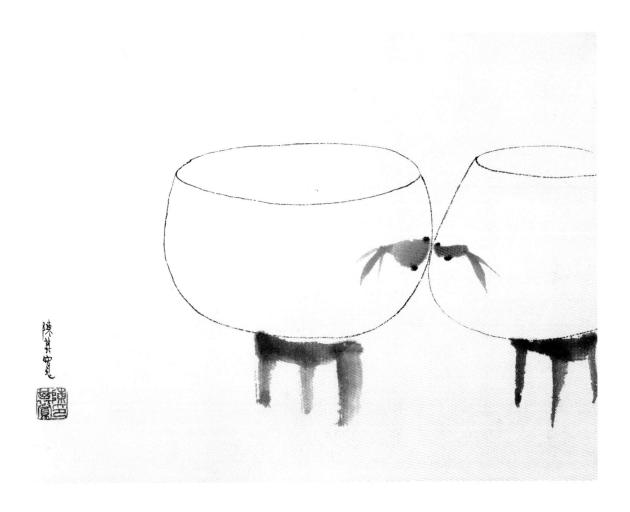

少則得

1976
石印版畫
44 x 59 公分
藝術家自藏

Less is More
1976
Lithography
44 x 59 cm
Collection of the Artist

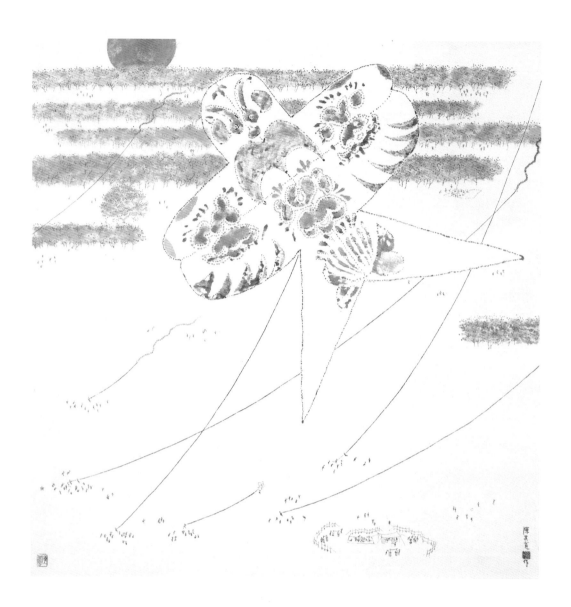

戲風-1
1989
水墨設色紙本
60 x 60 公分
藝術家自藏

Kite (I)
1989
Ink and color on paper
60 x 60 cm
Collection of the Artist

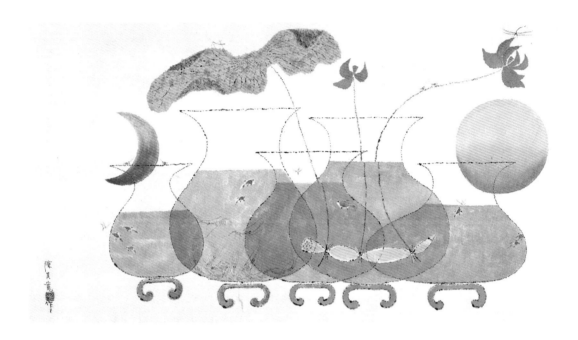

覓
1990
水墨設色紙本
31 x 62.5 公分
私人收藏

Search
1990
Ink and color on paper
31 x 62.5 cm
Private Collection

美食 Gourmet

陳其寬取材於日常最簡單的事物，如花、鳥、蟲、魚，而用新的技巧，寫成了微妙的形象，予人深思哲理。這種作風，顯然是受了中國南宋時代禪宗畫的影響而來的……牧谿的禪宗畫，尤其是他幾張在日本的蔬果，影響最大。用最普通的題材，用最簡潔的手法，來寫出了真髓，以表現禪宗「一粒沙中有一個世界」的思想。(李鑄晉)

The subject matter of Chen Chi-kwan's works comes from the simplest things of everyday life, such as flowers, birds, insects and fish, portrayed with delicate images using new techniques, and conveying profound philosophical insight. This style is clearly influenced by Chan Buddhist paintings of southern China from the Song dynasty... The influence is particularly great in a number of these bucolic Zen paintings of fruit and vegetables that he produced in Japan. He used the most ordinary of subject matter and the simplest and cleanest of techniques to render the essence of things, expressing the Zen idea that "the whole world exists in a grain of sand." (Li Chu-tsing)

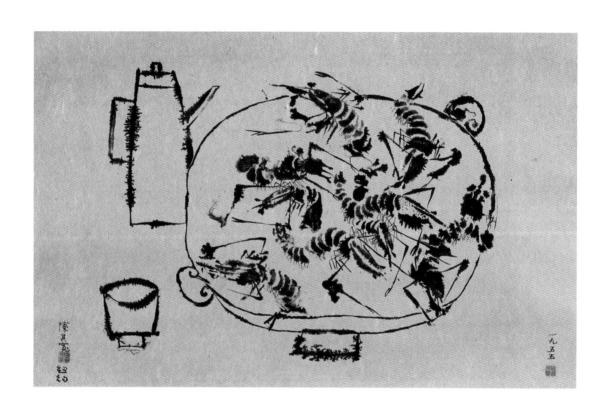

美食 -2
1955
石印版畫
23 x 30 公分
藝術家自藏

Gourmet (II)
1955
Lithograph
23 x 30 cm
Collection of the Artist

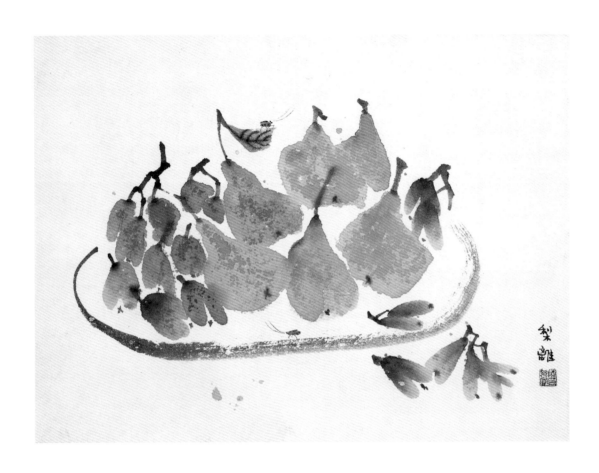

梨離

1962
水墨設色紙本
23 x 31 公分
水松石山房收藏

Pears Apart
1962
Ink and color on paper
23 x 31 cm
Shuisongshi Shanfang Collection

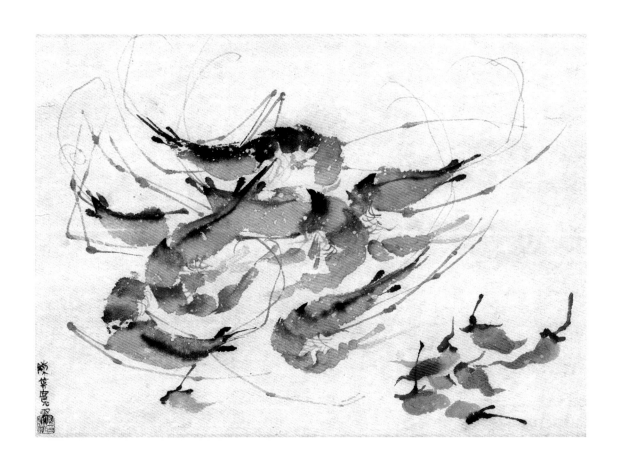

生鮮
1964
水墨設色紙本
21 x 31 公分
藝術家自藏

Raw
1964
Ink and color on paper
21 x 31 cm
Collection of the Artist

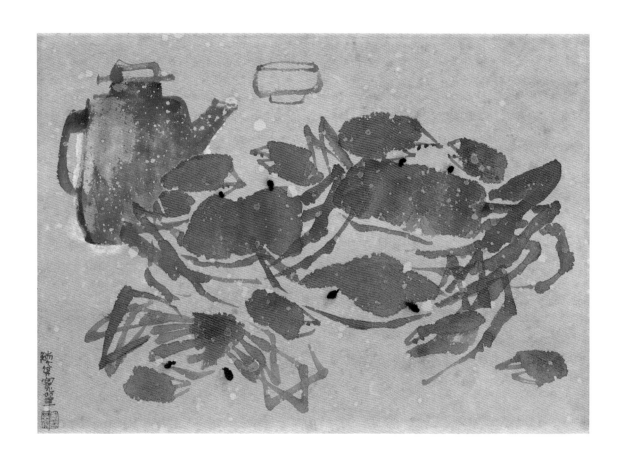

秋色 -2
1964
水墨設色紙本
21 x 31 公分
藝術家自藏

Autumn Scent (II)
1964
Ink and color on paper
21 x 31 cm
Collection of the Artist

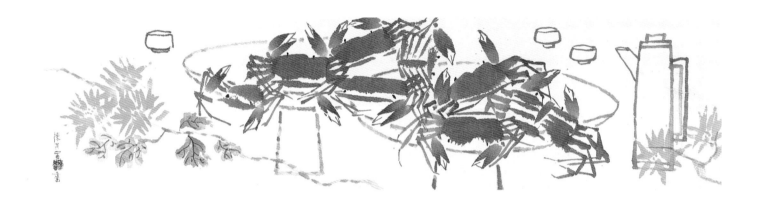

加飯
1991
水墨設色紙本
15 x 62 公分
藝術家自藏

Wine
1991
Ink and color on paper
15 x 62 cm
Collection of the Artist

附錄

Appendix

肉眼、物眼、意眼與抽象畫

(本文原刊於民國五十一年《作品》三卷四期, 1962)

陳其寬

前些時，報紙雜誌上看到不少關於討論抽象畫的文章，拜讀之餘，我以為如果大家靜下心把抽象畫的來源研究一下，也許可以找出一些依據，而不必再有何爭持。願就陋見所及，用簡單通俗的說法，討論一下。至於抽象畫指的是什麼，也不擬在此作咬文嚼字的工夫給下定義，假定讀者對抽象畫的範圍已有所知，想可心照不宣。

談到繪畫，我們不得不聯想到「眼」，因為繪畫是與「視覺」有關的藝術，正如音樂是聽覺的藝術與耳有關，吃飯是味覺的藝術與舌有關相似。另外一點就是：我們不能忘了我們現在是生活在二十世紀中，是一個科學的世紀。我們的「眼」所看到的事物範圍已經不再是以前的眼－「肉眼」所看到的範圍了。除了肉眼所能看到的事物起了變化以外，另外科學上發現的工具把我們視界的範圍已經擴展到無窮，換句話說，我們有了「物眼」。更進一步由於科學上的發現，工業的成長，社會的驟變，生活的繁雜，使我們感官上，心靈上也起了變化與反應，因之「意眼」的看法也不同了。總括說一句，科學在目前的世紀中佔有最重要的影響地位，它影響到視覺，因之也就影響到畫。

現在讓我們先看「物眼」的影響，古人常說畫家要行萬里路，多見多聞，至於行路所見，仍是限於肉眼所見的範圍。近代人有了科學工具，他可以不出門便知天下事，他可以在實驗室內發現新天地，旅行到另一個世界。由於X光，顯微鏡，望遠鏡，照相機的發明，把我們眼力擴張了，把我們的視域在空間上，時間上，型態上，色彩上，質感上，都引到了一個新的無限境域。這裡面有另一個「美」的世界是我們以前沒有看見過的。有很多藝術家在有意無意中受到這種新境域的影響而有意 (理性) 無意 (感情) 的把它表現出來，因此新的繪畫誕生了。例如在X光的照相中，我們能看透人體，這種照片有一種透明感，深度感，裡面的影像有互相重疊的現象，這種現象是以前肉眼看不到的，而在今天可以借X光照相看到了。在目前很多現代畫中我們就可以發現有很多表現法是這種現象的影響而在古畫中是不常見到的。又如在顯微鏡中我們看到了放大百倍，千倍的東西，千變萬化的型態，顏色，質地（註釋1），都是肉眼在通常情形下所不能看到的。筆者曾看到一位雕刻家做過一些雕刻就是花蕊部分的放大（註釋2），另外一位專以作動態雕刻知名的雕刻家柯達爾 (Alexander Calder, 1898-1976) 作了一件非常類似昆蟲頭部觸角經過放大數十倍以後的型態，這些顯微鏡下所見的事物，千變萬化，實非想像所能及，當我們看到這些雕刻家的作品時，的確有一種發現新世界的愉快與欣喜。另一位加拿大畫家葛斯頓 (Philip Gueston, 1913-1980) 我發現他的畫簡直就是顯微鏡下的各種結晶斑紋的複製，像這些畫都不是我們日常生活所能看到的景像，因之也就不能以日常生活肉眼所見的情況去領略，再例如喜歡照相的人一定有過經驗知道用望眼鏡頭所照的相與通常的照相不同（註釋3），在這種照相中我們可以發現頗與中國畫表現類似之處，就是把遠近事物都縮小在咫尺範圍之內，真有咫尺千里之感。在那些天文望眼鏡中所攝得的照相中，那更是咫尺億萬里，而感覺上的確也有無窮的深度存在，而這種深度的空間的現象，也正是目前畫家所急欲表現的對象之一。由上所述可見「物眼」對我們的眼與畫是有多麼深的影響。

再說肉眼所能見的事物，在這個世紀中也因為科學的發明，機械的進步，引起了急驟的變化，進入了嶄新的境界。比較直接的例子，像由飛機上所見的事物雖然與登高山相似，主要的不同是速度不同了。快速的交通工具給予我們的視覺，感覺上的變化，令我們對速度、時間、動的形態、相對關係，這些問題起了極大的興趣。如何把動的現象表現出來，如何由相對的觀點去看事物，也就成為目前藝術家急欲表現的對象之一。近代抽象化中的各種變形，多半是這種為了達成表現「動」的形態的後果，畢加索的人像更是眾人皆知的例子。照相機與感光紙的發明，使我們對速度、動態，有了進一步的認識，快速度照相把不成形的快動作凝固成肉眼可見的形態，而延時照相又把動的型態紀錄為一連續的現象。因之產生了新的形態。受了這種影響，有些畫家便想用連續動作來表現動，如法國畫家杜相 (Marcel Duchamp, 1887-1968) 所作之《下樓梯》(Nude Descending the Stairway, 1930)。有的畫家把動作連成線條狀，如美國畫家托比 (Mark Tobey, 1890-1976) 的畫恰巧與我國的書法相類似，因為我國的書法就是筆的連續動

作所產生的一種形態。有很多西洋畫家逐突然發現中國書法之奧妙而群起模仿,更進一步發展成一新形式。再譬如由電視、電影的發明,啟示了我們當一系列的「單獨印象」與「時間」配合時,可得到一個總的、動的印象。這種「有時間性的畫」也給予畫家以極多的啟示與對事物新的看法。因而產生新的畫,再譬如電燈的發明,使我們肉眼在夜間感到的光彩進入新的境界。當我們由摩天樓的窗中看到一個近代都市的夜景時,其光怪陸離的現象,實在不是中古世紀的人所能想像得到的。有些畫家便急欲用一些新的辦法來表現這五顏六色的「光」的世界,於是新的畫自然產生。

至於由於工業的發展,繪畫材料與繪畫工具也有了新的可能與改變,這些因素都使畫家在表現上有了新的可能性與新的境界。

由於肉眼,物眼所見在這個世紀中起了變化,因之心理上,精神上也起了共鳴,新的想法產生了,新的看法產生了,姑名之為「意眼」。這種由意眼所產生的畫派也是罄筆難書。一方面是畫家根據了物眼所見,更進一步的發展下去而成了一種畫,可能是連物眼都看不到的幻想之國。是一種意志的表現。例如:荷蘭畫家蒙德里安 (Piet Mondrian, 1872-1944) 的極度準確的,機械的畫,確實反應了近代科學、工業之準確比例。另一方面有些畫家受了這世紀環境變化的刺激而產生意亂神迷不安的情緒,像美國畫家潑羅克 (Jackson Pollock, 1912-1956) 的畫十足表現了美國人生活的動亂情緒,畫家已不能再安心來仔細的畫「工筆」而必須用潑、灑、淋漓,大筆一揮近於瘋狂狀態去作畫了。再一方面工業革命後所形成的商業社會的競爭,為了刺激購買心理而趨向於標新立異,一切商品化、商標化,以達宣傳之效。於是一些畫家便專以怪誕為能事,例如西班牙畫家大理 (Savador Dali, 1904-1989) 的畫,以「怪」為「意」便已形成了一種新畫派與新畫法。工業發展之另一結果是一部份人的生活日趨安閒,因此產生了所謂「週末畫家」,他們是以畫自娛而不是以畫維生的人,這點頗有似我國以前士大夫作畫的態度,他們作畫是無目的的、無約束的,無任務的,如果他們是在一個民主自由的國度裡,他們真可說是無憂無慮,不必駭怕有人來干涉他非走什麼路線不可,也更不必怕被批評。

總之抽象畫是由於在這個科學的世紀中,肉眼、物眼、意眼所見不同而產生的。它是有理性的、也是有感情的,在目前由於它仍在繼續不斷的發展,所以我們不能蓋棺論定它是對與不對,筆者以為它的確是與這個世紀有不可分的關係,所以它是有價值的。

問題是如果有一些畫家,他們的生活、所見、所聞仍是在十八世紀中而突然也畫起抽象畫來,潑起墨來,則令人感到這畫是否真的代表他們的感情與理性,抑或只是臨摹,這問題是值得想一想。不過我們也不能說他們不能畫,如果他們是真的了解,真的有一種意志要那樣畫的話,因為他們有他們的自由,而只有在自由的氣氛下,藝術才真的能發揚光大。

註釋
1 Texture,為視覺要素之一。
2 Jacques Lipchitz (1891-1973),美國雕刻家。
3 照相術所給予近代畫家的反作用,也可以說是副作用:是放棄文藝復姓以來西洋畫所習慣用的一種透視 (不動的),但是照相術的其他方面的可能與發現給予近代畫之影響有過於此反作用力。

龍柏與相思樹

(本文原刊於民國六十五年《房屋月刊》十二月號, 1976)

陳其寬

筆者在本省從事建築設計十餘載，每當遇到有庭園設計時，所遭遇的最大困擾就是業主大半都喜歡種龍柏，而不喜歡種相思樹，讀者也許要問，可以種的樹有幾百種何必偏偏把龍柏與相思樹相提並論？因為筆者認為這兩種樹對建築與環境有極不相同的影響，也代表了完全相反的看法。

由這麼多年的經驗，發現了為什麼那麼多人喜歡龍柏的原因。第一是很多人以為價錢貴的就是好東西，一棵龍柏起碼也要幾千元 (民國六十五年價格)。而相思樹是不值錢的，再者很多人想到相思樹便聯想到在本省是用來作木炭的材料，不是值錢的東西；還有，本省相思樹漫山遍野都是，東西多了也就不覺得稀奇。至於龍柏，由於難長，長得慢，培養困難，相形之下就顯得貴重。

事實上，龍柏在這種亞熱帶地方本來就不適合，原本應該長在高山、寒帶的東西，硬把它種在熱帶平地，已經是非常勉強了。難道是因為龍柏冬夏常青，予人以永恒感，所以才被人這樣垂青？就像本省墓園都大量種龍柏一樣，因為墓園較普通建築物更具永久性的緣故，因此形成了這種趨向，難道這也是原因之一嗎？

龍柏種在墓園倒沒有什麼妨害，可是種在普通建築物的周圍，確是對設計有極大的影響。這種影響，起因於樹的型態。龍柏的型態是個圓錐體，固定不變，予人以呆板的感覺。這種鍥形樹型有如一把利刃，種在建築物前面，把一幢完整建築物的立面切得七零八落，極具破壞性。建築物本身多半是幾何型態，是硬性的東西需要柔和的東西來陪襯，不需要像這類硬性的東西來干擾。再者那些喜歡在庭園中種龍柏的人，難道不怕人聯想到像像個墓園嗎？這真是百思不得其解的事。

反過來看，相思樹可能是本省樹木中最有變化、最美的樹。軀幹曲折有致，真可稱得上是婀娜多姿，樹葉綑少，有精緻感，近看成叢，遠看成林。

本省常見的樹，像油加里、木麻黃，樹幹都是直挺挺的，缺少變化與生動。像茄冬、樟樹，枝幹雖曲折，可惜乾瘦多疤，老態龍鍾。榕樹很美，可惜長得慢。鳳凰木枝幹結構美，可惜太脆弱，經不起颱風，這些缺點，相思樹都沒有，它長得快，不怕颱風，不怕乾旱，貧瘠的土質也照長不誤，春季黃花盛開，香聞十里，冬季也不落葉，不致落得只剩下樹幹，因此也可說是冬夏常青的。

相思樹唯一的缺點是易於長毛蟲，這一點是可用藥物處理的，筆看曾看到螞蟻把榕樹吃空，把油加里的皮一層層吃去，但是相恩樹就沒有這種白蟻問題。

本省漫山遍野能有鄉思樹，真是景觀上一大福氣。在大陸的山，多半是童山濯濯，很少看到相思樹的蹤跡，想到大陸的山景，真要慶幸本省有這樣一種強勁而又柔美的樹種。在筆者主持的工程中，只有東海大學沒有種過一株龍柏，而幸運的種滿了相思樹，密種的樹叢在景觀上協助了建築群中空間的形成，走進了東海的校園，感覺上是不一樣的，何故?除了大草坪以外，相思之功甚緯。台北的松山國際機場，也沒有種龍柏，這得歸功於民航局有眼光，請了夏威夷的庭園專家，總算逃過了種龍柏的大劫。

當然，龍柏也並不是完全沒有發揮的機會，要看如何用法，如杲把它種成行，或是以兩行夾道而種，可以把視線導引到一個目標或一個方向，適合用在具有紀念性的設計中，像南京中山陵兩側都是如此處理，不過那種龍柏的高度多在五、六公尺左右，本省的龍柏長不到這種高度。在歐洲有很多宮殿中的庭園也有這種手法，但是總令人感到呆板，印度的泰姬瑪哈陵前面水池兩旁也種有龍柏兩行，由於高度在陵的基礎之下，所以不會破壞陵的造型。

寫到此地，又聯想到有很多名建築中，不但不能種龍柏，就是任何樹都不種，為的是怕破壞了建築的造型，與空間環境，像北平太和殿的大院子中，就找不到一株樹；在日本京都皇城中，主殿前的大庭，只左右各種一小棵，一棵櫻花，另一棵是橘子樹。在奈良的法隆寺中，也是一棵樹都沒有的，在威尼斯聖馬可廣場，也是找不到一棵樹。

歐洲有很多廣場，都讓噴泉、燈柱、雕像、茶座、人群、鴿子等，取代了樹的地位，因此也並不顯得太冷酷。不過見不到樹的影子，總令人覺的失之過嚴，但是從表現建築物的景觀來看，.有時是有此必要的，因為樹是無法控制的東西，年代久遠，失去了控制，後果是無法預期的了。

筆者想籍這篇短文提供同業參考，一方面也想提醒有關的業主，別再種龍柏來破壞環境。

陳其寬年表

1921　生於北平

1923　居江西、南昌

1925　居北平，私塾家教

1929　居南京，私塾家教

1930　小學教育於北平方家胡同小學，曾獲全校書法首獎

1933　初中教育於南京中學及鎮江中學

1937　高中教育於安徽和縣鍾南中學

1940　畢業於四川合川國立二中高中部

1944　畢業於中央大學建築系，四川重慶沙坪壩

1945　被徵調擔任印緬戰區中美聯合遠征軍少校翻譯，足跡遍川、滇、黔、桂、西南各省及印度緬甸

1946　任南京基泰建築事務所設計師

1947　任內政部營建司技師

1948　任南京美軍顧問團工程師

1949　獲美國伊利諾大學建築碩士學位／獲伊利諾丹佛市市政廳設計第一獎

1950　於美國加州大學研究繪畫、工業設計、陶瓷

1951　任美國麻省康橋葛羅匹斯建築事務所設計師

1952　任麻省理工學院建築系設計講師

1954　與紐約貝聿銘建築師合作設計東海大學

1956　獲美國《市集建築雜誌》主辦青年中心全美建築競圖第一獎

1957　赴日本及緬甸、泰國、歐洲等地作畫，考察建築／返台主持東海大學建築事宜，設計全部庭園

1958　離台前已將東海校園的地景地貌作成初步整理與改善，使校園觀瞻耳目一新／參觀比利時世界博覽會／赴緬甸、泰國、中東考察

1959　赴歐洲旅行作畫

1960　返台灣任東海大學建築主任／擔任故宮博物院遷建工程評審委員及建築顧問

1961　完成東海大學建築系教室／完成東海大學藝術中心／擔任故宮博物院遷建工程顧問1962完成東海大學校長宿舍／東海大學藝術中心

1963　東海大學路斯義教堂落成，獲世界建築界重視

1965　赴菲律賓設計西里蒙大學教堂，並旅行作畫，考察建築

1967　當選為台灣十大建築師

1969　應舊金山重建局之聘，赴美設計舊金山中國文化貿易中心陸橋，並在舊金山市重建局舉行個展／赴歐洲旅行／設計中央大學校園全部規劃

1970　林口新城規劃（合作建築師漢寶德、李祖原、王體復、華昌宜）

1975　赴越南、馬來西亞旅行作畫，並考察建築／泰國曼谷亞洲理工學院區域實驗研究中心

1976　赴沙烏地阿拉伯，擔任老皇大學建築顧問

1977　赴約旦從事建築工程，並考察當地建築

1978　設計中央警官大學

1979　彰化銀行大樓設計，合作設計師沈祖海，獲台北市政府頒贈台北第一屆最佳建築設計獎

1980　任東海大學工學院院長

1985　完成台北懷恩堂

1990　設計台北市區地下鐵路台北車站（合作建築師沈祖海、郭茂林）

1994　設計約旦、安曼紀念老王回教堂

1995　當選台灣首屆傑出建築師

1996　中央聯合辦公大樓／淡水集合住宅（合作建築師紐約 P.C.F. 貝.柯.富.設計）

Biography of Chen Chi-kwan

1921 Born in Beijing

1923 Lived in Nanchang, Jiangxi

1925 Lived in Beijing

1929 Lived in Nanjing

1930 Enrolled Fangjiahutong Elementary School in Beijing

1933 Enrolled Nanjing Junior High School and Zhenjiang Junior High School

1937 Enrolled Zhongnan High School in Anhui

1940 Graduated from Hochun National High School in Cichuan

1944 Bachelor of Architecture Engineering, National Central University, Chungking

1945 Interpreter for Sino-American Expedition Force, Burma-India Theatre/ traveled extensively in Burma and India

1946 Designer of Jitai Architects & Association

1947 Technician of Construction and Planning Agency, Ministry of Interior

1948 Engineer of US Military Intelligence in Nanjing

1949 Master of Science in Architecture, University of Illinois/ first prize, City Hall Design Competition of Danville, Illinois

1950 Studied oil painting, ceramics, interior and industrial design, University of California, Los Angeles

1951 Worked with Gropius and the Architects Collaborative (TAC), Cambridge, Massachusetts

1952 M.I.T. Instructor of Architectural Design

1954 Designed Tunghai University Master Plan (Associate Architect I. M. Pei, C. K. Chang)

1956 First Prize, Youth Center Design Competition sponsored by Architectural Forum

1957 Traveled extensively in Japan/ first visit to Taiwan

1958 Renovating Tunghai University Campus/ visited Expo in Belgium/ traveled in Burma, Thailand

1959 Traveled extensively in Europe

1960 Appointed Chairman, Architecture Department, Tunghai University, Taiwan/ appointed committee member to the Relocation Program of National Palace Museum

1961 Completed Architectural Classroom, Tunghai University/ Appointed advisor to the Relocation Program of National Palace Museum/ traveled in South-East Asia

1962 Completed President Mansion and Art Center, Tunghai University

1963 Completed Luce Chapel, Tunghai University, acquired worldwide reputation/ traveled in Europe and Egypt

1965 Traveled in Philippines, Completes Chapel, Library, Silliman University, Damaguete, Philippines

1967 Listed among the top ten of Taiwan architects

1969 Traveled in Europe/ Commissioned by San Francisco to design Overpass for the Chinese Culture and Trade Center

1970 Jointed Regional Planning, Linko New Town (Associate Architects P.T. Han, T.F. Wong, C. Y. Hwa)

1975 Traveled in South Vietnam and Malaysia/ designed Regional Experimental Research Center, Asia Institute of Technology, Bangkok, Thailand

1976 Appointed advisor to the Architectural Expansion Program of King Abdulaziz University, Jeddah, Saudi Arabia

1977 Designed Amman industrial Estate, Amman, Jordan in association with Chemech Industries Ltd., Singapore

1978 Designed Central Police College

1979 Completed Chang Hwa Bank Building (Associate architect, Haigo Shan)

1980 Appointed Dean of The College of Engineering, Tunghai University, Taiwan

1985 Baptist Church, Taipei

1990 Designed Taipei New Railway Station (Associate architect Haigo Shan& M.L. Koo)

1994 Royal Memorial Mosque, Amman, Jordan

1996 Awarded Outstanding Architect by ROC Government/ High Rise Condominium, Tang Shu (Associate architect P.C.F., N.Y.) / 1996 Central United Office Building

陳其寬個展

1952　麻省理工學院藝術館個展／波斯頓卜郎畫展個展

1954　波斯頓卜郎畫廊個展／紐約懷伊畫廊個展

1955　波斯頓卜郎畫廊個展／紐約懷伊畫廊個展／菲利浦學院萊蒙藝術館個展

1957　紐約米舟畫廊／波士頓大學、卜藍代斯大學等聯展

1958　時代雜誌主辦之巡迴畫展／

1960　美國百年畫水彩畫展

1961　波斯頓設計研究畫廊個展／紐約米舟畫廊個展／哥倫比亞大學個展

1962　密西根大學藝術館「十年回顧展」

1963　紐約米舟畫廊個展

1964　紐約米舟畫廊個展

1966　「中國山水畫新傳統」美國巡迴展

1969　舊金山市重建局個展

1974　香港藝術中心個展

1977　加拿大維多利亞畫廊個展(徐小虎策劃)／加拿大巡迴個展

1980　台北歷史博物館個展

1981　歷史博物館與巴黎賽鈕斯奇美術館合辦之「中國傳統畫」聯展，於巴黎展出

1983　香港藝術中心「二十世紀中國現代畫」聯展

1984　檀香山藝術學院（夏威夷）美術館個展

1986　香港大學與《明報》合辦「當代中國繪畫」聯展及討論會／台北市立美術館「水墨抽象聯展」

1987　台北歷史博物館「現代繪畫新貌聯展」／加拿大溫哥華美術館「水松石山房收藏展」

1988　「北京國際水墨展」（中國美術家協會、中國畫研究院主辦）／樂山堂收藏展於香港及台北

1989　樂山堂收藏展於香港及台北

1991　樂山堂香港聯展／瑞士蘇黎世，瑞德伯美術館個展／台北市立美術館「陳其寬七十回顧展」

1992　第二屆「國際水墨畫展」於深圳

1994　台灣省立美術館「中國現代水墨大展」／高雄市立美術館開館展

1996　柏林東亞美術館個展

1998　中央大學藝文展示中心「陳其寬個展」

1999　牛津大學ASHMOLEAN美術館個展

2000　「陳其寬八十回顧展」於北京中國美術館及上海美術館

Selected Exhibitions

1952 Solo Exhibition, M.I.T. Cambridge, Massachusetts／Solo Exhibition, Margaret Brown Gallery, Boston

1954 Solo Exhibition, Margaret Brown Gallery, Boston／Solo Exhibition, Weyhe Gallery, New York

1955 Solo Exhibition, Margaret Brown Gallery, Boston／Solo Exhibition, Weyhe Gallery, New York／Solo Exhibition, The Lamont Gallery, Phillips
 Exeter Academy

1957 Solo Exhibition, Mi Chou Gallery, New York／Group Exhibition at Boston University, Brandeis University

1958 "Crosscurrents," a show sponsored ed by Time, Inc

1960 Group Exhibition "100 Years of American Watercolor," Guild Hall, East Hampton, New York

1961 Solo Exhibition, Mi Chou Gallery, New York／Solo Exhibition, Design Research, Boston／Solo Exhibition, Columbia University, New York

1962 Solo Exhibition "A Decade in Retrospect," The University of Michigan Museum of Art

1963 Solo Exhibition, Mi Chou Gallery, New York

1964 Solo Exhibition, Mi Chou Gallery, New York

1966 Traveling Exhibition "The New Chinese Landscape" sponsored by American Federation of Arts, New York, organized by Chu-tsing Li

1969 Solo Exhibition, San Francisco Redevelopment Agency

1974 Solo Exhibition, Hong Kong Arts Centre

1977 Solo Exhibition "Inner Eye of Chen Chi-kwan," Art Gallery of Greater Victoria, B. C. Canada／Solo traveling Exhibition in Canada

1980 Solo Exhibition, National Museum of History, Taipei

1981 Group Exhibition sponsored by Museum of History, Taipei and Musee Cernuschi, Paris

1983 Group Exhibition "Some Recent Developments in Twentieth Century Chinese Painting: A Personal View", organized by Hugh Moss for Hong
 Kong Arts Festival, The Hong Kong Arts Centre

1984 Solo Exhibition, Honolulu Academy of Arts, Hawaii

1986 Group Exhibition "Contemporary Chinese Painting," sponsored by Chinese University of Hong Kong and Ming Pao／Group Exhibition
 "Abstract Ink Painting, " Taipei Fine Arts Museum

1987 Group Exhibition "The New Look of Chinese Modern Art," National Museum of History, Taipei／Solo Exhibition, Shuisongshi Shangfang
 Collection, The Vancouver Art Gallery, Vancouver

1988 Group Exhibition "International Ink Painting in Beijing" sponsored by Chinese Fine Artists Association and Chinese Traditional Painting
 Research Institute／Group Exhibition, Lo Shan Tang Collection, Hong Kong, Taipei

1989 Group Exhibition, Lo Shan Tang Collection, Hong Kong and Taipei

1991 Group Exhibition, Lo Shan Tang Collection, Hong Kong ／Solo Exhibition, Rietberg Museum Zurich, Switzerland／"Chen Chi-kwan
 Retrospective", Taipei Fine Arts Museum

1992 The 2nd "International Ink Painting Exhibition," Shen Zhen

1994 Group Exhibition "Chinese Modern Ink Painting, "Taiwan Museum of Arts／Group Exhibition, Inaugural Exhibition of Kaohsiung Museum of
 Fine Arts

1996 Solo Exhibition, Musem fuer Ostasiatische Museum, Berlin

1998 Solo Exhibition, Art Center of National Central University

1999 Solo Exhibition, Ashmolean Museum, Oxford University

2000 Solo Exhibition "A Retrospective: Chen Chi-kwan at the Age of Eighty," Beijing and Shanghai

參考書目 Bibliography

陳其寬著作

〈肉眼‧物眼‧意眼與抽象畫〉, 作品三卷四期, 1962, P. 37-38

〈非不能也, 是不為也！〉, 建築雙月刊1, 1962. 4.

〈貢獻一磚〉, 建築雙月刊2, 1962. 6.

〈貢獻一磚 (續)〉, 建築雙月刊5, 1962. 12.

〈東海大學藝術中心〉, 建築雙月刊6, 1963. 2.

〈薄膜結構－建築界的新猶：陳其寬建築師訪問記〉, 建築與藝術, 1968. 4.

〈未來建築展望〉 (筆名：木訥, 原載於新聞週刊4月, 19.1971作者戴維斯), 建築與計劃12, 1971. 5.

〈城中之城〉 (筆名：木訥), 建築與計劃12, 1971. 5.

〈室中之室〉 (筆名：木訥), 建築與計劃13, 1971. 7.

〈超現圖案與現代建築〉 (筆名：木訥), 建築與計劃13, 1971. 7.

〈巴黎重建中的陣痛〉 (筆名：木訥), 建築與計劃16, 1972. 12.

〈街景〉, 房屋市場月刊16, 1974. 11.

〈亞特蘭大海亞特旅館〉, 房屋市場月刊, 1976. 9.

〈龍柏與相思樹〉, 房屋月刊, 1976. 12.

〈參與東海生命的蘊釀, 規劃東海景觀的成長〉

〈低價得標制－建築品質低劣的根源〉

陳其寬作品相關論述

M.B. 〈Fifty-seventy Street in Review〉. In: Art Digest, The News Magazine of Art 27, 15. November 1952.

L.C., 〈Review and Previews: Chi Kwan Chen〉. In: Art News 51.7, November 1952, P. 45.

Dorothy Adlow, 〈A Chinese in Cambridge〉. In: The Christian Science Monitor, 22. December 1953.

〈A Gifted Chinese〉. In: New York Herald Tribune, 28. November 1954.

〈Contemporary Art by Orientals in New York〉. In: The New York Times, 28. November 1954.

I.G., 〈Chen Chi Kwan〉, In: Art Digest, The News Magazine of Art 29, 1. December 1954.

F. O'H., 〈Reviews and Previews: Chen-Chi [Kwan]〉. In: Art News 53.8, December 1954, P. 51

L.L., 〈Chi Kwan Chen〉. In: Pictures on Exhibit 18, 1954, 3.

Howard Devree, 〈Chi-Kwan Chen's Water-colors on View〉. In: The New York Times, 28. November 1955.

〈25 Prize Buildings for the Community〉. In: Architectural Forum, March 1956.

〈Chapel for China〉. In: Architectural Forum, March 1957.

Edith Weigle, 〈Blend Old China, Modern Art〉. In: Chicago Daily Tribune, 27. April 1957.

Nelson I. Wu, 〈The Ideogram in the Modern Chinese Dilemma〉. In: Art News 56.7, November 1957, P. 34-37, P. 52-53.

Michael Sullivan, Chinese Art in the 20th Century, Berkeley 1959, P. 58, 60, Fig. 56, 57.

〈Art Exhibition Notes〉. In: New York Herald Tribune, 1. April 1961.

James Cahill, *Remarks in Connection with a Chi-Kwan Chen Exhibition at the Mi Chou Gallery*, March, 1962

Richard Edwards, *Chi-kwan Chen: A Decade in Retrospect*. University of Michigan Museum of Art, Ann Arbor 1962.

李鑄晉 & Thomas Lawton, *中國山水畫的新傳統*, 美國藝術協會, 紐約, 1966

Helmut Jacoby, *Architekturdarstellung*, .Stuttgart 1971, P. 110

席德進, 〈中國畫新傳統開拓者陳其寬〉, 《雄獅美術》1971, 10(8), p. 36-41

Michael Sullivan, *The Meeting of Eastern and Western Art*: From the Sixteenth Century to the Present Day, London 1973, p. 191, 194

何弢, 〈香港藝術中心主辦陳其寬畫展〉, 香港, 1974

李鑄晉, 〈The Visions Chen Chi-Kwan〉, 《藝術家》4, 1977, 4(24)

Joan Stanley-Baker (徐小虎), *The Inner Eye of Chen Chi-kwan*. Art Gallery of Greater Victoria B.C., Victoria 1977

何懷碩, 〈納須彌於芥子〉, 聯合副刊 (jan. 25), 1980

陳其寬畫集, Chen Chi Kwan Paintings 1940-1980, 台北：藝術圖書公司, 1981

Peintures chinoises traditionelles 1975-1980. Musee Cernuschi, Paris 1981

Hugh Moss, *Some Recent Developments in Twentieth Century Chinese Painting*: A Personal View, Hong Kong 1982, P. 19, 32-35, 38-43, 70-71

Hugh Moss, *The Experience of Art*: Twentieth Century Chinese Paintings from the Shuisonfshi Shanfang collection, Hong Kong 1983, P. 141-179

Chen Qikuan 陳其寬, Honolulu Academy of Arts, Honolulu 1984

陳其寬別冊, 《藝術家》, Artist 19, 1985, 3[111]

葉維廉, 〈陳其寬：中國現代畫的生成〉, 《藝術家》22, 1986, 3(130)

何懷碩, 〈我看當代水墨畫〉, 《藝術家》24, 1987, 3 (142) , p.108-116

Arnold Chang, 〈Tradition in the Modern Period〉. In: *Twentieth Century Chinese Painting*, Oxford 1988

巴東, 〈由過海三家看傳統中國畫之現代轉化與發展〉, 《故宮文物月刊》 7.12, 1990, 3 (84) , P.97-120

Robert Hall & Edwin Miller, *Contemporary Chinese Painting III*: Migration. Lo Shan Tang, Hong Kong 1990

Anne M. Grande, 〈對一種優雅革命的禮讚〉, 《雅砌》, *The Asia Magazine of Architecture, Design, and Visual Communications*, 1990, 7

郭繼生, 〈傳統的變革—陳其寬的藝術〉, *中國—現代—美術：兼論日朝現代美術國際學術研討會論文集*, 台北市立美術館, 1991, 頁61-89

陳其寬特集, 名家翰墨20, 香港：名家翰墨, 1990

Chen Chi-kwan: Ein zeitgossischer chinesischer Maler. Museum Rietberg, Zurich 1991

陳其寬七十回顧展, Chen Chi-kwan Retrospective, 台北市立美術館, 1991

漢寶德, 〈自眼界到境界—看陳其寬的藝術〉, 《現代美術雙月刊》, 台北市立美術館, 1991

趙家琪訪問, 林忖姜整理, 〈建築‧繪畫—訪學貫中西陳其寬建築師〉, 《建築師》十七卷十一期, 1991, 頁76-80

林建業, 〈陳其寬的畫—時代文化學識結晶品〉, 《建築師》十七卷十一期, 1991, 頁72-75

吳慧芳, 〈以毫末之筆塑寰宇之妙—陳其寬、林明哲對談錄〉, 《炎黃藝術》二十四期, 頁31-37, 1991

Lina Lin (林莉娜), 〈Seeing the World through Chen's Eyes: A Study of Chen Chi-Kwan's Painting〉, 《Asia Culture Quarterly》, 20:1, pp.15-36, 1992

陳英德, 〈彩墨畫的新境界—陳其寬先生七十回顧展後觀〉, 《雄獅美術》二五四期, 四月, 1992, 頁83-93

郭繼生, *陳其寬專輯*, 中國巨匠美術週刊64期, 台北：錦繡出版事業有限公司, 1995

傳統與創新：二十世紀中國繪畫, 香港 1995, 頁310-311

陳其寬／晴川, 中國進代名家書畫全集 14, 香港：名家翰墨, 1996

林詮居, 〈全新時空、全新境界—訪當代水墨家陳其寬〉, 《典藏藝術》二八期, 一月, 1995, 頁174-181

Chinesische Tuschmalerei im 20. Jahrhundert. Museum fur Ostasiatische Kunst Koln. Muchen 1996

須彌芥子：陳其寬八十回顧展, 北京美術館, 上海美術館, 2000

東海大學建築系編, *建築之心—陳其寬與東海建築*, 台北：田園城市出版社, 2003

路思義教堂大事紀　Chronology of Luce Chapel

東海路思義教堂即是美國著名的《時代雜誌》、《生活》雜誌創辦人亨利路思義 (Mr. Henry R. Luce) 先生，爲了宣揚福音並紀念父親亨利溫特斯路思義牧師 (Mr. Henry W. Luce) 而捐款興建的。

Tunghai University's Luce Chapel was built from donations by the famous American founder of Time and Life magazines, Henry R. Luce, in order to spread the gospel and commemorate his father, Rev. Henry W. Luce.

1954 教堂興建的啓端　Beginning of Construction

1954年貝、陳、張受委託設計校園，校園規劃中的三個中心點爲教堂、圖書館、活動中心。

In 1954 I.M. Pei, Chen Chi-kwan and Chang Jau-kang are commissioned to design the Tunghai campus. The campus plan identifies three focal points -- the chapel, the library and the activity center.

1956 -57 教堂設計構思期　Conceptual Phase

1. 貝聿銘最早的構想爲一磚砌歌德式拱門，類似中國的無樑殿拱。陳其寬依據貝先生的想法試驗以木條製成此拱，平面則成六角形，類似一個小禮堂。

M. Pei's earliest concept is a Gothic arch made of brick, similar to the Chinese beamless temple arch. Based on I.M. Pei's ideas, Chen Chi-kwan experiments with the construction of such an arch from strips of lumber. His plans call for a hexagonal shape, similar to a small sanctuary.

2. 模型有似船底，貝聿銘看到這模型後，傾向以木製船爲準則，同時去信台灣要張先生調查木船的作法。(張肇康於1956年8月來台監造第二期工程)

A model of the chapel is built, resembling the bottom of a boat. After I.M. Pei sees the model, he favors using a wooden ship as the chapel's archetype. He also sends a letter to Chang Jau-kang, asking him to research construction methods for wooden boats. (Chang Jau-kang went to Taiwan in August of 1956 to supervise the second phase of construction.)

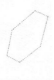

3. 1956年貝聿銘二度來台時赴成大演講，成大同學提及東海第一期工程沒有新意，貝聿銘返回紐約後對陳其寬說：「我們要作點新的東西」。陳其寬以當時最流行之雙曲面薄殼爲最具挑戰性之結構型式，遂決定向此方向進行，因而逐構成此四片雙曲薄殼之造型。

In 1956 I.M. Pei visits Taiwan for the second time, delivering a lecture at National Cheng Kung University, where students note that the first phase of construction of the Tunghai campus has presented no new ideas. After returning to New York, Pei tells Chen Chi-kwan, "We need to do something new." Chen Chi-kwan identifies the hyperbolic shell, then extremely fashionable, as the most challenging structural form, and decides to proceed in that direction. He subsequently designs a hyperbolic shell in four pieces.

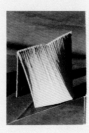

4. 貝事務所的Cobb先生所畫的花瓶切面，上面的開口讓陳其寬聯想到中國的一線天，遂決定把屋頂分開，形成天窗。

The mouth of a flower vase drawn in cross-section by Henry N. Cobb, a member of I.M. Pei's architecture firm, inspires in Chen Chi-kwan an association with the single line of visible sky in Chinese architecture. He then decides to divide the roof, forming a skylight.

本大事紀乃依陳其寬先生提供之資料與「東海風－東海大學創校四十週年特刊」作成

5. 隨後又加入了邊窗。

Afterward, side windows are added.

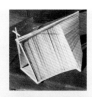

6. 之後又把神壇上面的兩片屋頂加高，突顯神壇的部位。

Later, the two sections of roof above the altar are raised in height to accentuate the position of the altar.

7. 最後依基督教高等教育董事會的福開森女士的意見，取法中國屋頂的曲線。此種構成邊線為曲線的雙曲面 (Conoid)，為拋物雙曲面的一種。

Finally, Ms. Fergusion of the United Board for Christian Higher Education in Asia suggests adopting the curved lines of a traditional Chinese roof. This form of hyperbolic plane using curved sidelines is a hyperbolic paraboloid known as a conoid.

1958 - 59　教堂興建工程停擺　Halt in Construction

陳其寬二度來台，教堂破土，但是因木製結構與混凝土結構之間的爭議，使得教堂興建停頓。其間陳其寬受委託抵台規劃設計校長住宅、活動中心，並籌辦東海建築系。

Chen Chi-kwan comes to Taiwan for a second time. Ground has been broken on the chapel, but a dispute over whether to use wood or cement halts construction. During this period, Chen Chi-kwan is commissioned to go to Taiwan to design the president's residence and the activity center, and to form the Tunghai University architecture department.

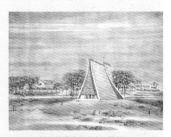

1957.08 教堂整體造型定案，陳於 Architectural Forum 發表彩圖 (宣紙)
The Chapel's overall design is finalized. Chen Chi-kwan publishes colored drawings (on xuan calligraphic paper) in Architectural Forum.

1960　重啟教堂興建工程　Resumption of Construction

1960年老魯斯來台後，催促教堂興建工事的重新啟動。

After visiting Taiwan in 1960, Henry Luce urges that construction of the chapel be recommenced.

1961 - 62　工程結構之爭議　Dispute over Structure

鳳後三先生提案的混凝土結構仍令人質疑，爭議不斷。

The cement structure proposed by Feng Hou-san is met with skepticism, and disagreement continues unabated.

1962 - 63　興建與完工　Construction and Completion

結構爭議終於平息，教堂得以於1962.11.01開工，並於1963.11.01落成。

The dispute over construction finally ebbs. Construction of the Luce Chapel begins on Nov. 1, 1962. It is completed on Nov. 1, 1963.

This chronology was constructed from information provided by Mr. Chen Chi-kwan, and *Tunghai Style*, a special publication at the 40th anniversary of the founding of Tunghai University.

001

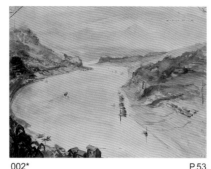

002*　　　　　　　　P.53

003*　　　　　P.52

006*　　　　　　　　P.52

004*　　　　　P.52

005*　　　　　P.52

007*　　　　　P.52

008*　　　　　P.52

009*　　　　　P.53

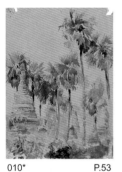

010*　　　　　P.53

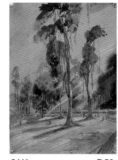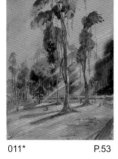

011*　　　　　P.53

012

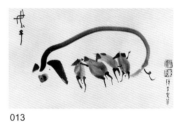

013

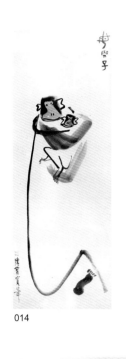

014

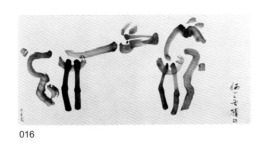

016

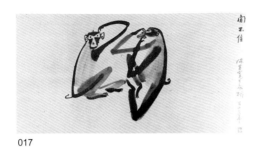

017

015

019　　020　　021

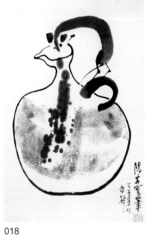

018

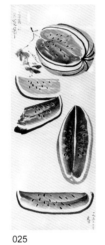

025

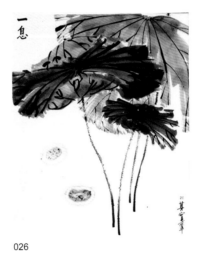

026

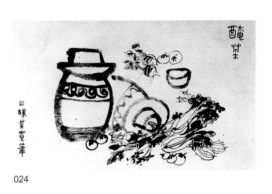

024

022

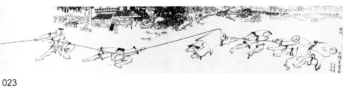

023

014	015	016	017	018	019	020
母與子-1	德孤	兩小無猜	閒不住-1	鼠	蝦群	球賽-1
Mother and Child (I)	Lonesome Character	Passion	Busy (I)	Character	Movement & Direction	Ball Game -1
1952	1952	1952	1952	1952	1952	1952
水墨紙本	水墨紙本	水墨紙本	水墨紙本	水墨紙本	水墨紙本	水墨紙本
Ink on paper	Ink on paper	Ink on paper	Ink on paper	Ink on paper	Ink on paper	Ink on paper
尺寸不詳, Unknown size	尺寸不詳, Unknown size	25×50 cm	18×30 cm	尺寸不詳, Unknown size	尺寸不詳, Unknown size	120×25 cm
收藏者不明	收藏者不明	收藏者不明	收藏者不明	收藏者不明	收藏者不明	收藏者不明
Unknown Collector	Unknown Collector	Unknown Collector	Unknown Collector	Unknown Collector	Unknown Collector	Unknown Collector

021	022	023	024	025	026
球賽-2	拔河1	拔河2	醃菜	夏日炎炎	一息
Ball Game -2	Tug of War-I	Tug of War-II	Pickled Cabbage	Hot Sommer	Secret Life
1952	1952	1952	1952	1952	1952
水墨紙本	水墨紙本	水墨紙本	水墨紙本	水墨紙本	水墨紙本
Ink on paper	Ink on paper	Ink on paper	Ink on paper	Ink on paper	Ink on paper
120×25 cm	25×120 cm	25×120 cm	25×45 cm	尺寸不詳, Unknown size	尺寸不詳, Unknown size
伯克基金會	收藏者不明	收藏者不明	蘇利文收藏	收藏者不明	收藏者不明
Mary and Jackson Burke Foundation	Unknown Collector	Unknown Collector	Mr. & Mrs. Michael Sullivan	Unknown Collector	Unknown Collector

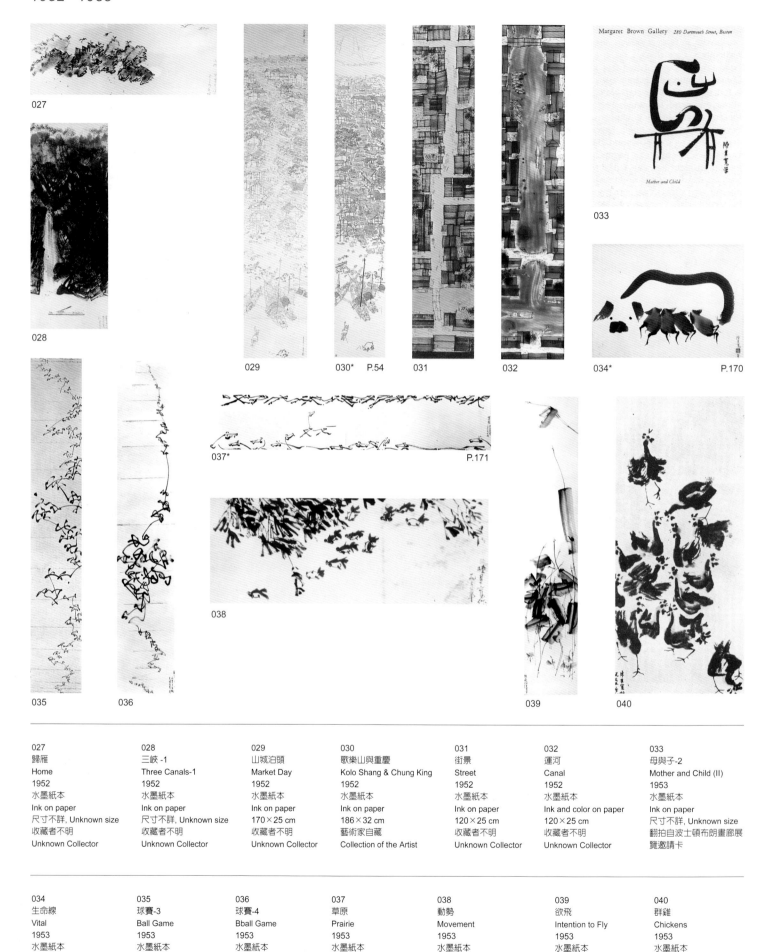

027
歸雁
Home
1952
水墨紙本
Ink on paper
尺寸不詳, Unknown size
收藏者不明
Unknown Collector

028
三峽 -1
Three Canals-1
1952
水墨紙本
Ink on paper
尺寸不詳, Unknown size
收藏者不明
Unknown Collector

029
山城泊頭
Market Day
1952
水墨紙本
Ink on paper
170×25 cm
收藏者不明
Unknown Collector

030
歌樂山與重慶
Kolo Shang & Chung King
1952
水墨紙本
Ink on paper
186×32 cm
藝術家自藏
Collection of the Artist

031
街景
Street
1952
水墨紙本
Ink on paper
120×25 cm
收藏者不明
Unknown Collector

032
運河
Canal
1952
水墨紙本
Ink and color on paper
120×25 cm
收藏者不明
Unknown Collector

033
母與子-2
Mother and Child (II)
1953
水墨紙本
Ink on paper
尺寸不詳, Unknown size
翻拍自波士頓布朗畫廊展
覽邀請卡

034
生命線
Vital
1953
水墨紙本
Ink on paper
22.6×29.7 cm
藝術家自藏
Collection of the Artist

035
球賽-3
Ball Game
1953
水墨紙本
Ink on paper
120×25 cm
收藏者不明
Unknown Collector

036
球賽-4
Bball Game
1953
水墨紙本
Ink on paper
120×25 cm
收藏者不明
Unknown Collector

037
草原
Prairie
1953
水墨紙本
Ink on paper
25×120 cm
藝術家自藏
Collection of the Artist

038
動勢
Movement
1953
水墨紙本
Ink on paper
尺寸不詳, Unknown size
收藏者不明
Unknown Collector

039
欲飛
Intention to Fly
1953
水墨紙本
Ink on paper
112×23 cm
收藏者不明
Unknown Collector

040
群雞
Chickens
1953
水墨紙本
Ink on paper
尺寸不詳, Unknown size
收藏者不明
Unknown Collector

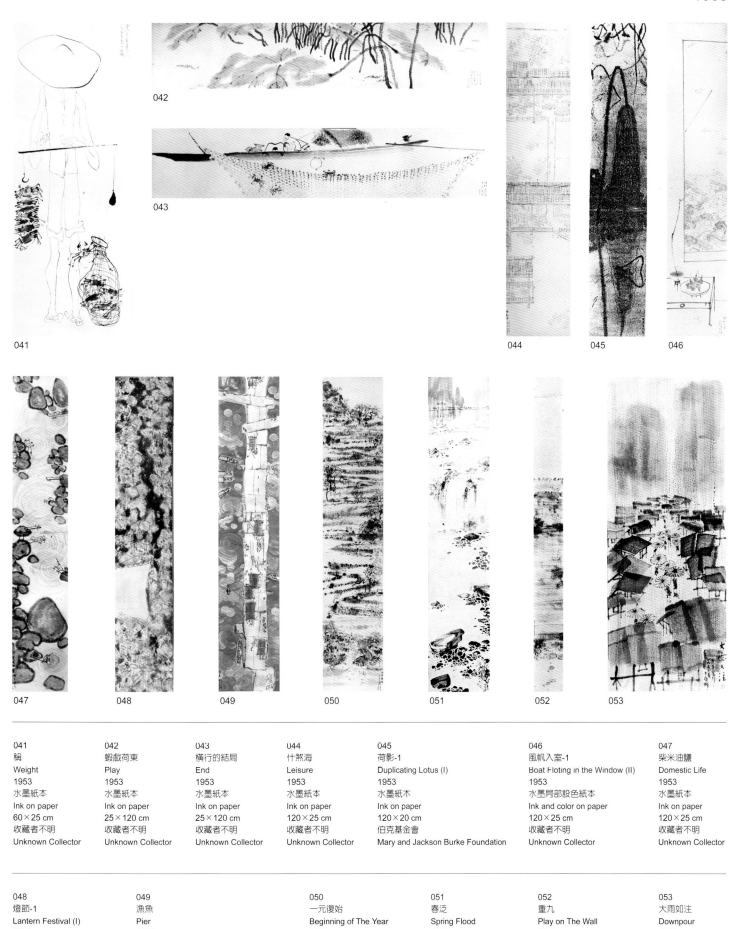

041	042	043	044	045	046	047
稱	蝦戲荷東	橫行的結局	什剎海	荷影-1	風帆入室-1	柴米油鹽
Weight	Play	End	Leisure	Duplicating Lotus (I)	Boat Floting in the Window (II)	Domestic Life
1953	1953	1953	1953	1953	1953	1953
水墨紙本	水墨紙本	水墨紙本	水墨紙本	水墨紙本	水墨局部設色紙本	水墨紙本
Ink on paper	Ink on paper	Ink on paper	Ink on paper	Ink on paper	Ink and color on paper	Ink on paper
60×25 cm	25×120 cm	25×120 cm	120×25 cm	120×20 cm	120×25 cm	120×25 cm
收藏者不明	收藏者不明	收藏者不明	收藏者不明	伯克基金會	收藏者不明	收藏者不明
Unknown Collector	Unknown Collector	Unknown Collector	Unknown Collector	Mary and Jackson Burke Foundation	Unknown Collector	Unknown Collector

048	049	050	051	052	053
燈節-1	漁魚	一元復始	春泛	重九	大雨如注
Lantern Festival (I)	Pier	Beginning of The Year	Spring Flood	Play on The Wall	Downpour
1953	1953	1953	1953	1953	1953
水墨設色紙本	水墨設色紙本	水墨紙本	水墨紙本	水墨紙本	水墨紙本
Ink and color on paper	Ink and color on paper	Ink on paper	Ink on paper	Ink and color on paper	Ink on paper
125×25 cm	120×25 cm	120×25 cm	120×25 cm	120×12 cm	69×25 cm
收藏者不明	伯克基金會	收藏者不明	收藏者不明	收藏者不明	收藏者不明
Unknown Collector	Mary and Jackson Burke Foundation	Unknown Collector	Unknown Collector	Unknown Collector	Unknown Collector

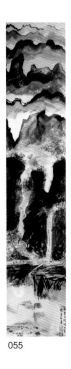

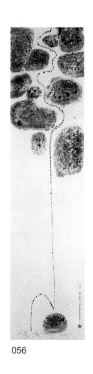

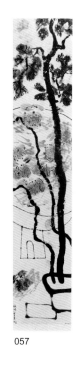

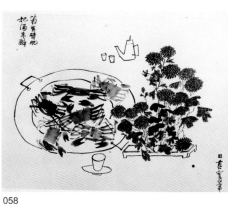

058

054

055

056

057

059

061

060

063

064

062

066

065*

P.189

054	055	056	057	058	059
西山滇池	黔邊印象	子曰 (水之就下沛然莫能禦之)	秋味	菊黃蟹肥	風吹草低見牛羊
Tien Lake, West Mountain	Lodge	Water Flowing Downward	Autumn Taste	Still Life	Ranch
1953	1953	1953	1954	1954	1954
水墨設色紙本	水墨紙本	水墨設色紙本	水墨紙本	水墨紙本	水墨紙本
Ink and color on paper	Ink on paper	Ink and color on paper	Ink on paper	Ink on paper	Ink on paper
120×25 cm	120×25 cm	22.7×92.4 cm	120×25 cm	尺寸不詳, Unknown size	尺寸不詳, Unknown size
收藏者不明	收藏者不明	翻拍樂山堂拍賣目録1990	伯克基金會	收藏者不明	伯克基金會
Unknown Collector	Unknown Collector		Mary and Jackson Burke Foundation	Unknown Collector	Mary and Jackson Burke Foundation

060	061	062	063	064	065	066
戲風	風帆入室-2	窗上行舟	負擔-1	美食-1	美食-2	聽聲下注
Paly with Wind	Boat Floting in the Window (I)	Window Landscape	Weight (I)	Gourmet (I)	Gourmet (II)	Cricket Fight
1954	1954	1954	1955	1955	1955	1955
水墨紙本	水墨局部設色紙本	水墨局部紙本	水墨紙本	石印版畫	石印版畫	水墨紙本
Ink on paper	Ink on paper	Ink on paper	Ink on paper	Lithograph	Lithograph	Ink on paper
25×120 cm	120×25 cm	121.5×23 cm	25×45 cm	23×30 cm	23×30 cm	25×120 cm
收藏者不明	收藏者不明	收藏者不明	伯克基金會	藝術家自藏	藝術家自藏	收藏者不明
Unknown Collector	Unknown Collector	Unknown Collector	Mary and Jackson Burke Foundation	Collection of the Artist	Collection of the Artist	Unknown Collector

069

070

067 068 071 072

074

075

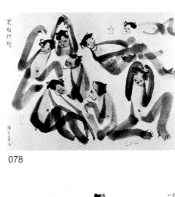

078

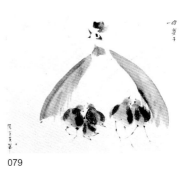

073 077 076 079

067	068	069	070	071	072	073
老死不相往來	荷影-2	把酒臨風	漁	窗上行舟	北海	市雨
Isolated	Duplicating Lotus (II)	Breeze	Fishing	Window Screen	White Pagoda	City, Rain, Night
1955	1955	1955	1955	1955	1955	1955
水墨紙本	水墨紙本	水墨紙本	水墨紙本	水墨設色紙本	水墨紙本	水墨紙本
Ink on paper	Ink on paper	Ink on paper	Ink on paper	Ink and color on paper	Ink and color on paper	Ink and color on paper
120×25 cm	38×8 cm	25×120 cm	25×120 cm	120×25 cm	120×25 cm	120×25 cm
收藏者不明	收藏者不明	收藏者不明	收藏者不明	伯克基金會	收藏者不明	收藏者不明
Unknown Collector	Unknown Collector	Unknown Collector	Unknown Collector	Mary and Jackson Burke Foundation	Unknown Collector	Unknown Collector

074	075	076	077	078	079
靜觀	娛	幻遊	布魯克林橋	眾醉獨醒	母與子
Quite Eye	Amusement	Rock Garden	Brooklyn Bridge	Drunk	Cover
1955	1955	1955	1955	1956	1956
水墨紙本	水墨紙本	水墨紙本	水墨設色紙本	水墨紙本	水墨紙本
Ink on paper	Ink on paper	Ink on paper	Ink and color on paper	Ink on paper	Ink on paper
60×50 cm	60×50 cm	120×25 cm	120×25 cm	23×25 cm	23×25 cm
收藏者不明	收藏者不明	伯克基金會	藝術家自藏	收藏者不明	收藏者不明
Unknown Collector	Unknown Collector	Mary and Jackson Burke Foundation	Collection of the Artist	Unknown Collector	Unknown Collector

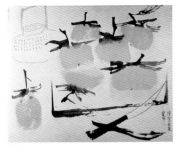

080

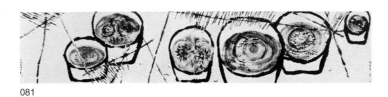

081

090* P.102

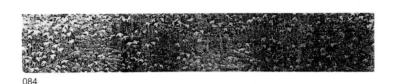

083

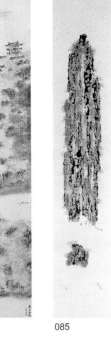

082 085

084

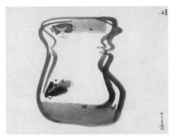

088* P.150

091

092* P.100

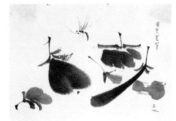

086 087* P.62 089 093

080	081	082	083	084	085	086
冬景	老死不相往來	暮雲春樹	聖馬可廣場-1	聖馬可廣場-2	出世	泣月
Winter	Isolated	Spring Blossom	Piazza San Marco (I)	Piazza San Marco (II)	Retreat	Melancholic Moon
1956	1956	1956	1956	1956	1956	1956
水墨設色紙本	水墨紙本	水墨設色紙本	水墨設色紙本	水墨設色紙本	水墨設色紙本	水墨設色紙本
Ink and color on paper	Ink on paper	Ink and color on paper	Ink and color on paper	Ink and color on paper	Ink and color on paper	Ink and color on paper
19×23 cm	25×120 cm	120×25 cm	23×120 cm	23×120 cm	120×23 cm	120×30 cm
收藏者不明	收藏者不明	伯克基金會	私人收藏	伯克基金會	私人收藏	私人收藏
Unknown Collector	Unknown Collector	Mary and Jackson Burke Foundation	Private Collection	Mary and Jackson Burke Foundation	Private Collection	Private Collection

087	088	089	090	091	092	093
夕舟	嬉	蔬果	慾	日光浴	洗凝脂	海女
Evening Boat	Joy	Vegetable	Lust	Sun Tan	Bather	Deep Diver for Pearls
1957	1957	1957	1957	1957	1957	1957
水墨設色紙本	水墨紙本	水墨設色紙本	水墨設色紙本	水墨紙本	水墨設色紙本	水墨紙本
Ink and color on paper	Ink on paper	Ink and color on paper	Ink and color on paper	Ink on paper	Ink and color on paper	Ink on paper
120×30 cm	23×30 cm	尺寸不詳, Unknown size	23×30 cm	25×120 cm	23×120 cm	25×120 cm
國立台灣美術館典藏	藝術家自藏	翻拍自展覽介紹1953	藝術家自藏	收藏者不明	藝術家自藏	伯克基金會
National Taiwan Museum of Fine Arts	Collection of the Artist		Collection of the Artist	Unknown Collector	Collection of the Artist	Mary and Jackson Burke Foundation

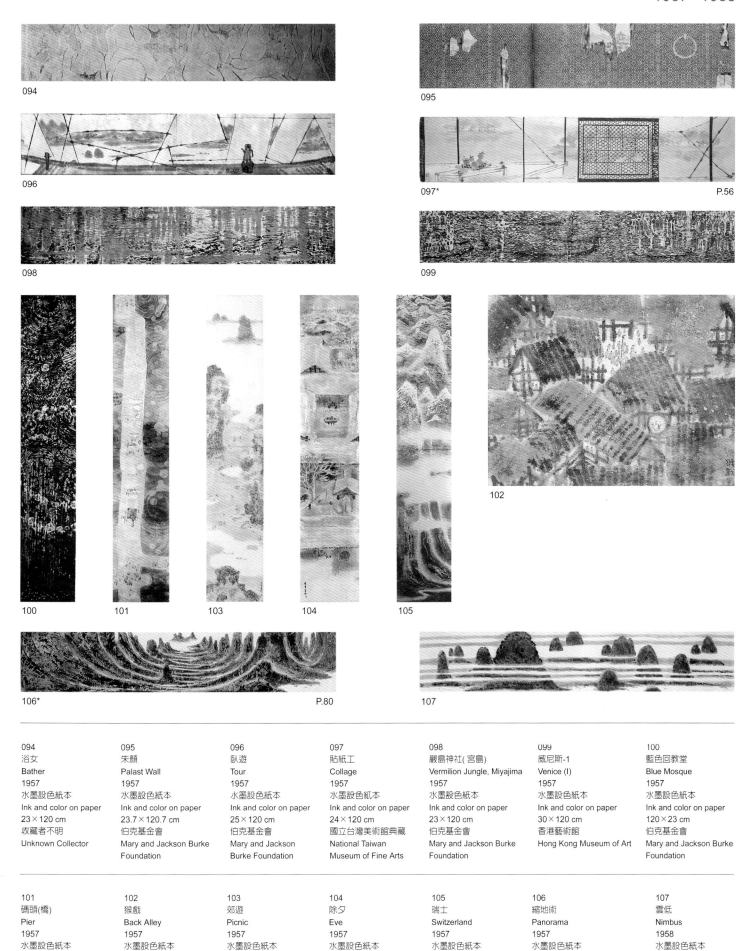

094

095

096

097* P.56

098

099

100 101 103 104 105

102

106* P.80

107

094	095	096	097	098	099	100
浴女	朱顏	臥遊	貼紙工	嚴島神社(宮島)	威尼斯-1	藍色回教堂
Bather	Palast Wall	Tour	Collage	Vermilion Jungle, Miyajima	Venice (I)	Blue Mosque
1957	1957	1957	1957	1957	1957	1957
水墨設色紙本	水墨設色紙本	水墨設色紙本	水墨設色紙本	水墨設色紙本	水墨設色紙本	水墨設色紙本
Ink and color on paper	Ink and color on paper	Ink and color on paper	Ink and color on paper	Ink and color on paper	Ink and color on paper	Ink and color on paper
23×120 cm	23.7×120.7 cm	25×120 cm	24×120 cm	23×120 cm	30×120 cm	120×23 cm
收藏者不明	伯克基金會	伯克基金會	國立台灣美術館典藏	伯克基金會	香港藝術館	伯克基金會
Unknown Collector	Mary and Jackson Burke Foundation	Mary and Jackson Burke Foundation	National Taiwan Museum of Fine Arts	Mary and Jackson Burke Foundation	Hong Kong Museum of Art	Mary and Jackson Burke Foundation

101	102	103	104	105	106	107
碼頭(橋)	猴戲	郊遊	除夕	瑞士	縮地術	雲低
Pier	Back Alley	Picnic	Eve	Switzerland	Panorama	Nimbus
1957	1957	1957	1957	1957	1957	1958
水墨設色紙本	水墨設色紙本	水墨設色紙本	水墨設色紙本	水墨設色紙本	水墨設色紙本	水墨設色紙本
Ink and color on paper	Ink and color on paper	Ink and color on paper	Ink and color on paper	Ink and color on paper	Ink and color on paper	Ink and color on paper
115×23 cm	23×25 cm	120×25 cm	120×25 cm	120×23 cm	23×122 cm	22.8×121 cm
私人收藏	伯克基金會	伯克基金會	伯克基金會	私人收藏	太平洋東方藝術公司	收藏者不明
Private Collection	Mary and Jackson Burke Foundation	Mary and Jackson Burke Foundation	Mary and Jackson Burke Foundation	Private Collection	Pacific and Oriental Arts Ltd.	Unknown Collector

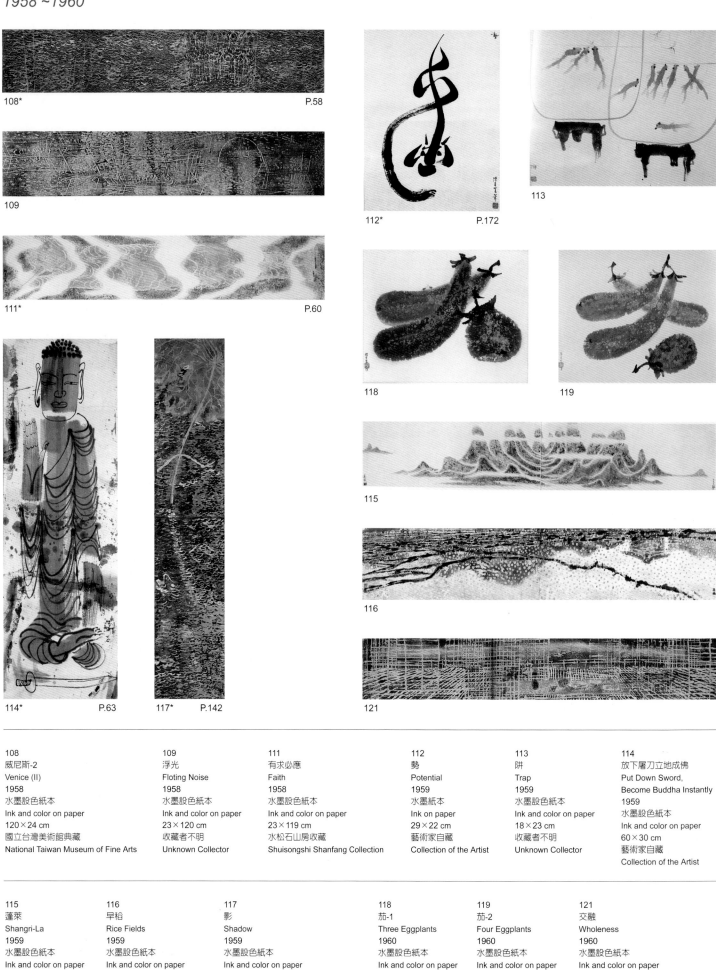

108*　　　　　　　　　　　　　　　　　　　　P.58

109

111*　　　　　　　　　　　　　　　　　　　　P.60

112*　　　　　　　　　P.172

113

118　　　　　　　　　　119

115

116

121

114*　　　　P.63　　　117*　　P.142

108	109	111	112	113	114
威尼斯-2	浮光	有求必應	勢	阱	放下屠刀立地成佛
Venice (II)	Floting Noise	Faith	Potential	Trap	Put Down Sword, Become Buddha Instantly
1958	1958	1958	1959	1959	1959
水墨設色紙本	水墨設色紙本	水墨設色紙本	水墨紙本	水墨設色紙本	水墨設色紙本
Ink and color on paper	Ink and color on paper	Ink and color on paper	Ink on paper	Ink and color on paper	Ink and color on paper
120×24 cm	23×120 cm	23×119 cm	29×22 cm	18×23 cm	60×30 cm
國立台灣美術館典藏	收藏者不明	水松石山房收藏	藝術家自藏	收藏者不明	藝術家自藏
National Taiwan Museum of Fine Arts	Unknown Collector	Shuisongshi Shanfang Collection	Collection of the Artist	Unknown Collector	Collection of the Artist

115	116	117	118	119	121
蓬萊	早稻	影	茄-1	茄-2	交融
Shangri-La	Rice Fields	Shadow	Three Eggplants	Four Eggplants	Wholeness
1959	1959	1959	1960	1960	1960
水墨設色紙本	水墨設色紙本	水墨設色紙本	水墨設色紙本	水墨設色紙本	水墨設色紙本
Ink and color on paper	Ink and color on paper	Ink and color on paper	Ink and color on paper	Ink and color on paper	Ink and color on paper
23×120 cm	24×120 cm	120×24 cm	23×31 cm	23×31 cm	29.8×181.6 cm
收藏者不明	太平洋東方藝術公司	國立台灣美術館典藏	私人收藏	私人收藏	伯克基金會
Unknown Collector	Pacific and Oriental Arts Ltd.	National Taiwan Museum of Fine Arts	Private Collection	Private Collection	Mary and Jackson Burke Foundation

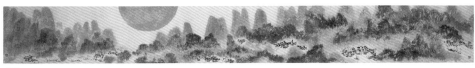

123

122

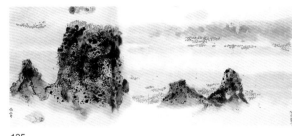

125

124

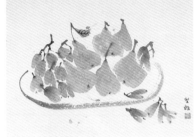

129*　　　　　　　　P.190

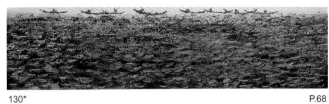

130*　　　　　　　　P.68

120*　P.64

126*　P.66

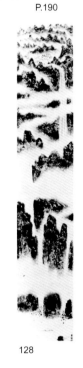

127*　P.65

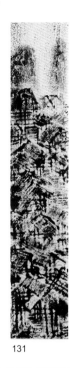

128

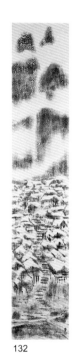

131

132

133*　P.67

120	122	123	124	125	126
教堂	威尼斯-3	霧	雨霽	瀑	今夕是何夕
Cathedral	Venice (III)	Fog	When the Rain Stops	Waterfall	Heaven is Eternal
1960	1960	1960	1960	1960	1961
水墨設色紙本	水墨設色紙本	水墨設色紙本	水墨設色紙本	水墨設色紙本	水墨設色紙本
Ink and color on paper	Ink and color on paper	Ink and color on paper	Ink and color on paper	Ink and color on paper	Ink and color on paper
182.5×30.5 cm	29.7×180.4 cm	185×22 cm	24×60.6 cm	45.5×45.7 cm	122×24 cm
水松石山房收藏	伯克基金會	藝術家自藏	伯克基金會	伯克基金會	水松石山房收藏
Shuisongshi Shanfang Collection	Mary and Jackson Burke Foundation	Collection of the Artist	Mary and Jackson Burke Foundation	Mary and Jackson Burke Foundation	Shuisongshi Shanfang Collection

127	128	129	130	131	132	133
燈節-2	蜀道	梨離	泛舟	雨	雪-1	仙源何處
Lantern Festival (II)	Road in Shu	Pears Apart	Afloat	Rain Scene	Snow (I)	Where is Arcadia
1961	1961	1962	1962	1962	1962	1962
水墨設色紙本	水墨設色紙本	水墨設色紙本	水墨設色紙本	水墨設色紙本	水墨設色紙本	水墨設色紙本
Ink and color on paper	Ink and color on paper	Ink and color on paper	Ink and color on paper	Ink on paper	Ink and color on paper	Ink and color on paper
30.5×120 cm	120×23 cm	23×31 cm	22.5×91 cm	120×25 cm	121.5×23 cm	92.5×22.5 cm
水松石山房收藏	翻拍自1966年「中國山水畫的新傳統」展覽小冊	水松石山房收藏	太平洋東方藝術公司	收藏者不明	收藏者不明	太平洋東方藝術公司
Shuisongshi Shanfang Collection		Shuisongshi Shanfang Collection	Pacific and Oriental Arts Ltd.	Unknown Collector	Unknown Collector	Pacific and Oriental Arts Ltd.

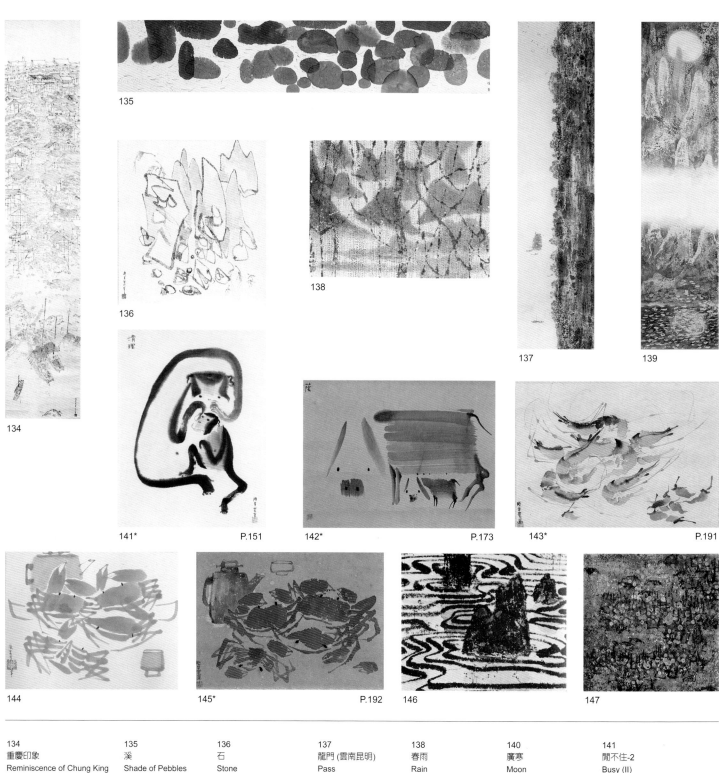

134
重慶印象
Reminiscence of Chung King
1962
水墨紙本
Ink on paper
30.1×149.9 cm
私人收藏
Private Collection

135
溪
Shade of Pebbles
1963
水墨設色紙本
Ink and color on paper
22×118.5 cm
私人收藏
Private Collection

136
石
Stone
1963
水墨局部設色紙本
Ink and color on paper
尺寸不詳, Unknown size
收藏者不明
Unknown Collector

137
龍門 (雲南昆明)
Pass
1963
水墨設色紙本
Ink and color on paper
92×22.5 cm
私人收藏
Private Collection

138
春雨
Rain
1963
水墨設色紙本
Ink and color on paper
22×31 cm
私人收藏
Private Collection

140
廣寒
Moon
1964
水墨設色紙本
Ink and color on paper
93×23 cm
收藏者不明
Unknown Collector

141
閒不住-2
Busy (II)
1964
水墨紙本
Ink on paper
30×23 cm
水松石山房收藏
Shuisongshi Shanfang Collection

142
蔭
Shelter
1964
水墨紙本
Ink on paper
23×30 cm
藝術家自藏
Collection of the Artist

143
生鮮
Raw
1964
水墨設色紙本
Ink and color on paper
21×31 cm
藝術家自藏
Collection of the Artist

144
秋色-1
Autumn Scent (I)
1964
水墨設色紙本
Ink and color on paper
22×31 cm
水松石山房收藏
Shuisongshi Shanfang Collection

145
秋色-2
Autumn Scent (II)
1964
水墨設色紙本
Ink and color on paper
21×31 cm
藝術家自藏
Collection of the Artist

146
桃源-2
Arcadia (II)
1964
水墨紙本
Ink on paper
尺寸不詳, Unknown size
收藏者不明
Unknown Collector

147
燈
Lights
1964
水墨設色紙本
Ink and color on paper
60×60 cm
藝術家自藏
Collection of the Artist

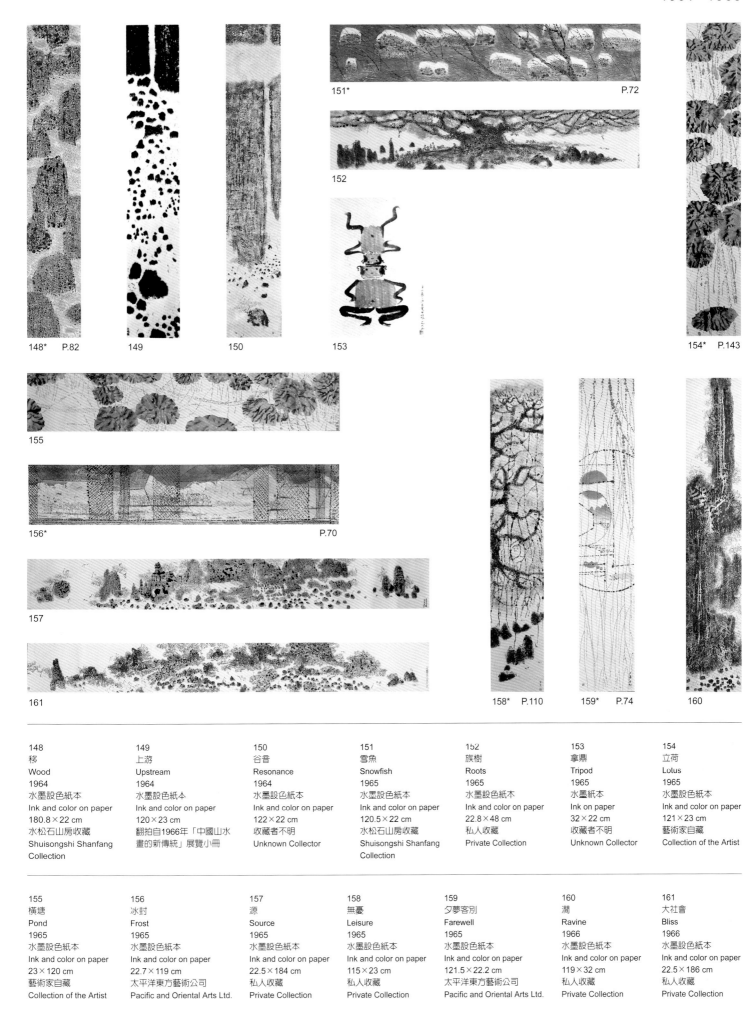

151* P.72

152

148* P.82 149 150 153 154* P.143

155

156* P.70

157

161

158* P.110 159* P.74 160

148	149	150	151	152	153	154
移	上游	谷音	雪魚	族樹	享鼎	立荷
Wood	Upstream	Resonance	Snowfish	Roots	Tripod	Lotus
1964	1964	1964	1965	1965	1965	1965
水墨設色紙本	水墨設色紙本	水墨設色紙本	水墨設色紙本	水墨設色紙木	水墨紙本	水墨設色紙本
Ink and color on paper	Ink and color on paper	Ink and color on paper	Ink and color on paper	Ink and color on paper	Ink on paper	Ink and color on paper
180.8×22 cm	120×23 cm	122×22 cm	120.5×22 cm	22.8×48 cm	32×22 cm	121×23 cm
水松石山房收藏	翻拍自1966年「中國山水	收藏者不明	水松石山房收藏	私人收藏	收藏者不明	藝術家自藏
Shuisongshi Shanfang	畫的新傳統」展覽小冊	Unknown Collector	Shuisongshi Shanfang	Private Collection	Unknown Collector	Collection of the Artist
Collection	Unknown Collector		Collection			

155	156	157	158	159	160	161
橫塘	冰封	源	無憂	夕夢客別	潤	大社會
Pond	Frost	Source	Leisure	Farewell	Ravine	Bliss
1965	1965	1965	1965	1965	1966	1966
水墨設色紙本	水墨設色紙本	水墨設色紙本	水墨設色紙本	水墨設色紙本	水墨設色紙本	水墨設色紙本
Ink and color on paper	Ink and color on paper	Ink and color on paper	Ink and color on paper	Ink and color on paper	Ink and color on paper	Ink and color on paper
23×120 cm	22.7×119 cm	22.5×184 cm	115×23 cm	121.5×22.2 cm	119×32 cm	22.5×186 cm
藝術家自藏	太平洋東方藝術公司	私人收藏	私人收藏	太平洋東方藝術公司	私人收藏	私人收藏
Collection of the Artist	Pacific and Oriental Arts Ltd.	Private Collection	Private Collection	Pacific and Oriental Arts Ltd.	Private Collection	Private Collection

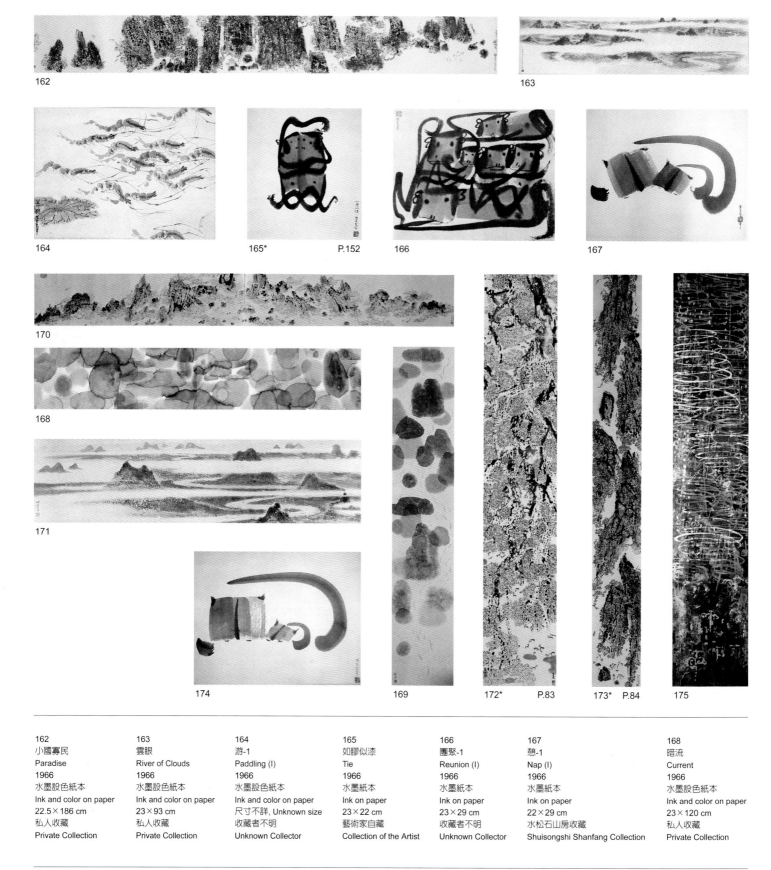

162

163

164

165* P.152 166

167

170

168

171

174 169 172* P.83 173* P.84 175

162
小國寡民
Paradise
1966
水墨設色紙本
Ink and color on paper
22.5×186 cm
私人收藏
Private Collection

163
雲眼
River of Clouds
1966
水墨設色紙本
Ink and color on paper
23×93 cm
私人收藏
Private Collection

164
游-1
Paddling (I)
1966
水墨設色紙本
Ink and color on paper
尺寸不詳, Unknown size
收藏者不明
Unknown Collector

165
如膠似漆
Tie
1966
水墨紙本
Ink on paper
23×22 cm
藝術家自藏
Collection of the Artist

166
團聚-1
Reunion (I)
1966
水墨紙本
Ink on paper
23×29 cm
收藏者不明
Unknown Collector

167
憩-1
Nap (I)
1966
水墨紙本
Ink on paper
22×29 cm
水松石山房收藏
Shuisongshi Shanfang Collection

168
暗流
Current
1966
水墨設色紙本
Ink and color on paper
23×120 cm
私人收藏
Private Collection

169
鬧溪
Stream
1966
水墨設色紙本
Ink and color on paper
180×30 cm
私人收藏
Private Collection

170
桃源-1
Arcadia (I)
1966
水墨設色紙本
Ink and color on paper
23×120 cm
水松石山房收藏
Shuisongshi Shanfang Collection

171
咫尺千里
River Mist
1966
水墨設色紙本
Ink and color on paper
25×100 cm
私人收藏
Private Collection

172
山水之間
Monkeyscape
1966
水墨設色紙本
Ink and color on paper
22.5×120.4 cm
水松石山房收藏
Shuisongshi Shanfang Collection

173
潤
Gorge
1966
水墨設色紙木
Ink and color on paper
180×22.5 cm
水松石山房收藏
Shuisongshi Shanfang Collection

174
滿足
Content
1966
水墨紙本
Ink on paper
22×29 cm
水松石山房收藏
Shuisongshi Shanfang Collection

175
香火
String of Smoke
ca.1966
水墨設色紙本
Ink and color on paper
115×23 cm
私人收藏
Private Collection

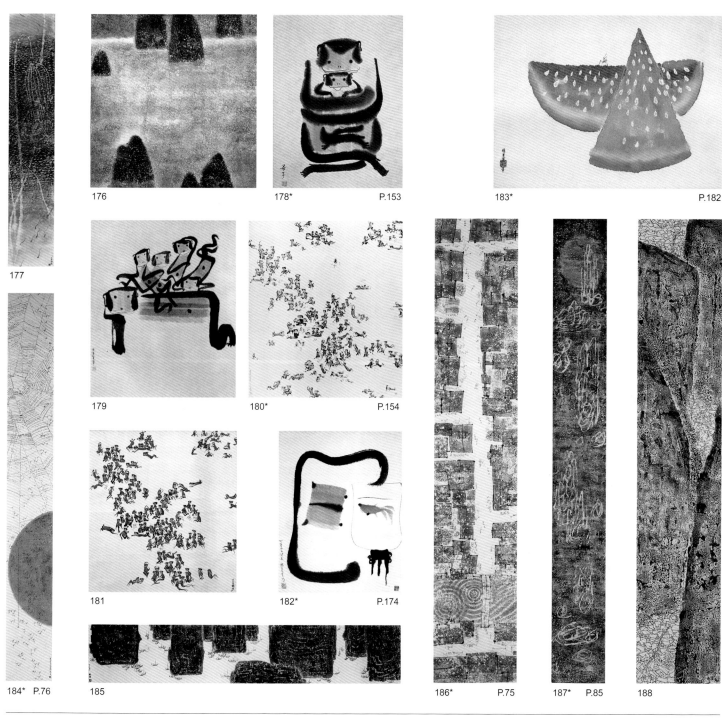

176
水墨設色紙本

177

178* P.153

183* P.182

179

180* P.154

181

182* P.174

184* P.76 185

186* P.75 187* P.85 188

176	177	178	179	180	181	182
霧	夕陽漁影	吾子	老奴	眾生相(稿)	眾生相	惑 (可望而不可及)
Mist	Shadow	Son	Slave	Phase(Sketch)	Phase	Untouchable
ca.1966	1967	1967	1967	1967	1967	1967
水墨設色紙本	水墨設色紙本	水墨紙本	水墨紙本	水墨紙本	水墨紙本	水墨紙本
Ink and color on paper	Ink and color on paper	Ink on paper	Ink on paper	Ink on paper	Ink on paper	Ink on paper
尺寸不詳, Unknown size	122×22.5 cm	30×22.7 cm	24×33 cm	70×65 cm	70×65 cm	29×22 cm
私人收藏	私人收藏	水松石山房收藏	藝術家自藏	藝術家自藏	水松石山房收藏	藝術家自藏
Private Collection	Private Collection	Shuisongshi Shanfang Collection	Collection of the Artist	Collection of the Artist	Shuisongshi Shanfang Collection	Collection of the Artist

183	184	185	186	187	188
渴	蜉�蝣半日-1	蝦舟	通衢	夢遊	山居
Thirsty	Ephemera (I)	Fishing	Thoroughfare	Vision	Village
1967	1967	1967	1967	1967	1967
水墨設色紙本	水墨設色紙本	水墨設色紙本	水墨設色紙本	水墨設色紙本	水墨設色紙本
Ink and color on paper	Ink and color on paper	Ink and color on paper	Ink and color on paper	Ink and color on paper	Ink and color on paper
22×23 cm	183.5×23.5 cm	22.5×121 cm	120.9×22.6 cm	183.5×22.3 cm	126×23 cm
藝術家自藏	水松石山房收藏	收藏者不明	水松石山房收藏	水松石山房收藏	收藏者不明
Collection of the Artist	Shuisongshi Shanfang Collection	Unknown Collector	Shuisongshi Shanfang Collection	Shuisongshi Shanfang Collection	Unknown Collector

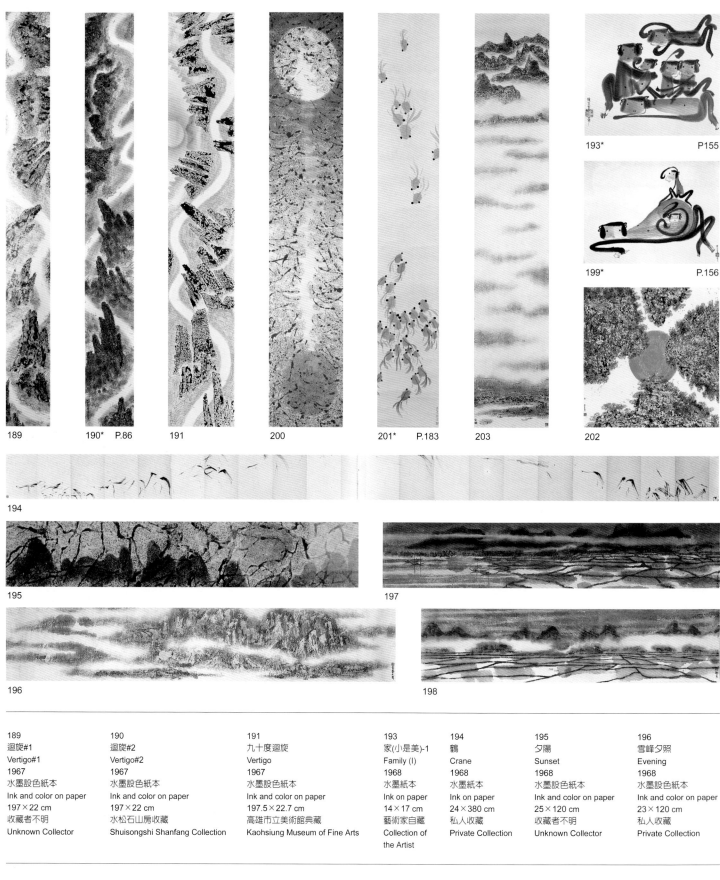

189

190*　P.86

191

200

201*　P.183

203

202

193*　P155

199*　P.156

194

195

197

196

198

189	190	191	193	194	195	196
迴旋#1	迴旋#2	九十度迴旋	家(小是美)-1	鶴	夕陽	雪峰夕照
Vertigo#1	Vertigo#2	Vertigo	Family (I)	Crane	Sunset	Evening
1967	1967	1967	1968	1968	1968	1968
水墨設色紙本	水墨設色紙本	水墨設色紙本	水墨紙本	水墨紙本	水墨設色紙本	水墨設色紙本
Ink and color on paper	Ink and color on paper	Ink and color on paper	Ink on paper	Ink on paper	Ink and color on paper	Ink and color on paper
197×22 cm	197×22 cm	197.5×22.7 cm	14×17 cm	24×380 cm	25×120 cm	23×120 cm
收藏者不明	水松石山房收藏	高雄市立美術館典藏	藝術家自藏	私人收藏	收藏者不明	私人收藏
Unknown Collector	Shuisongshi Shanfang Collection	Kaohsiung Museum of Fine Arts	Collection of the Artist	Private Collection	Unknown Collector	Private Collection

197	198	199	200	201	202	203
霞	藍	孕	金烏玉兔	有朋自遠方來	午	空
Sunset	Blue Landscape	Conception	Sun and Moon	Visitors	Noon	Ethereal
1968	ca.1968	1969	1969	1969	1969	1969
水墨設色紙本	水墨設色紙本	水墨紙本	水墨設色紙本	水墨設色紙木	水墨設色紙本	水墨設色紙本
Ink and color on paper	Ink and color on paper	Ink on paper	Ink and color on paper	Ink and color on paper	Ink and color on paper	Ink and color on paper
25×120 cm	23×115 cm	25×34 cm	115×23 cm	183×23 cm	45×45.5 cm	121×22.5 cm
私人收藏	私人收藏	藝術家自藏	私人收藏	藝術家自藏	私人收藏	私人收藏
Private Collection	Private Collection	Collection of the Artist	Private Collection	Collection of the Artist	Private Collection	Private Collection

205* P.158 206 207

204

208 209* P.157 211* P.175

210

213* P.77 215* P.184 216 212* P.176 214* P.111 217* P.185

204	205	206	207	208	209	210
白塔	情	全家福	老奴	協力	舉	古木
White Pagoda	Caress	Family	Bearing	Team	Lifting	Ancient Tree
ca.1969	1970	1970	1970s	1970s	1970s	1971
水墨設色紙本	水墨紙本	水墨紙本	水墨紙本	水墨紙木	水墨紙本	水墨設色紙本
Ink and color on paper	Ink on paper	Ink on paper	Ink on paper	Ink on paper	Ink on paper	Ink and color on paper
120×25 cm	25×35 cm	33×28 cm	尺寸不詳, Unknown size	尺寸不詳, Unknown size	26×31 cm	22.4×119.2 cm
私人收藏	藝術家自藏	私人收藏	私人收藏	私人收藏	藝術家自藏	水松石山房收藏
Private Collection	Collection of the Artist	Private Collection	Private Collection	Private Collection	Collection of the Artist	Shuisongshi Shanfang Collection

211	212	213	214	215	216	217
憩-2	大劫難逃	沙	雪-2	孿	水鄉	少則得
Nap (II)	Fatal	Beach	Snow (II)	Twins	Wetland	Less is More
1972	1973	1973	1973	1973	1975	1976
水墨局部設色紙本	水墨紙本	水墨設色紙本	水墨紙本	水墨設色紙本	水墨設色紙本	水墨設色紙本
Ink and color on paper	Ink on paper	Ink and color on paper	Ink on paper	Ink and color on paper	Ink and color on paper	Ink and color on paper
24×45 cm	29×22 cm	120×30 cm	22×28 cm	24×18 cm	尺寸不詳, Unknown size	14×17 cm
藝術家自藏	藝術家自藏	藝術家自藏	藝術家自藏	藝術家自藏	私人收藏	加拿大維多利亞美術館
Collection of the Artist	Collection of the Artist	Collection of the Artist	Collection of the Artist	Collection of the Artist	Private Collection	Art Gallery of Victoria in British Columbia, Canada

218

219

220*　　　　　　　　　　P.112

221

226

222

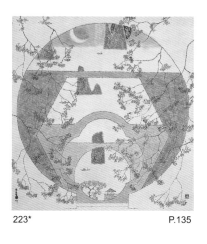

223*　　　　　　　　　　P.135

225

227

228

230*　　　　　　　　　　P.159

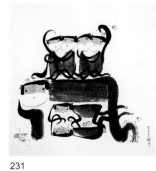

231

218	219	220	221	222	223
終點	痛飲	河套	凍港	山門	昇
Impasse	Thirsty	River Bend	Deep Freeze	Temple's Gate	Ascend
1977	1977	1977	1977	1978	1978
水墨紙本	水墨設色紙本	水墨設色紙本	水墨設色紙本	水墨設色紙本	水墨設色紙本
Ink on paper	Ink and color on paper	Ink and color on paper	Ink and color on paper	Ink and color on paper	Ink and color on paper
23×30 cm	29.7×23 cm	23×30 cm	30×22.8 cm	62×62 cm	60×60 cm
水松石山房收藏	水松石山房收藏	藝術家自藏	水松石山房收藏	私人收藏	藝術家自藏
Shuisongshi Shanfang Collection	Shuisongshi Shanfang Collection	Collection of the Artist	Shuisongshi Shanfang Collection	Private Collection	Collection of the Artist

225	226	227	228	230	231
鶴	荷	秀色-1	秀色-2	童心	老奴
Crane and Mountains	Lotus	Torso-1	Torso-2	Youth	An Old Men with Large Offspring
1979	1979	1979	1979	1979	1979
水墨設色紙本	水墨設色紙本	水墨設色紙本	水墨設色紙本	水墨紙本	水墨紙本
Ink and color on paper	Ink and color on paper	Ink and color on paper	Ink and color on paper	Ink on paper	Ink on paper
185×31 cm	尺寸不詳, Unknown size	36×35 cm	36×35 cm	30.5×29 cm	45×48 cm
私人收藏	私人收藏	私人收藏	私人收藏	藝術家自藏	私人收藏
Private Collection	Private Collection	Private Collection	Private Collection	Collection of the Artist	Private Collection

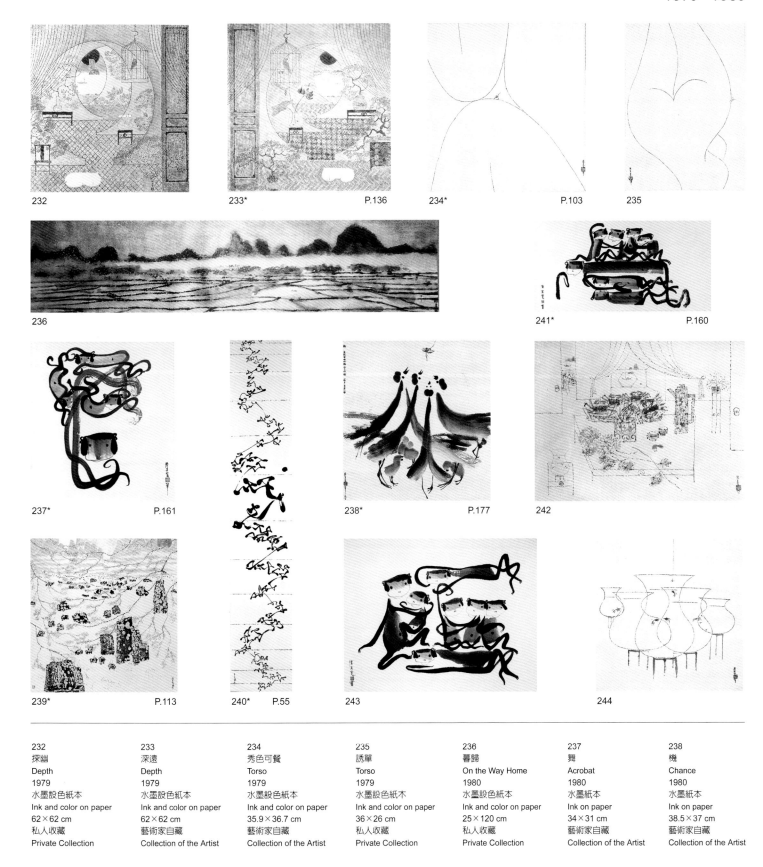

232

233*　　　　　　　P.136

234*　　　　　　　P.103

235

236

241*　　　　　　　P.160

237*　　　　　　　P.161

238*　　　　　　　P.177

242

239*　　　　　　　P.113

240*　　　P.55

243

244

232	233	234	235	236	237	238
探幽	深遠	秀色可餐	誘單	暮歸	舞	機
Depth	Depth	Torso	Torso	On the Way Home	Acrobat	Chance
1979	1979	1979	1979	1980	1980	1980
水墨設色紙本	水墨設色紙本	水墨設色紙本	水墨設色紙木	水墨設色紙本	水墨紙本	水墨紙本
Ink and color on paper	Ink and color on paper	Ink and color on paper	Ink and color on paper	Ink and color on paper	Ink on paper	Ink on paper
62×62 cm	62×62 cm	35.9×36.7 cm	36×26 cm	25×120 cm	34×31 cm	38.5×37 cm
私人收藏	藝術家自藏	藝術家自藏	私人收藏	私人收藏	藝術家自藏	藝術家自藏
Private Collection	Collection of the Artist	Collection of the Artist	Private Collection	Private Collection	Collection of the Artist	Collection of the Artist

239	240	241	242	243	244
細水長流	球賽-5	負擔-2	宴-2	家族-1	迷
Long Last	Ball Game（Ⅴ）	Weight (II)	Banquet (II)	Family Members (I)	Maze
1980	1980	1980s	1980s	1980s	1980s
水墨設色紙本	水墨紙本	水墨紙本	水墨設色紙本	水墨紙本	水墨設色紙本
Ink and color on paper	Ink on paper	Ink on paper	Ink and color on paper	Ink on paper	Ink and color on paper
68×69.5 cm	186×30 cm	30×61 cm	23×30 cm	尺寸不詳, Unknown size	36×35 cm
私人收藏	藝術家自藏	藝術家自藏	藝術家自藏	私人收藏	私人收藏
Private Collection	Collection of the Artist	Collection of the Artist	Collection of the Artist	Private Collection	Private Collection

246

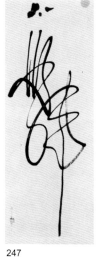

247

249

250

251*　　P.104

248*

P.178

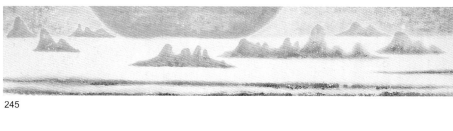

245

252　254

253

255

256*　　P.144

257

245	246	247	248	249	250	251
夕	嬉	聞雞起舞	放鶴圖	決	蝦	灘
Sunset	Duo	Dancing	The Returning Cranes	1981	Shrimp	Beach Scene
ca.1980	1981	1981	1981	水墨紙本	1981	1982
水墨設色紙本	水墨設色紙本	水墨紙本	水墨紙本	Ink on paper	水墨設色紙本	水墨設色紙本
Ink and color on paper	Ink and color on paper	Ink on paper	Ink on paper	尺寸不詳, Unknown size	Ink and color on paper	Ink and color on paper
25×120 cm	29×34 cm	尺寸不詳, Unknown size	7.8×360.5 cm	收藏者不明	13×16.6 cm	92×30 cm
私人收藏	私人收藏	收藏者不明	水松石山房收藏	Unknown Collector	水松石山房收藏	藝術家自藏
Private Collection	Private Collection	Unknown Collector	Shuisongshi Shanfang Collection		Shuisongshi Shanfang Collection	Collection of the Artist

252	253	254	255	256	257
約	憶	田	內海	生	始
West Chamber	Recall	Terrace	Inland Sea	Life	Genesis
1982	1982	1983	1983	1983	1983
水墨設色紙本	水墨設色紙本	水墨設色紙本	水墨設色紙本	水墨設色紙本	水墨設色紙木
Ink and color on paper	Ink and color on paper	Ink and color on paper	Ink and color on paper	Ink and color on paper	Ink and color on paper
144.5×30 cm	44×46 cm	183×30 cm	48×48 cm	67×34 cm	186×30 cm
私人收藏	私人收藏	私人收藏	私人收藏	藝術家自藏	私人收藏
Private Collection	Private Collection	Private Collection	Private Collection	Collection of the Artist	Private Collection

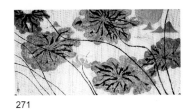
271

272

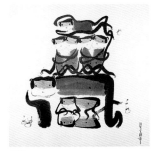
275

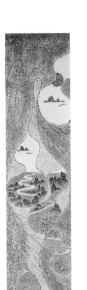
273

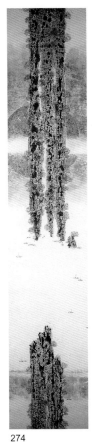
274

277

278

279

280

276

281

285

284*

P.128~130

271
崖-1
Remote Hills (I)
1985
水墨設色紙本
Ink and color on paper
30.5×62 cm
私人收藏
Private Collection

272
海月入室
Inviting Moon and Ocean
1985
水墨設色紙本
Ink and color on paper
32×186 cm
私人收藏
Private Collection

273
蘆
Gourd
1985
水墨設色紙本
Ink and color on paper
185×30 cm
私人收藏
Private Collection

274
重九
September 9
1985
水墨設色紙本
Ink and color on paper
161×33 cm
私人收藏
Private Collection

275
鼎
Carrying
1985
水墨紙本
Ink on paper
45.7×47.6 cm
私人收藏
Private Collection

276
靜物
Still Life
1985
水墨設色紙本
Ink and color on paper
29×40 cm
私人收藏
Private Collection

277
翔
Aloft
1985
水墨設色紙本
Ink and color on paper
186×31 cm
私人收藏
Private Collection

278
曦
Aurora
1985
水墨設色紙本
Ink and color on paper
185×30 cm
私人收藏
Private Collection

279
轉
Turning
1985
水墨設色紙本
Ink and color on paper
186×30 cm
私人收藏
Private Collection

280
門
Gate
1985
水墨設色紙本
Ink and color on paper
183×30 cm
私人收藏
Private Collection

281
瓶（和平）
Peace
1985
水墨設色紙本
Ink and color on paper
60×60 cm
私人收藏
Private Collection

284
陰陽2
Yin Yang No.2
1985
水墨設色紙本
Ink and color on paper
30×540 cm
藝術家自藏
Collection of the Artist

285
紅絲雨
Drizzling in Red
1986
水墨設色紙本
Ink and color on paper
31×62 cm
私人收藏
Private Collection

286

287

288

289

290

291

292

293

294

295* P.88

296

297

298

286
團聚-2
Reunion (II)
1986
水墨紙本
Ink on paper
34×44.5 cm
私人收藏
Private Collection

287
夕鄉
Nostaligia
1986
水墨設色紙本
Ink and color on paper
30×46 cm
私人收藏
Private Collection

288
境
Place
1986
水墨設色紙本
Ink and color on paper
30×30 cm
私人收藏
Private Collection

289
透
See Through
1986
水墨設色紙本
Ink and color on paper
30×30 cm
私人收藏
Private Collection

290
透-1
Transparency (I)
1986
水墨設色紙本
Ink and color on paper
31×62 cm
私人收藏
Private Collection

291
慾
Desire
1986
水墨設色紙木
Ink and color on paper
47.5×61 cm
私人收藏
Private Collection

292
候鳥
Migration
1986
水墨設色紙本
Ink and color on paper
186×30 cm
私人收藏
Private Collection

293
泰(易經,天地交而萬物生)
Interplay
1986
水墨設色紙本
Ink and color on paper
188×30 cm
私人收藏
Private Collection

294
巽 (易經, 兩風相隨)
Wind
1986
水墨設色紙本
Ink and color on paper
187×30 cm
私人收藏
Private Collection

295
嶺
Watershed
1986
水墨設色紙本
Ink and color on paper
186×32 cm
藝術家自藏
Collection of the Artist

296
顛
Peak
1986
水墨設色紙本
Ink and color on paper
185×30 cm
私人收藏
Private Collection

297
朝霧
Morning Mist
1986
水墨設色紙本
Ink and color on paper
34×43 cm
私人收藏
Private Collection

298
宴-1
Banquet (I)
1986
水墨設色紙本
Ink and color on paper
33.5×44cn
翻拍樂山堂拍賣目錄
1990

326

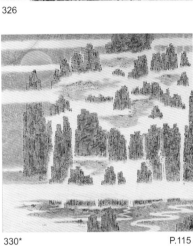

330* P.115

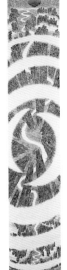

327* P.89

331

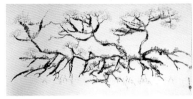

328

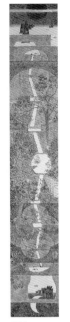

329

332* P.90

333

334

336

337

338

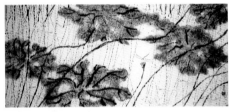

335

326	327	328	329	330	331	332
長庚	遙	橋	園	高原	猴子樹	霧鳴
Venus	Afar	Bridge	Garden	Plateau	Root	Sound of Fog
1988	1988	1988	1988	1988	1988	ca.1988
水墨設色紙本	水墨設色紙本	水墨設色紙本	水墨設色紙本	水墨設色紙本	水墨設色紙本	水墨設色紙本
Ink and color on paper	Ink and color on paper	Ink and color on paper	Ink and color on paper	Ink and color on paper	Ink and color on paper	Ink and color on paper
60×61.5 cm	181×31 cm	61×61 cm	186×30 cm	61.5×61 cm	33×69 cm	186×30 cm
私人收藏	藝術家自藏	私人收藏	私人收藏	私人收藏	翻拍自樂山堂拍賣目錄1990	水松石山房收藏
Private Collection	Collection of the Artist	Private Collection	Private Collection	Private Collection		Shuisongshi Shanfang Collection

333	334	335	336	337	338
雨-1	雨荷	伊甸園	生態	暮雲春樹	自由
Rain (I)	Rain on Lotus	Eden	Little Universe	Spring Landscape	Born Free
1989	1989	1989	1989	1989	1989
水墨設色紙本	水墨設色紙本	水墨設色紙本	水墨設色紙本	水墨設色紙本	水墨設色紙本
Ink and color on paper	Ink and color on paper	Ink and color on paper	Ink and color on paper	Ink and color on paper	Ink and color on paper
31×62 cm	31×62 cm	14.5×187 cm	25×61 cm	尺寸不詳, Unknown size	尺寸不詳, Unknown size
私人收藏	私人收藏	私人收藏	私人收藏	私人收藏	私人收藏
Private Collection	Private Collection	Private Collection	Private Collection	Private Collection	Private Collection

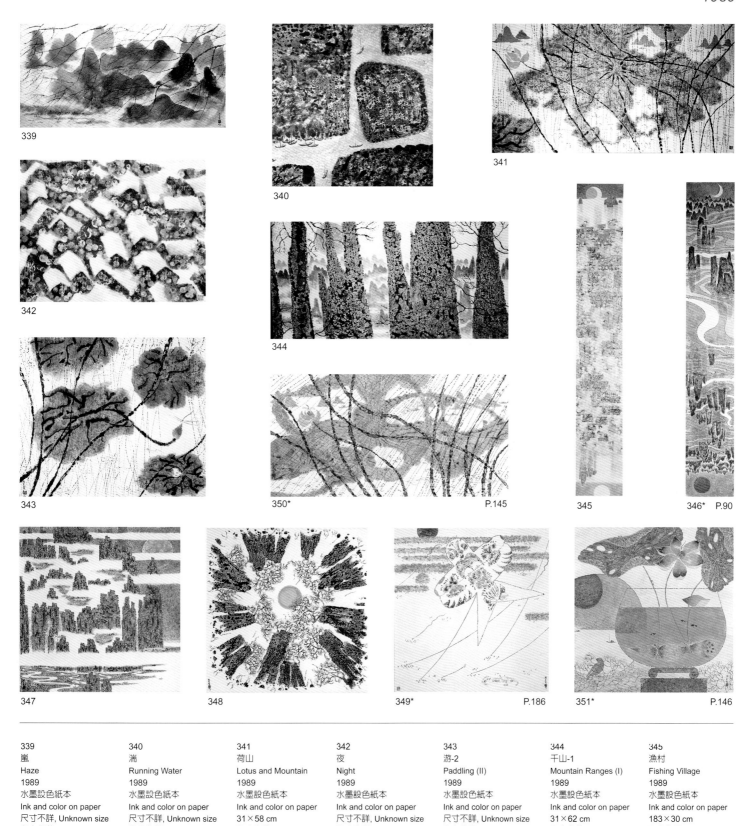

339

340

341

342

343

344

345

350* P.145

346* P.90

347

348

349* P.186

351* P.146

339	340	341	342	343	344	345
嵐	湍	荷山	夜	游-2	千山-1	漁村
Haze	Running Water	Lotus and Mountain	Night	Paddling (II)	Mountain Ranges (I)	Fishing Village
1989	1989	1989	1989	1989	1989	1989
水墨設色紙本	水墨設色紙本	水墨設色紙本	水墨設色紙本	水墨設色紙本	水墨設色紙本	水墨設色紙本
Ink and color on paper	Ink and color on paper	Ink and color on paper	Ink and color on paper	Ink and color on paper	Ink and color on paper	Ink and color on paper
尺寸不詳, Unknown size	尺寸不詳, Unknown size	31×58 cm	尺寸不詳, Unknown size	尺寸不詳, Unknown size	31×62 cm	183×30 cm
私人收藏	私人收藏	私人收藏	私人收藏	私人收藏	私人收藏	私人收藏
Private Collection	Private Collection	Private Collection	Private Collection	Private Collection	Private Collection	Private Collection

346	347	348	349	350	351
遠	天・地・人	紫陽	戲風-1	雨-2	迷宮
Yon	Heaven, Earth and Man	Purple Sun	Kite (I)	Rain (II)	Labyrinth
1989	1989	1989	1989	1989	1989
水墨設色紙本	水墨設色紙本	水墨設色紙本	水墨設色紙本	水墨設色紙本	水墨設色紙本
Ink and color on paper	Ink and color on paper	Ink and color on paper	Ink and color on paper	Ink and color on paper	Ink and color on paper
186×30 cm	61.5×61 cm	61×61 cm	60×60 cm	31×62 cm	61×61 cm
水松石山房收藏	私人收藏	私人收藏	藝術家自藏	台北市立美術館典藏	藝術家自藏
Shuisongshi Shanfang Collection	Private Collection	Private Collection	Collection of the Artist	Taipei Fine Arts Museum	Collection of the Artist

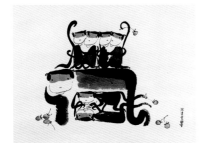

380*　　　　　　　　　P.162

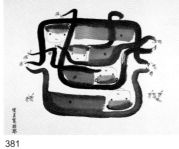

381

383

384

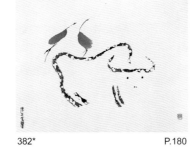

382*　　　　　　　　　P.180

386

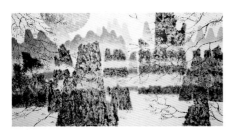

387

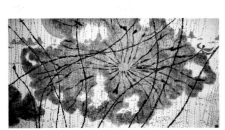

388

389

390

385

391

392*　P.92

380
老奴-2
Supporting
1990
水墨局部設色紙本
Ink and color on paper
45×48 cm
藝術家自藏
Collection of the Artist

381
包容-3
Caress (III)
ca.1997
水墨局部設色紙本
Ink and color on paper
33×60 cm
私人收藏
Private Collection

382
浮生半日閒-2
Leisure (II)
1990
水墨紙本
Ink on paper
36×47.5 cm
藝術家自藏
Collection of the Artist

383
崖-2
Remote Hills (II)
1990
水墨設色紙本
Ink and color on paper
30.5×62 cm
私人收藏
Private Collection

384
互助
Co-dependence
1990s
水墨局部設色紙本
Ink and color on paper
尺寸不詳, Unknown size
私人收藏
Private Collection

385
年夜
The Night before New Year
1990左右
水墨設色紙本
Ink and color on paper
22.5×30.5 cm
水松石山房收藏
Shuisongshi Shanfang Collection

386
除夕夜
New Year's Eve
1990左右
水墨設色紙本
Ink and color on paper
22×120 cm
私人收藏
Private Collection

387
三峽-2
Three Canals-2
ca.1990
水墨設色紙本
Ink and color on paper
31×62 cm
私人收藏
Private Collection

388
荷遊
Lotus Cruise
ca.1990
水墨設色紙本
Ink and color on paper
31×62 cm
私人收藏
Private Collection

389
生生不息
Metabo Lism
1991
水墨設色紙本
Ink and color on paper
186×31 cm
私人收藏
Private Collection

390
庭
Lourt Yard
1991
水墨設色紙本
Ink and color on paper
186×31 cm
私人收藏
Private Collection

391
源遠流長
Nature and Man
1991
水墨設色紙本
Ink and color on paper
92×186 cm
私人收藏
Private Collection

392
北辰
Polaris
1991
水墨設色紙本
Ink and color on paper
185×30 cm
藝術家自藏
Collection of the Artist

393

394* P.193

400

401

395

396

404

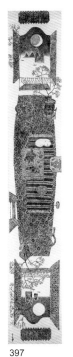

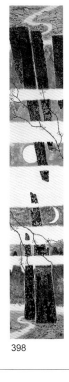

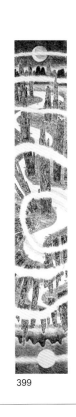

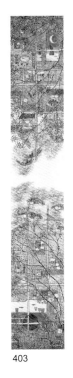

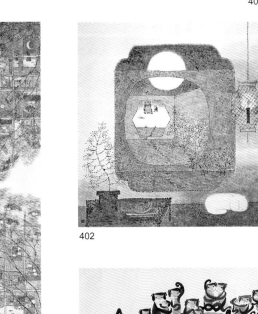

402

405* P.165

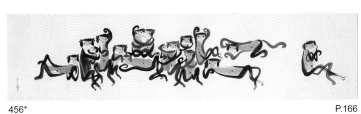

397 398 399 403

456* P.166

393	394	395	396	397	398	399
荷塘清趣	加飯	機緣	日出三峽	室	會合	週
Lotus Pond	Wine	Luck	Day by Sun Raise	Interieur	In Touch	Cycle
1991	1991	1991	1992	1992	1992	1992
水墨設色紙本	水墨設色紙本	水墨紙本	水墨設色紙本	水墨設色紙本	水墨設色紙木	水墨設色紙本
Ink and color on paper	Ink and color on paper	Ink on paper	Ink and color on paper	Ink and color on paper	Ink and color on paper	Ink and color on paper
30×61 cm	15×62 cm	44.6×44.6 cm	92×186 cm	186×30 cm	186×30 cm	186×30 cm
私人收藏	藝術家自藏	私人收藏	私人收藏	私人收藏	私人收藏	私人收藏
Private Collection	Collection of the Artist	Private Collection	Private Collection	Private Collection	Private Collection	Private Collection

400	401	402	403	404	405	456
勁荷	風勁荷柔	歸舟	鬧	負擔-3	豐收	緣
Lotus in Gust	Lotus in Storm	Sailing Home	Noise	Weight (III)	Harvest	Fate
1992	1992	1992	1992	1992	1992	1997左右
水墨設色紙本	水墨設色紙本	水墨設色紙本	水墨設色紙本	水墨局部設色紙本	水墨局部設色紙本	水墨紙本
Ink and color on paper	Ink and color on paper	Ink and color on paper	Ink and color on paper	Ink and color on paper	Ink and color on paper	Ink on paper
尺寸不詳, Unknown size	34×138 cm	62×61.5 cm	186×30 cm	尺寸不詳, Unknown size	70×45 cm	143×35 cm
私人收藏	私人收藏	私人收藏	私人收藏	私人收藏	藝術家自藏	私人收藏
Private Collection	Private Collection	Private Collection	Private Collection	Private Collection	Collection of the Artist	Private Collection

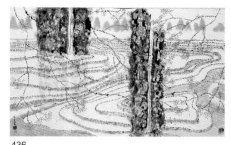
436

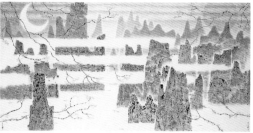
437*　　　　　　P.124

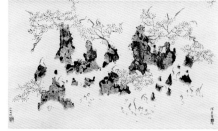
438

435

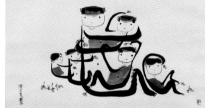
442*　　　　　　P.167

446*　　　　　　P.120

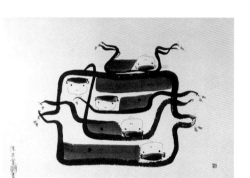
443

435

439*　P.148

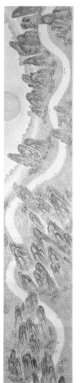
440

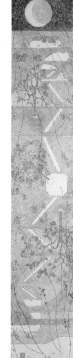
441*　P.96

444*　　　　　　P.168

439*　P.148

447*　P.134

435	436	437	438	439	440	441
蜉蝣半日-2	雞犬相聞	憶三峽 1973	翠溪	光陰過隙	浪與潮	天旋地轉
Ephemera (II)	Dreamland	Memory on Three Canals in 1973	Green River	Time Goes By	Waves and Tides	Vertigo#3
1995	1996	1996	1996	1996	1996	1996
水墨設色紙本	水墨設色紙本	水墨設色紙本	水墨設色紙本	水墨設色紙本	水墨設色紙本	水墨設色紙本
Ink and color on paper	Ink and color on paper	Ink and color on paper	Ink and color on paper	Ink and color on paper	Ink and color on paper	Ink and color on paper
186×32 cm	60×62 cm	93×186 cm	35×60 cm	186×32 cm	186×32 cm	186×32 cm
藝術家自藏	私人收藏	私人收藏	藝術家自藏	藝術家自藏	藝術家自藏	藝術家自藏
Collection of the Artist	Private Collection	Private Collection	Collection of the Artist	Collection of the Artist	Collection of the Artist	Collection of the Artist

442	443	444	445	446	447
一點紅	包容-1	包容-2	浮生半日閒-1	世外桃源	徑欲曲
Red Fruit	Caress (I)	Caress (II)	Leisure (I)	Arcadia	Path Tends to Bend
1997	1997	1997	1997	2002	1997
水墨局部設色紙本	水墨局部設色紙本	水墨局部設色紙本	水墨紙本	水墨設色紙本	水墨設色紙本
Ink and color on paper	Ink and color on paper	Ink and color on paper	Ink on paper	Ink and color on paper	Ink and color on paper
33×60 cm	34×49 cm	34×60 cm	34×34 cm	32×186 cm	186×32 cm
藝術家自藏	藝術家自藏	藝術家自藏	藝術家自藏	台北市立美術館典藏	藝術家自藏
Collection of the Artist	Collection of the Artist	Collection of the Artist	Collection of the Artist	Taipei Fine Arts Museum	Collection of the Artist

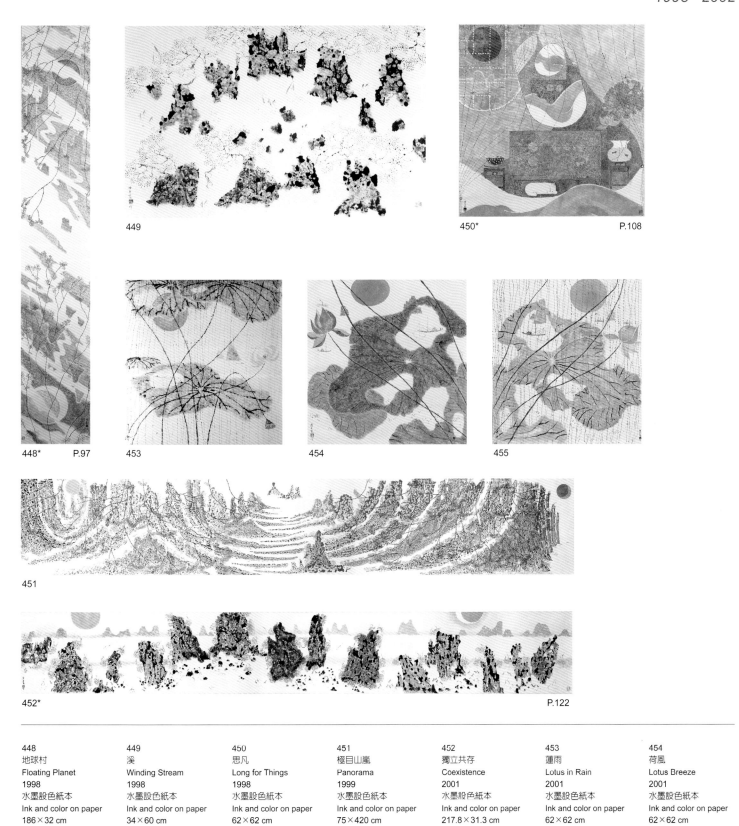

449

450* P.108

448* P.97

453

454

455

451

452* P.122

448	449	450	451	452	453	454
地球村	溪	思凡	極目山嵐	獨立共存	蓮雨	荷風
Floating Planet	Winding Stream	Long for Things	Panorama	Coexistence	Lotus in Rain	Lotus Breeze
1998	1998	1998	1999	2001	2001	2001
水墨設色紙本	水墨設色紙本	水墨設色紙本	水墨設色紙本	水墨設色紙本	水墨設色紙本	水墨設色紙本
Ink and color on paper	Ink and color on paper	Ink and color on paper	Ink and color on paper	Ink and color on paper	Ink and color on paper	Ink and color on paper
186×32 cm	34×60 cm	62×62 cm	75×420 cm	217.8×31.3 cm	62×62 cm	62×62 cm
藝術家自藏	藝術家自藏	藝術家自藏	藝術家自藏	私人收藏	私人收藏	私人收藏
Collection of the Artist	Collection of the Artist	Collection of the Artist	Collection of the Artist	Private Collection	Private Collection	Private Collection

455
驟雨
Sudden Rain
2002
水墨設色紙本
Ink and color on paper
62×62 cm
藝術家自藏
Collection of the Artist

編者註

※本專輯共收錄陳其寬作品計四百四十六件，然而其創作總量應超過此數。尤其是一九五〇年代創作初期的作品大多因年代久遠，散佚不可考，猶待進一步的追蹤與挖掘。

This volume documents 446 of Chen Chi-kwan's works; however, the total number of pieces he has created greatly exceeds this figure. His artwork from the 1950s, in particular, is widely scattered and difficult to trace because of the passage of many years, and awaits more extensive research and discovery in the future.

※作品編號旁標有＊者為「雲煙過眼－陳其寬的繪畫與建築」展出作品（2003年十一月八日至2004年十月一日，臺北市立美術館）

Works with a ＊ next to their serial number were displayed as part of the exhibition "The Painting and Architecture of Chen Chi-kwan" (Nov. 8, 2003 to Oct. 1, 2004, Taipei Fine Arts Museum).